GLOBAL CAPITAL, LOCAL CULTURE

Toby Miller
General Editor

Vol. 16

PETER LANG
New York • Washington, D.C./Baltimore • Bern
Frankfurt am Main • Berlin • Brussels • Vienna • Oxford

Anthony Fung

GLOBAL CAPİTAL, LOCAL CULTURE

Transnational Media Corporations in China

PETER LANG
New York • Washington, D.C./Baltimore • Bern
Frankfurt am Main • Berlin • Brussels • Vienna • Oxford

Library of Congress Cataloging-in-Publication Data

Fung, Anthony Y.H.
Global capital, local culture: transnational media
corporations in China / Anthony Y.H. Fung.
p. cm. — (Popular culture and everyday life; 16)
Includes bibliographical references and index.
1. Mass media and culture—China.
2. Piracy (Copyright)—China. I. Title.
P94.65.C6F86 302.230951—dc22 2007024360
ISBN 978-0-8204-9501-9 (hardcover)
ISBN 978-0-8204-9500-2 (paperback)
ISSN 1529-2428

Bibliographic information published by **Die Deutsche Bibliothek**.
Die Deutsche Bibliothek lists this publication in the "Deutsche
Nationalbibliografie"; detailed bibliographic data is available
on the Internet at http://dnb.ddb.de/.

Cover design by Joni Holst

The paper in this book meets the guidelines for permanence and durability
of the Committee on Production Guidelines for Book Longevity
of the Council of Library Resources.

Printed in the United States of America

Contents

Figures, Tables, and Charts

Preface

From China Phobia to China Mania

Fifteen years ago, I put my first step into China for research. It was just a few years after the June 4 Incident. The political atmosphere was tense and unstable. I remembered I had to bring along with me a special entry certificate given to the ethnic Chinese of Hong Kong—in fact a crude, light brown booklet with the emblem of the PRC (People's Republic of China) on the cover—to "return" to the motherland for personal purposes. I literally had to write down minute details of the "materialistic goods," including watches, cameras, and the amount of petty cash that I brought into the Communist country on this travel permit, and I also had to make sure that these goods accompanied me back to the capitalist side on my return trip lest the latter get into mainland hands and "pollute" mainland minds. In theory, a student like me could create no harm to the regime and I knew that I shouldn't be afraid of anything. But somehow I was worried about my past as an ex-journalist position although as it turned out that nobody in the entire country—with the exception of a single security guard—was interested in my trivial past history. I knew that I was indeed spying something in the PRC, but even as I anonymously walked down the street, the panoptic gaze of strangers could suffocate me. Besides the odd psychology of the trip, the nature of the research was a problem. I surmised that being a researcher in China was no different from being an agent of the CIA or KGB (I only knew that the consequences would be as serious if I got caught behind the Iron Curtain). Conducting surveys or interviews was hardly an open activity; however, data collected through whatever mysterious means could be quite superficial in quality. In-depth ethnographic work in the sensitive media locales such as radio, television stations, or newspapers was simply out of the question. In that particular period, for me and for many others, China phobia was the catchword to describe our rendezvous with the mainland. Despite the fear, Westerners or people with Western education like me were always curious about the mystical authoritarian rule behind the veil. Thus, quite commonly, the purpose for studying China at that time was not because we were captivated by a profound Chinese culture of 5,000 years. In political science, sociology, media studies, or other related disciplines, the investigation of how public opinion was manipulated by propaganda, by what means Chairman Mao could proselytize the young generation, and the processes of how media were censored, to name a few, were the naked desires we sought

satisfaction for.

Today, with China's boosted economy and a stronger national power, the entire orientation toward China and the purposes behind reaching out to the Communist regime has changed. From China phobia to China mania, people flock to the mainland in the hopes of expanding their revenues in trade and business with China and of perceiving a more accurate picture of Communist politics. To research China hence is more of practical concern. However, many studies are partial and incomprehensible in that the anatomy of the Chinese media are heavily laden with the same preconceptions and assumptions I made 15 years ago, ones that are no longer applicable to the advancing China. This book then is not just my analysis of the data collected in my current research project, or simply my recollection, reflection, and personal viewpoint on the change of media scene in China over these many years. It can be regarded as a rebuttal against the intentional stigmatization, frivolous comments, sententious and prejudiced cultural analysis of China—mainly based on partial information and from a political standpoint—that could hardly lead us to a deeper understanding of the culture and media of China.

Not that I am the only one with a better and sharper analysis. Anyone having a passion for China can do it. The key is always the modus operandi of "feeling" it. I attempt to research my questions and hypothesis not purely as an insouciant researcher merely intending to search for objective answers to the questions and immerse myself in the field bearing the concern and the sensitivity that a cultural worker should have. Interviewees were not just our sources of information; we became members of the field to be interviewed. They discussed and analyzed the industry with us. Many a time, my assistant and I were asked to prescribe strategies and solutions to optimize business operations. At some point, lost in orientation, I did feel that I was a frontline media practitioner. Given that the world (and all transnational corporations that I encountered) prefers to talk about efficiency over anything else, I realized that in-depth "data mining" was probably not the way to do quick-and-dirty research. The extra benefits or added value that I have gained in this abnormal academic study is not what a traditional researcher can offer. I was really fortunate and blessed to meet many good friends who inspired me with different points of view, helped me and directed me to different avenues for this data collecting. With their guiding light I contacted many related media and stations, and walked into different media sites for my field work. For months at a time I stayed in Beijing, Shanghai, Guangzhou, and

many locales alone in the middle of nowhere that I often felt as if I were somehow hovering between life and death. Many people took care of me and protected me.

With this imprudent attitude, which let passion infiltrate into my research work, I extensively interviewed more than 100 important people in the field, dashed into many used-to-be restricted arenas, and was able to "feel" and "palpate" the entire gamut of industries, from production, dissemination, promotion, circulation, to distribution and consumption. The key to this success, I would say, are all the interviewees that I am indebted to. I am particularly impressed by the open attitude of many Chinese officials, cultural critics, industry workers, and personnel of transnational media corporations in China. When I told my former American colleagues about how supportive the offices of Sony, Viacom, Warner and News Corporation in China were, apart from envying me, they found my experience amazing. Most of them did run into roadblocks when trying to contact the headquarters in the United States. In China, I would interpret the lukewarm sincerity and transparency of these transnational media corporations as an opportunity for them to publicly express that they are not arrogant representatives of the ethnocentric West there to emancipate China, but genuine buddies of China. Personnel in the major state media organs, CCTV and SMG, were as compassionate and open: with a high tolerance for my strongly accented Putonghua, they explained how they devised new strategies to bolster their internal competitive power and often adumbrated more collaboration with the transnational media in the face of globalization. The fieldwork was equally rewarding. After cycles of setbacks and politico-economic reforms, I finally witnessed a vibrant China with professional media practices and routines. Although the ubiquitous security guard in PLA-like uniform was still stationed at every post, I could actually tour back and forth between television, radio stations, and press offices with my camera, recording pen and field notes, and was able to meet producers and administrators at different corners of the stations, from head office, censorship units, to editorial rooms and even broadcasting studio that was on the air. This might be a privilege for a Hong Kong scholar with a young Chinese face on the mainland (of course without it being known that I am in fact a Canadian citizen). Data in ethnographic work in the project is then rich. I realized that looking from the viewpoints of the Chinese producers and decision makers, the perspective could be very different. I could actually feel why a controller cut a newscast, why a DJ chose to ban the "problematic" ballads and casual

dialogues of some artists, and why a producer has to evade certain issues.[1] Watching the audience downstage chuckling, howling, and chatting about the singers, contests and the shows was also rewarding. In these events, as scholars mentally we understood more the impulsive responses and complex interactions among/of the audiences, but as one of the hysterical fans of popular culture, I was also enthralled by the thrilling atmosphere and spellbinding entertainment. After all, what I study is not insipid hardcore politics, wearing moral philosophy or unbendable journalistic principles. I simply have a penchant for what I study: popular culture, music, MTV, film, soap operas, performance, and entertainment. Cultural production, spectacular concerts and performance, media hype, and glamorous public events that I researched simply jazzed up my life, animated my zeal and fostered my interest in this project on transnational media in China.

After almost five years of fieldwork, finally I could distill all my excitement and organize the data and compile this book. Based on a perspective of political economy of communication, the book explicates the process of localization of transnational media in China with a focus on the entertainment media and popular culture, namely, film, television, and music industries after China's entry into the WTO. These global media corporations include Warner Bros. Pictures, Viacom's MTV Channel, and Nickelodeon, News Corporation's Channel V and its partially owned Phoenix TV, SonyBMG, the UK-based EMI, the American Universal Music, Warner Music, Google, and Yahoo, to name a few. The scope of concern fills the large gap left by academic publications that are predominantly about Chinese journalism and news media, which, paradoxically, are forbidden areas by the state, and which do not leave too much room for discussion. It focuses on the concrete globalization/localization strategies of these transnational media to cope with the various political and economic constraints in the Chinese context. In contrast to previous research in this area that relies largely on journalistic reports and publicly released figures of dubious accuracy as well as educated guesswork and the manipulation of the state, I attempted to answer the research question with firsthand data and sources, and vivid eyewitnessed experiences in the field.

As an alternative but an important angle, the book also sheds light on how and why the Chinese authorities accommodate global media capital. My impression is that most academic accounts of the transnational media place emphasis on how the global media actively have surmounted the obstacles in the Chinese market. But such arguments neglect the fact that the Chinese

state could progress to actively produce measures and policies to contain the global, or even to become the global. However, with a dominant but partially mistaken discourse—that China also behaves as a hardliner suppressing freedom, rejecting Western thoughts, and downplaying issues of human rights—many of the academic discussions missed the active role of the state in the process. The book, however, does not immediately begin with the issue of the state and the transnational media. Instead, I wanted to bring audience back from the frequently misguided focus on the issue of privacy that is always echoed in international politics, a diplomatic politics that distracts us from the real issue of the complicated process of state control over distribution and circulation of cultural products in China. Centering on the problematic of the state-global dynamic, the book then proceeds to reconstruct a historical narrative about the development of the phenomenon of cultural globalization in China that reflects both the role of globalizing media in China and how the Chinese authorities reacted to it through political and legal means. Only with the entire historical backdrop established can we dwell into the central arguments in the book.

An easy way to read this book is to dissect the core arguments into two threads—the argument that the active role of the global media is to localize in the China market, and that the state proactively receives and enhances the globalization of these foreign capitals—one thread interwoven with another. In times of globalization, the global media and the Chinese state are interdependent, and the move of one party will also impinge on the subsequent strategies of the other. The question here is not to ask which thread is more important in explicating the epiphenomenal media globalization of China, but how these two threads intertwine and the consequences of the existence of the dual threads. That is, under what circumstances do the agendas of the state and the global media conflict or concur, and in what ways do they coexist to reach their own goals and coproduce a mutually beneficial politico-economic milieu? As a book on media and communication, I think such a theoretical inquiry and its necessary illustrations are much more important than recounting the fast-changing nitty-gritty detail of Chinese media globalization. The cultural logic of the political economy of the media and the state described in the book should transcend events in China for quite sometime to come.

Note

1. Not all the interviews with these industry workers were directly quoted in the chapter partly because of the sensitivity of the issues. Some interviews were conducted for the purpose of understanding the background.

Acknowledgments

I would like to express my greatest gratitude to the following interviewees or informants who formally or informally provided me invaluable industry information for this project (arranged in order by surname). I am also indebted to many of the anonymous interviewees who I could not list here but who have contributed a lot to my research.[1]

Bai Yihua Gia, Director in Production, Channel V China

Bi Benny, General Manager, Ocean Butterflies Music Beijing

Cao Jun, Editor, *Easy Magazine*

Chang, Kenneth, Chief Operating Officer, Clear Channel Entertainment

Chen Daoming, Former A&R, Sony Music China

Chen Luo, A&R, Perfect Music Production

Chen, Jiemin, Secretary-General, Guangdong Popular Music Association

Chen Ning, Editor, Nanjing Broadcasting Radio

Chen Shi, Vice Director, Pearl River Economic Radio

Chen Yourong, Chief Representative, BMG

Chen Jixin, General Manager, Times New Century Culture Company

Chen Xiaoqi: General Manager of Guangzhou Chen Xiaoqi Music Company, Director of Guangdong Popular Music Association

Cheung Yim Ling, President, Hong Kong Teresa Teng Fan Club

Ching Anthony, Executive Director, Guangzhou New Mind Culture Communication Company

Cui Wendou, General Manager, Beiwutang Entertainment Company

Dai Mingzhi, Director, Marketing Department, Shanghai EE-Media Company

Deng Liangping, General Manager, Crazy English & Music Heaven

Deng Daniel, Founder, Yuanct.com

Ding Johnson, A&R Director, Modern Sky Entertainment Company

Ding Qiuling, Producer, Variety Channel, Jiangsu Broadcasting Television

Fan Li, Marketing Manager, Zhenlong Culture Company

Fan Yijin, Former Director, Nanfang Media Group

Feng Qi, Presenter, Hunan TV, and Assistant to Channel Controller, CETV

Gao Yusong, Producer, Lucky 52, CCTV

Geng Xilin, Assistant to the Director, China Film Group

Goh Silvia, Creative and Content Director of Viacom China

Guan Yan, Vice Director of General Editorial Board, Nanjing Television

Guo Xiaoxu, General Manager, Chaochen Culture Company

Han Xiaofeng, Manager, Promotion Division of Starwin

He Long, Director, Entertainment News Department, *Yangcheng Evening Daily*

Hong Feng, A&R, New Bees Music Production

Ho Roger, General Manager, Sing Shine Group Advertising Company

Hong Tao, Producer of Music Forever Fans Club, Hunan TV

Hu Bo, Artist Manager

Hu Ling, Deputy Director, Xiamen Music Radio

Hu Mage, A&R, Pi Side Records

Hu Min, Vice General Manager, Warner China Film HG Corporation

Hu Nan, Manager in Marketing Department, Universal Music China

Hu Weilin, Professor, Jiaotung University and Consultant of Ministry of Culture on cultural industry

Hu Xiaolu, Manager in Marketing Department, Jingwen Music

Hu Zhanying, General Manager, Xinghan Music

Huang Andy, General Manager, New-Style Entertainment Company

Huang Xiaomao, General Manger, Warner Music China

Jiang Hong, General Manager, Star-Making Music Company

Jiang Ling, General Manager, Chitai Ice Music Production

Jin Zhaojun, Music Critic

Jin Yan, General Manager, Concert Division, NMG Entertainment

Jin Yuanpu, Professor, Remin University and Founder of Cultural Industry Web site in China

Kong Jing, Manager, Sony Music, Beijing

Lam, Eddie, Century China Entertainment Company

Li Conghui, Deputy General Manager, Managing Center, China Record Company

Li Dai, Managing Director, Channel V China

Li Dawei, General Manager, Titian Culture Company

Li Guangping, President, Platinum Music

Li Hao Eric, Marketing Director, Channel V China

Li, Qiang, Manager, New Era Audio & Video Company

Liang Shiyun, Chinese Artist

Liao Weiming, Deputy General Manager, White Swan Music Company

Lin Feng, Radio Presenter, Shanghai East Radio

Lin Mingyang, Music and Concert Producer and Former Producer of Polygram

Liu Zhiwen, Musician, Perfect Music Production

Lee, Philip, VP of the New Film Content, Celestial Pictures

Lo Lo, Deputy Manager, Dada Records and Dada Entertainment

Long Danni, Director of Programming, Hunan Economic TV

Long Mei, Producer, Hunan TV

Lowe Paul, Managing Director, Sunshine Group Entertainment Company

Lu Xiaoyang, Associate Professor, School of Journalism and Communication, Beijing University, and Member of China Film Association Theory Working Group

Ma Xiaonan, A&R, China Record Company

Man Chun, Artist Manager to Supergirl Chris Lee, Shanghai EE-Media

Company

Ng, Bunns, Director, Genie's Production

Ng Ronald, Composer and Producer, and Principal of Baron School of Music

Ng Yu, CEO, Emperor Entertainment Limited

Ning Xiaozhou, Director, Guangzhou Television Station

Pi Li, Lecturer, China Center Academy of Fine Arts

Qi Hang, Chinese Musician

Shan Peter, Executive Officer, Marketing, Ocean Butterflies Music Beijing

Shan Qi, Manager in Artist Management and Programming, MTV China

Shao I Te, General Manager, Artists Management Division, EMI Music China

Shen Lihui, General Manager, Modern Sky Entertainment Company

Shi Peng, Chinese Artist

Shi, Jian, Producer, Art Department, Guangzhou Television Station

Song Ke, Vice General Manager, A& R, Warner Music (China)/Managing Director, Taihe Rye Music Company

Sim, Danny, Director, Artist Management, Starwin Culture Communication

Tao Xin, Associate Professor, Shanghai Conservatory of Music

Wan Li, Program Officer, Variety Channel, Jiangsu Broadcasting Television

Wang Albert, Composer, Rain Forest Studio Company

Wang Fulin, Deputy Director, Haizheng Music and Dance Troupe

Wang Ju, Secretary-General, China Audio-Video Association

Wang Lei, Vice General Manager, Starwin Music Company

Wang Weiyi, D&P Department, China Record Company

Wang Xiaofeng, Reporter, *Lifeweek*

Wang Xiaojing, General Manger, Beijing Century Stardisc Culture Company

Wang Zhihua, Chief Planner, Perfect Music Production

Wang Zhiguo, Manager of Events Division, Jingwen Music

Wang Ziming, Artist

Wen Zhen, Music Producer

Weng Lei, General Manager, White Swan Music Company

Weng Mingze, President, Shanghai Audio & Video Press

Wong Tommy, Starwin Culture Communication Company

Wood Crystal, Marketing Manager, Universal Music China

Wu Bin, President, Firstone Culture Company

Wu Marilyn, Marketing and Communication Director of Viacom China

Wu Juan, Deputy Executive Director, United Creation

Wu Xiaoying, Vice Chief-in-Editor, Audio & Video World Magazine

Wu Yue, General Manager, Sony Music China

Xiao Lu, Radio Presenter, Shanghai Radio

Xie Haixiang, Director, Sports Channel, Nanjing Broadcasting Radio

Xu Ben, Production Manager, TVB Multimedia

Xu Peidong, Executive President of China Musician Institute and General Secretary of Communist Party

Xu Jin, A & R, White Swan Music Company

Xu Zhiyuan, Editor, *Economic Observer*

Xu Zhongming, General Manager, Jingwen Music

Yang Chengang, Online Singer

Yang Xingnong, Vice President, SMG

Yang Yue, Vice Manager, Artist Management Division, MTV China

Ye Ying, Chief Editor, *Economic Observer Lifestyle Supplement*

Yu Ge, Chief Representative at Beijing Office, Forward Music

Yu Wei, Beijing Zhanghong Culture Communication

Yuan Tao, A&R, Jungle Music and Rock Records China

Zang Yanbin, General Manager, Rock Music China

Zhai Yue, Assistant Manager, Beijing Polybona Film Publishing

Zhan Hua, A&R, Crystal Music

Zhang Bill, Chief Vice President, Rock Records Company

Zhang Jing, Presenter, Shanghai Radio

Zhang Lei, Manager, Artist Management, Hairun Entertainment

Zhang Lu, General Manager, Mingying Music

Zhang Pingfeng, Artist Manager

Zhang Xiaohong, Editor, Shanghai Oriental TV

Zhang Shurong, Director, Beijing People's Broadcasting Station

Zheng Wei, Producer, Happy Dictionary, CCTV

Zhang Weining, General Manager, 21 East Music Company

Zhang Yadong, Musician

Zhang Yiqian, Artist Manager

Zhao, Qing, Vice General Manger, Hua Yi Music

Zhong, Luming, Producer, Hong Kong Oriental Film Group

Zhou Bin, DJ and Deputy Director of Program, Guangdong Radio

Zhou Ruikang, Chief Representative, Universal Music China

Zhou Starr, Channel Controller, CETV

Zhou Yaping, General Manager of Beijing Birdman Culture Company

Zhu Derong, General Manager, Jiuyuejiu Culture Company

Zhu Ning, Marketing Director, MTV China

Zhu, Rikun, Film Critics, Fanhall Films

Finally, I wish to thank the University Grant Committee of Hong Kong for funding this project.[2] I would also like to express my heartfelt gratitude to

everyone who contributed to the publication of this book, including all the named and anonymous interviewees, my research assistants Amy Chung and Wuyi Zhang, my respected teacher in the field Zhaojun Jin, my friend and copy editor Daniel Reeves, and the series editor Toby Miller. Without their assistance and encouragement, I would not have been able to accomplish the project and put together this book.

Notes

1. Chinese media are a fast-changing industry, and people move around rapidly in the circle. The title(s) denote(s) the positions people held when I conducted the fieldwork/ interview(s). Because the interviewees are Chinese, I chose to put the surname first to reflect the practice of Chinese naming.

2. The research project was fully supported by a grant from the Research Grant Council of Hong Kong Special Administrative Region. (Project no. CUHK4274/ 03H)

Piracy, Market, and Politics

The Politics of Piracy

The issue of piracy always seems the key international issue when it comes to trade and business pertinent to goods and intellectual properties with the People's Republic of China (PRC). Yet, it is, and it will also be an unresolved issue in international politics. In April 1996, Chinese President Hu, Jintao made an unprecedented visit to the United States. At the White House, among the issues discussed with George Bush, the issue of China's effort to crack down on rampant piracy by Chinese businesses and enforce intellectual property rights was deemed crucial. Despite the handshaking hype of the meeting, the issue was soon revisited in April 2007 when for the first time the United States filed a complaint at the WTO (World Trade Organization) over what it called unchecked piracy in China on books, software, music, and movies. With figures supplied from U.S. lobbying groups representing Microsoft Corp., Walt Disney Company, and Vivendi SA, officials estimated that the breach of copyright cost them more than US$2.2 billion in 2006 (Bloomberg, 2007, April 7: 10). The European Trade Commissioner Peter Mandelson also addressed the same discourse on piracy in China less than two months after the American visit. These repeated exchanges between global leaders and their Chinese counterparts have made the issue of piracy a critical issue for Chinese business. Since it seems quite necessary, in international politics, that certain controversial issues must be notoriously persevered and raised out to bargain with rivals or would-be competitors, the issue of piracy is not too likely to be over given the various global vested interests with the PRC. The international media would continue to suggest that there are huge financial implications connected to piracy, while the Western states signal their obligation to protect corporate interests.

International political and mediated discourse depicts global capital caught in a dilemma. With China's formal entry to WTO, these global players are legitimate to share in the China market, as China has also annually exported a huge amount of goods produced by its cheap labor to the developed world. But at the same time, for these players, the more extensive capital penetration, the higher the risk for unrestrained piracy they are bearing. The scale of privacy in China is so huge that the loss due to piracy might offset any profits that these players could redeem in the China market. While average piracy in the world is around 15 percent, industry manage-

ment estimates that 95 percent of the DVD and CD sales in China were lost due to piracy (Ccidnet.com, 2004, July 23). Pirated items have physically occupied the shelves of many music retail shops, driving away the authentic versions. The scope of pirated items is immense—covering fake luxury goods, toys, watches, handbags, software, fake aircraft parts, and medicines, to name a few. With regard to cultural industry, apart from the piracy of CDs and DVDs, the transnational media corporations are in addition concerned that Chinese television stations are failing to pay royalties for broadcasting European programs, and cloning or dubbing programs without paying franchise fees (VOA, 2006, August 11).

From Obscurity to Clarity

Given these risks, any practitioner or intellectual would ask these questions: Is piracy really an unsolvable issue in China? If not, are there any ways to effectively control, manage, or monitor it? Is piracy *the* major obstacle for transnational media and cultural industries? Should the issue of piracy delay the business decisions to enter China? From my observations and talks to many of the professionals, I would say that piracy is not as uncontrollable as it might have first seemed and also not nearly as obscure and mysterious an underground operation as first thought. In telephone diplomatic talks between Hu and Bush, Hu repeatedly emphasized China's effort to combat infringement of intellectual properties. As China merges with the global world, there are many clear signs that show that China has taken practical and legal measures to comply with international rule.

In recent years, there have been public reports demonstrating that China as a whole has begun to defuse piracy using legal practices and policies that facilitate the proper handling of intellectual property. Since 2000 in large shopping malls in Beijing and Shanghai (where the purchasing rate is higher), local music retail shops—resembling those international chains such as HMV and Tower Records—are selling authentic versions of CDs and DVDs. Shanghai Audio-Visual City established in 2005 sells only authentic products. The government shares only 2 percent ownership; the city is otherwise owned by business tycoons who attempted to build up China's first national brand name audiovisual chain. In Beijing, besides the various state-owned bookstores such as the Wangfujin Bookstore, for the very first time, FAB, as part of Oriental Plaza, is making authentic products highly accessible to the public.

In terms of the copyright of television programs, China was infamous for dubbing, cloning, and adapting the format of foreign media programs without paying any franchise fee (Keane, Fung, and Moran, 2007). Well-known international television programs, including quiz shows (e.g., *Who Wants to Be a Millionaire*), reality shows (e.g., *Amazing Race* and *Survivor*), and soap operas (*Sex and the City*) all had the cloned Chinese versions. Initially, around 2003, when these fake versions appeared, apart from exorbitant franchise costs, the main reason for not legally adopting the program from Western counterparts was the rigidity involved in producing such programs that meant the Chinese producers had to surrender to the various requirements to be inspected by foreign consultants physically inspecting Communist-owned television stations that, until now, have been restricted for foreigners. As well, many requirements simply did not fit in with the local market and politics (interview with Producer of *Supergirl*, Hunan Satellite TV, Long, Danni on November 22, 2004). Chinese Central Television (CCTV) producer Zheng, Wei of Kaixin Zidian, the Chinese version of *Who Wants to Be a Millionaire* gave an example: in the case of the quiz program, not only were the profile and composition of the audiences different from Americans', a family-orientated program in China showcasing a materialistic philosophy of monetary reward might not be compatible with Chinese family values (interview with Zheng, Wei on September 23, 2003). It was not until 2006 that *Supergirl* of Hunan Satellite Television, a mimicry of the combined format of *Pop Idol* and BBC's *Film Academy*, became the top ranked program garnering an audience of 40 million (Shen and Wang, 2006, August 25)—and also reported on the front cover of Asian edition of *Time Magazine* in October 2005—proved that cultural productions with very different philosophies could have significant market returns. For *Supergirl*, with its inherent controversy over the democratic referendum format embed-ded in the program, audiences' unprecedented voting to elect their own idol attracted RMB200 million in advertising revenue (Qi, 2005, December 5). This strong commercial pull has the potential to change television culture in China. In November 2006, for the first time, a state-owned television group complied with the international copyright treaty to purchase a legal franchise of television program, namely, *Just the Two of Us,* from the BBC following its counterparts in Australia, Ukraine, and Belgium (BBC, 2006, November 23).

Internally, despite various political blunders, the Chinese authorities cur-rently also tend to align themselves with the law and take tough measures

and decisions. In recent years, there have been many reported successful police raids on illegal factories. Despite the fact that these illegal sites are often camouflaged as ordinary manufacturing sites, and well-guarded with a cadre of people outside the city, such operations are not too difficult to mount. Since the city or provincial authorities concerned usually possess full and accurate account of these unlawful players. As a matter of fact, the identity of the pirates is often an open secret: many of the large manufacturers of DVDs and CDs are also involved in the forgery of pirated versions, and there are many unproven assertions suggesting that quite a large portion of illicit piracy trade and distribution are often connected to business operations with the military. However, from a more cyclical point of view, what is "good" about these pirates is their business attitude. For these pirates, the boundaries between the legal and illegal markets are blurred; they are just markets that have different pricing—usually pirated Hollywood films are fixed at a price of RMB6 and the authentic DVDs are over RMB100. Thus, even interventional measures are not "allowed" and exercised to ban these activities; it is not difficult to deal with these commercial-cum-illegal activities with provision of economic incentives. Investors of large-scale films over RMB100 million (only 4 in 2005 in China) as a common industrial practice devised their own survival techniques (see Sina Entertainment, 2006, February 24) by controlling the pirated market through payments (to these pirates), first, to control and delay the starting date for piracy (which could happen only after formal public screenings), and, second, to exclude pirated copies from certain cities, thus ensuring the real ticket sales of movies.

Piracy and International Politics

The essence of piracy, however, is not simply about money. If so, there would not be continual American pressure against China. American media corporations in fact have for quite sometime swept the entire Chinese music and movie market. The movie industry, despite the limited number of Hollywood movies allowed to show on China's screen, has outwitted many of the local Chinese production in terms of ticket sales. In music industry, Sony Music's record-breaking sales figures for the albums of Jay Chou (over 3 million authentic albums sold for each of his CDs released) in China have demonstrated that there are other important factors that govern and influence the market of a cultural product in the PRC. If a complaint has to be filed, the

Chinese government should have made a stronger "cultural imperialistic" claim against the United States.

In the United States' complaints to the WTO are two documented cases in point: one complaining that China sets too high a value on pirated items before proceeding to prosecute the alleged violators and another one objecting to the restrictions imposed on the sale of foreign books and movies in China (Bloomberg, 2007, April 7). The former centers on prosecution procedures but ironically the coverage included an Associated Press eyewitness photo featuring Chinese police officers raiding an illegal facility in Chongqing, the largest city in China with a population of 31 million. The incident actually mitigated the charge that the Chinese refused to take intellectual properties seriously. The other element of the charge is related to an ongoing riposte of an existing power with a rising superpower. This is a real concern of the United States and perhaps the hegemonic American media. Certainly it is not politically correct to admit publicly their genuine anxiety. The U.S. government on behalf of all U.S. entertainment industries pressurized the Chinese counterparts, asserting that their own industries are "out of patience" with China's, framing the issue of Chinese piracy as a violation of business ethics rather than a political question. Ironically, the core industries that are deep into China remain standoffishly silent on the subject. Neither do we hear complaints from representatives of Warner Bros. Pictures for the faked DVDs in China; nor is Viacom seemingly worried about MTV being dubbed by Chinese television stations. It would seem that for global capitalists, direct political strategies are to be avoided and left to the politicians. The clear message from these real global players here is that politics has no guarantee for market success. What are on the table are concrete measures to set up offices in China, export goods, and the ability to negotiate with local officials. For the latter down-to-earth tactics, they require concessions and compromise. High principle usually means to give way to market interest.

The Active Global Capital

In fact, global capital, particularly in the media and cultural industries that have entered China since the 1990s, are quite clear on the rules of the game and the factors behind an improving market. While there is a distinct possibility that these global giants have some influence on the national level, they do not bear the smug optimism that politicians have when they see

China conceding on the piracy issue. Senior managements of global culture industries have after years of lengthy and sluggish business growth extricated themselves from the necessity of a piracy focus in China—realizing that they needed to be more proactive in steering their business forward rather than waiting for the situation to be improved. Global corporations have devised two concrete strategies to cope with the market: first, a more passive but direct strategy to compete with the pirated versions, and, second, and more importantly (and the main theme of this book), to tackle the real problems behind the existence of these pirated goods networks.

Efforts have been made to compete with the piracy as if it were an authentic market. By 2002–2003 the prices for CDs and DVDs were reduced. For example, CDs of Chinese popular songs from big international labels were usually packaged and sold at two different ranges: lower, light-packed CD usually with a bit rougher printing quality, were sold at RMB25 (just over US$3)—a price not imaginable in Western cities—and an expensive but "upgraded" edition of the package of the same CDs sold at RMB35–RMB80 (not over US$10). Clearly, the former was created to displace the pirated market that would cost RMB5–RMB8 in big cities. As well, global capital proactively set up networks of distribution and marketing in China involving, in the long term, the practical and theoretical question of localization, which in essence takes years to develop. The core question behind these moves is political control and the monetary expenses that have to be borne in order to acquire down-to-earth localization.

Piracy and Structure of Political Economy

In this chapter it is argued that piracy is simply the visible consequence of the structures of political economy in China. The core questions of why foreign DVDs, CDs, and other cultural products are not well circulated in China can be attributed to the complicated and not-well-documented "control mechanisms" authorities have over these cultural products. The procedures could be roughly classified into the following:

- Production: This involves foreign production on the mainland and joint production with a local or state-owned film corporation. Footage can be stolen during any stage of production;

- Censorship: The imported global content or the localized content has to be sent to the State Administration for Radio, Film and Television and later to the China Film Corporation for prior censorship; copies sent for censorship might be illegally copied;

- Printer: Only a licensed printer can own large-scale audiovisual duplication machines; located mostly in the suburbs, their operations were not monitored;

- Distribution: Most global companies rely on nonforeign private or government-owned distributors for distribution; copies could be leaked out for duplication;

- Promotion: National, regional, local state-owned media received products from distributors for promotional purposes; personnel at numerous media are uncontrolled;

- Circulation: Wholesale distribution can be local or regional and large-scale piracy ensues in the process; local retail that is not streamlined also makes privacy uncontrollable.

These steps were initially designed as a gatekeeping process to safeguard cultural production. They operate both as procedural censorships created by the government and semigovernment agents and as the legacy of Communist control deliberately left untouched so that when denationalization occurred, private enterprises could act as if they were representatives for "bridging"—if not obstructing—the process of production for global players. However, each of these segments of control led to increased hazards for piracy. Piecing together evidence from filmmakers and marketers, the rough outline of this "unsafe" process emerges: formally, it is compulsory to send two copies of the film and four videocassette tapes to the China Film Group—the agent for the authorities—for prior censorship, and it is usually accomplished in two–three days. It then takes a week for the license to be issued. Upon receiving the license, the production company forwards the mother tape to the state enterprise, Beijing Film Video Technology—the largest of its kind in the country for developing and producing the film—that then is handled to distributors and filmed in theaters. The entire procedure

takes more than a month and there is no way to guarantee that illegal copying does not take place during the process. In short, the state's own control mechanism actually puts both local and global capital in peril.

However, in the eyes of the nation, controlling the processes is necessary. The nature of the cultural industries in China is such that these industries are not for the market place, but a tool serving politics. Since the establishment of the PRC, all audiovisual cultural products have been conceived of as being politically motivated. This also applies to leisure, entertainment, arts, and the news. Under the Communist context, news or anything equivalent must be subject to censorship—though nowadays this takes on a slightly different degree and tone—before they are released and circulated to the public. Under the stringent Chinese censorship, criticism in these foreign cultural contents that challenge the legitimacy of the state and party is definitely out of the question. Cultural symbols, representations, and allegories that contradict the national policy of the PRC are equally banned.[1]

The censorship practiced in China has important implications. While censorship of the press was meant to streamline the ideological front, the application of a similar "censorship" system to cultural products had a different purpose. For the former, as the publishers, television and broadcasting stations and production companies that produced these programs or printed matter were either fully or partially owned by the government structures, the censor more or less operated as a kind of fine-tuner, with more tuning required when and if the authorities decided to ramp up the propaganda. For the latter, the restrictions on cultural production are less likely to be of hard propaganda in that the operations, stages, and processes of cultural productions were outside the direct jurisdiction of the authorities—this is especially true when the cultural productions were infiltrated with global influence. The global players were not obliged to be in tune with the prevailing leitmotiv of the PRC nor were the subject matter involved—entertainment and leisure—primarily designed for the sake of ideological control.

Because of the intrinsic apolitical nature of these foreign products, if the state is intent on embracing them for its own use, a complex and convoluted process of official manipulation is required. How the authorities control the consumption, distribution, promotion, and circulation parallels the issue of piracy. Piracy occurs and is controlled, but occasionally it goes uncontrolled. This is because there are many concomitant segments of official control. In a nutshell, piracy represents the epitome of the larger control mechanism of the

globalization of cultural production in China. Exactly how these attempts at ideological control are laid out under the commercialized context of cultural production is the subject of this text.

To Locate the "Book Blue"

The immediate response of the readers at this point is that there must be some kind of official channels, independent institutions or intermediate organizations that provide the "Blue Book" for Chinese media venture. The latter could have defined and documented the detailed contours of regime control, specified all the formal and informal regulations and rules for the transnational media, and indexed the "standard" that transnational corporations moving into China can reference. However, this is not the case. There is no official document, guidebook, or Web site that reflects this complex picture and its multiple layers of control. Nor does any single consulting firm provide an in depth account of the existing operations of the global media industries in China. Preoccupied more with political issues, neither international nor regional trade associations are interested in prescribing a "survival kit" for its members to surmount the legal obstacles in China. Even the U.S. government has given no clear roadmap for their most greedy American media industries. The absence of such Blue Book for China venture may be explained by the intention of these institutional bodies and governments that are less connected to business. However, I would argue that it may be largely due to the complexity of Chinese rules and regulations involved that foreign bodies simply find incomprehensible. Broadly speaking, besides various formal measures applicable to these transnational media, there are a large number of so-called interim arrangements and orders that dictate the de facto operations of these global players—not to mention the implicit and unwritten rules; even many of the legal and regulatory documents publicized contain no English terms for non-Chinese use. As well, they can be released either occasionally or unexpectedly and sometimes verbally by or through high-ranked officials. Oftentimes nonlocalized global players do not even know that these decrees exist.

There are several reasons for this state of affairs. First, it is contingent on internal politics as well as the new international order and therefore subject to vacillating PRC attitudes toward globalization. The state's dithering attitude toward globalization goes some way in explaining the absence of a static Blue Book. In the case of the Viacom's MTV award, it's the direct and

unanticipated ad hoc party orders, and in Warner Bros. Pictures' investment of Chinese theaters, interim regulations overwhelmed the "normal" national media and cultural policies. Second, it is not too damaging for the state to see some less than amused global capital. To cast the pattern of controls in concrete could allow global corporations to threaten the status quo. Thus, apart from the theoretical contribution on the political economy of global media in China, this book, for readers interested in media business, functions as a Blue Book that spells out the changing trends and structures of control.

The deliberately hidden picture of control is examined in detail and a list of requirements, practices, policies, decrees, interim arrangements, and informal rules that global corporations should comply with is compiled along with a list of desiderata necessary for any Sino-venture. In the study of the localization of transnational media corporations, besides formal laws and legal regulations there are interim regulations, exceptions and discretions, experimental decrees, and ad hoc executive orders that govern and inter-vene—and sometimes interrupt—the localization process of global capital that can and often is beyond the intuitive understanding of so-called controls in China. Formal control is discussed in tandem with informal control, intervention, and censorship. All these formal and informal controls form the interlocking bulwark of a control system subjugated global capital to ensure that it does not deviate from the hegemonic domination of the state. Complex as it is, these differing units of interlocking controls are confederated in concordant direction and work in an orderly sequence. Despite this, each controlling unit is independent, powerful, disjunctive in affiliation and difficult and problematic for novice global entrants.

The Da Vinci Code

To better illustrate the interlocking control of the entire media and cul-tural industry, one straightforward and simple method is used that deciphers the sequence of labels or logos printed on the final products of the audiovis-ual publishing industry. For CDs and DVDs, these would-be signs are printed on the back cover of the album or package. Noticeably, in the Chinese context, these labels—usually arranged in a logical order—contain more information than similar Western products, which, more or less, display the name of the recording company, distribution company, or the production house. This could be classified as a kind of economic relationship. However, those printed on the Chinese CDs or DVDs are "codes" representing different

units or networks of political controls—besides various economic interests; they are intermediates between the transnational capitals and the Chinese market. Politically, these intermediates have to announce their presence to signal political responsibility for the cultural consequence of the product. Financially, these represent layers of vested interests, each exploiting certain marginal values from the sale price.

Even industry personnel would have hard time to dissect the various connections among these intermediates. As described in the movie *The Da Vinci Code* (2006), where religious relics describe a hidden organization guarding a secret bloodline that could one day return to political power, the codes on the albums are a revelation of the potential omnipotent control that the state could exercise—although the authorities' presence in the current scenario is more or less symbolic since they are reluctant to intervene unless the product has the potential to cause a major reverberation in society. Among these codes, apart from the logo of the transnational record corporations and the affiliated production companies, there is also the local distributing branch of the corporation (which could also be partially owned by red capital), the real local distribution agent (which are mostly Chinese privileged enterprises), the corporation that owned the publishing rights, the partnered media, the sponsors, and other intermediates. Quite often, these intermediates have a robust relationship, at least, within a period of time in which they had contracts binding their alliance or partnership. This would usually be the case between the transnational music corporations that are legally obliged to entrust a local distributor to market their music in China. For example, in the period of 2003–2005, Warner Music (China)'s label quite often partnered with Meika, a national distribution network based in Guangzhou, owned by the listed company TCI; Sony Music, with their China company Epic; the distributor Shanghai Audio-Visual Corporation; and Universal Music with an independent distributor Xinwen with whom they had strategic partnership; and EMI with its owned affiliated distributor PSH Typhoon.

While the link between the global capital and the distributor is more stable, other strategic alliances are more sporadic and loose. The most unpredictable of these intermediates is the legal "publisher." Most of them are not involved with production of content; their historical linkage comes from governmental units that have bequeathed them the privilege making them de facto gatekeeping units. The incoming global and local players who would like to share a pie in the market should also share some of its revenues with

these privileged governmental units, the operation of which reflects the kind of inseparability between economy and politics in the current scenario of China.[2] To market their products in some of the regional markets, the global players have also to count on another type of important intermediates, namely the media, which includes the press, online media, and broadcasting media that play an important role to promote the cultural products.

As an epitome of the entire media environment, the "Da Vinci Codes" imprinted on these cultural products reflect not only the interlocking mechanism of control preset in the Chinese market. They are concrete evidences that suggest the necessity of the transnational media corporations to cope with the rules and cooperate with the intermediates for survivals. At this particular juncture, the current practices of these transnational media corporations seem to manifest a position in stark contrast to the mistaken-framed discourse of privacy—that is politically twisted to disparage China whose ascendant power has posed a threat to the dominant superpowers. Starting from the next chapter, I will redirect the discussion into the real problematic—how the global media capitals use specific strategies to diffuse the national control of the PRC in the process of their localization, and how the PRC manages to accommodate these global media capitals by devising policies and regulations that maximize their own interests.

Surviving with Controls

Transnational media corporations eyeing the China market are more "advanced" and pragmatic than the diplomats, politicians, and political leaders—understanding the reality that the real problem for their products' entry into China is not just a matter of piracy. What is being suggested here is not that piracy is not a serious or prevalent issue, nor that piracy does not cut into the profitability of the corporations. Rather that piracy only reflects the fundamental problem that transnational media corporations are faced with amidst a number of struggles in the China market: the problem is a matter of interlocking political and economic controls. Such control may not be a tour de force hammered out by the authorities after thoughtful consideration. Rather, it is most likely the outcome of multiple sources of power and residual controls that have been put in place throughout the years of control over culture and cultural industries. Overlapping and anachronistic as they are, to perpetuate these sequences of controls has a utilitarian consideration for the parties involved. With political controls mostly relinquished to the

media or other channels, this power extends their economic interests.

Leaving the minefield of political controls, the PRC might have another agenda in mind. With these obstacles—arbitrary, fluctuating, and dependent on the political atmosphere—global capital chooses to co-opt and accommodate them rather than to bypass them altogether since the consequences of the latter might be risky and devastating. The only option is to work closely with the authorities in different ways. Along the networks of intermediates, global capital adheres to the rules of the game, thereby being ensured and ensuring themselves that their products do not challenge the ideologies of the state. Outside the intermediates, they build up other links by collaborating with different authorities or semigovernmental bodies to market their cultural products in China. The consequence is obvious: state feels safe about the localization process of global capital, and meanwhile, by partnering with the global capital, it opens a new epoch for China's national cultural policy: they explore economic, cultural, and political interests out of the global-state synergy.

Arrangement of the Book

This chapter started with a discussion of the international issue of China's piracy of intellectual properties in relation to cultural products. On the level of global politics as a demarche, it is a constant that the piracy issue plagues China's market. But this issue of piracy has often dislocated the real problem: the complex, interlocking system of controls of production, distribution, circulation, and promotion of cultural products in China and their part in creating illegal reproductions. In sum, this chapter defines the problematic for transnational media and cultural productions in China, and clearly explicates the intriguing and fundamental question of the political economy of global capital and the structure of state involvement.

The second chapter defines the research question of the book. It also explains the theoretical framework of the book: a political economy analysis of the cultural production that also bridges into cultural studies and is concerned with consumption. The framework emphasizes the theoretical necessity of considering "politics" above "economics" in the study of the China market, in particular, in connection with cultural productions. Besides reviewing current and related literatures of media and cultural globalization, the chapter stresses the need to consider the state's conscious or unconscious move to globalize their (relative) local culture for the global market—or, namely,

glocalization—in conjunction with the discussion of localization of global capitals in China. A methodological note is appended at the end of the chapter.

The third chapter delineates the background of the globalization of cultural productions and media in China and is based on the case studies of transnational music records—the historical analysis documenting these interactions between the state and the global capital and demonstrating that global capital is not hamstrung so much by the market but by nonsophisticated and incomplete forms of localization in China. Some strategies devised by global corporations resulted in complete failure while some showed sleight of hand only sufficient to temporarily secure their presence in China. The kind of localization described has changed from one of mounting tension between the global and the state in the 1980s to a more collaborative mode currently.

The fourth chapter entitled "WTO, Politics of Control, and Collaborations" analyzes the new epoch of China's control of global media capital in China, from legal framework to the politics of intervention, as China formally entered the WTO in 2005. In this chapter, Warner Bros. Pictures in China is chosen for case analysis and reveals the extent and condition of collaborations of the state and global players.

The fifth chapter analyzes the presence of two global giants in China, Rupert Murdoch's Newscorp and Viacom from Redstone with their respective arm, Channel V and MTV Channel (China). It illustrates the similarity and differences between the two modes of localization between the two media corporations in China. While they peddle music forms such as rap and hip-hop as a medium and appeal to the China audience, they localize with two strategies: MTV localizes by hybridizing their Western culture with Chinese elements and Channel V dilutes their Western and global linkage by producing Chinese programs.

The sixth chapter examines the so-called variant cases in the China venture. They are variants because they are not the typical cases of transnational media that localize in the China market with sound strategies and demonstrated success. Among those, most non-Chinese satellite televisions struggle with their entry only with their cross-bordering signals beaming into China's territory on the sly. For a few of them, after getting clearance for grounding their reception, their contents were still couched carefully not to undermine the legitimacy of the state while being sufficiently touchy and controversial to attract the audience. The rest of them might even still be in search of a

clear direction. Besides the discussion on satellite televisions, the chapter elaborates on the circulation of non-China-capital-owned printed media, and the operations of a few foreign Internet portals and corporations such as Google and Yahoo. The examination of these variants helps further explicate the PRC's attitude toward these foreign media capitals.

The seventh chapter is about youth consumption of globalized popular culture in China. It is also a retort against two wrong assumptions: first, that China intends to clamp down on any cultural populism, and, second, that audiences are passive in receiving the global. On the former, while it is true that the PRC is cautious about the pernicious influence of global culture, they also want to be more active in "managing" the popular culture hand in hand with the global players. In other words, the Chinese authorities have softened their hard-line policy to reinvent them in the form of propaganda in its formal news and entertainment media. On the latter issue, while obdurately refusing to kowtow to media and cultural propaganda, the new generation stops short of refuting Chinese culture. The fusion between the national cul-ture—contributed by the involvement of national media—and the Western modernity precisely satiates public demand.

The last chapter illustrates the emerging media ecology and market in China. There is a trend toward not only national Chinese popular culture, but also the formation of media empires or corporations in China. Internally, it is characterized by intense competition among regional powers that explains why the different regional authorities choose to cooperate with the global media capital to increase their competitive power. Externally, many media now produce global programs—inevitably with national ideologies—to market overseas so as to extend the influence of their empires. In other words, the current global-state collaborations could be regarded as an interim step for the long-term mission of the Chinese media empires to go global. The book concludes by explaining the ideological nature of the global Chinese culture today.

Notes

1. In movie industry, for example, the director of the Hong Kong–imported crime thriller film *Infernal Affairs* (2002), the same movie that the American film *The Departed* (2006) was based on, had to create a different ending—that the wicked police in the movie was arrested finally as opposed to the original ending that suggested the evil prevailed over the virtue. The alternative ending was meant to satisfy the Chinese censorship system. In music industry, songs that provoke public superstitions, promote uses of "improper" languages, or incite sentiments and hatred on ethnic, political, or social disharmony are censored. For example, the songs "Ghost" and "Today's Evening News" were removed from the albums *The Great Leap 2005* and *Black Tangerine* of a Taiwan singer David Tao, respectively. The former song was said to spread the fear of gods, while the latter describes vivid crime scenes. Chinese Web sites that have downloading facilities also dared not to carry these songs.

2. Many local audiovisual products in fact relied on some unheard-of-publishers because of a relatively lower cost.

References

BBC (2006, November 23) BBC Worldwide Takes First BBC Format to China.
http://www.bbc.co.uk/pressoffice/bbcworldwide/worldwidestories/pressrelea ses/2006/11_november/china_format.shtml. Accessed on January 18, 2006.

Bloomberg (2007, April 7) US to Take WTO Action against China, 10.
http://www.taipeitimes.com/News/worldbiz/archives/2007/04/07/200335566 3. Accessed on April 23, 2007.

Ccidnet.com (2004, July 23) The World Piracy Is Serious; Amounting to US$4.5 Billion.
http://www.cnave.com/news/viewnews.php?news_id=2295&year=2004. Accessed on May 17, 2007.

Keane, Michael, Anthony Fung, and Albert Moran (2007) *New Television Globalization and East Asian Cultural Imaginations*. Hong Kong: Hong Kong University Press.

Qi, Lanzhu (2005, December 5) Do You Know How to Read *"Supergirl"*? http://www.mba163.com/glwk/ppgl/200512/21773_3.html.
Accessed on April 30, 2007.

Shen, Jia and Jinhui Wang (2006, August 25) Average Rating Exceeded CCTV's Spring Festival, Supergirl Made Super Tax.
http://post.baidu.com/f?kz=35921775. Accessed on April 30, 2007.

Sina Entertainment (2006, February 24) From the Operation of *The Promise*, Analyzing the Successful Factors for Ticket Sales
http://ent.sina.com.cn/m/c/2006-02-24/1708996538.html.
Accessed on May 10, 2007.

VOA (2006, August 11) Bilingual News, EU Trade Chief Urges China to Stop Widespread Product Piracy.
http://www.freexinwen.com/chinese/eng/news_bilingual/news/news_110806. asp. Accessed on February 15, 2007.

Chapter Two
From Globalization to Glocalization

This chapter defines the research questions and sets out the theoretical perspectives of this book. The obstacles faced by the global players, transnational media and cultural capital, discussed in the previous chapter, and how they strategize to overcome the constraints and limitations are examined. The framing for this deliberately fixes the tone of this book, which is a matter of "control." It examines the ways global media, transnational capital, and their owners survive these political and economic constraints to produce the content that is largely popular culture in China. Coherent to the logic behind studies of the political economy of communication (e.g., Mosco, 1996: 25–26), this study examines the social relations that mutually constitute the production, distribution, and consumption of resources. This political economy perspective seeks to explicate how culture, symbol, and mediated ideology—reflecting the various impacts of economic dynamics on the range and diversity of public cultural expression—are closely connected to the localization strategies of transnational media corporations under the framework of globalization (Golding and Murdock, 2000).

A Political Economy Approach

To begin with, as a theoretical pursuit, the contribution of this study lies in refuting some of the academic speculation and assertions about media globalization. Previous works such as James Curran and Myung-Jin Park's edited volume *De-Westernizing Media Studies* (2000) also carried this critical philosophy of rebuking the claims of the growing size and amount of global and digital media flow that render the national border indefensible and impotent. Specifically for this China case, Zhongshi Guo (2003) pointed out that the recent regulatory reform in Chinese media in response to the global "need" and pressure from the WTO in fact are more restrictive than liberalizing, erecting more obstacles than channels for these global flows. Theoretical works pointing to a similar direction also include John Downing's analysis (1996) suggesting that the major limitation of Western media theories (and theories that carry implications for other developing worlds) lies in its confinement of applicability in a relatively stable political economy of media and culture. All these studies imply that many assumptions made in any non-Western states, namely, the polity, economy, cultural texts, representations, ideologies, and the media ecology—and their flexibility, degree

of inseparability, and transformative powers—could be unsubstantiated and flawed.

More complex, the in-depth theorization of the political economy of the localizing global is often obscured by the common discourses of globalization. This popular discourse of globalization often lays emphasis on the power of the global to dismantle boundaries that eventually lead to the decline of the nation-state (Held, 1990). Even being fixed and refixed into discussion of localization, globalization is largely theorized as a one-way flow of culture from the global world to different locales. As well, the nation-state vis-à-vis the global is always thought as the defensive side, and at a minimum, not the active agent or partner in the process. The taken-for-granted assumption of the omnipotence of the globality tends to underestimate the power of the local tradition, regional economics, national power, and state policies. To fall back on a political economy framework, then, global political economy in terms of international pressure, economic resources, and capital are often conceived to outwit the would-be globalizing nation-states in this power struggle. This book, however, does not intend to provide a long discussion to establish the flip side of this outmoded conception—and of being reduced to Americanization, homogenization, and cultural imperialism—of how an outside superior power will dominate China—which in the current academic discussion has been elucidated enough. Rather, in this study, many of these assumptions are challenged and the problematic of political economy is reframed in a different light. In contrast to the liberal political economists who believe that globalization will bring the greatest freedom for consumers, it explains that the reverse may well be true. That is, with the global participation in the political economy of production and distribution in China, it is not necessarily the case that the local people will have a better and freer life.

On the basis of a political economy framework, the interplay of power between the global media and the state, between the commercial interests and the ideology, and between the economics and the politics in this Chinese setting are examined, and this is done in such a way that there's no presumption that either one is over the other. Also, as a book that aims to enhance theoretical understanding of the state and global, it has reconceived political economy in a framework that not only addresses the core question of how the array of social forces and power relations operate, as circulated through various political and economic constraints, how they affect diversity of media and people's access to cultural content, but also how the consequences

of the production, distribution, and audiences' consumption could reproduce and reinforce the formation of the structure of the media and the society. Central in the analysis thus is, first, the analysis of the state regulations, policy, and other informal constraints over the content production and distribution and, second, the hegemonic cultural content and texts produced under real circumstances, and, third, the cultural consumption of the audiences and how it circulates back and stabilizes the structures of reproduction and production.

The two dimensions featured in Peter Golding and Granham Murdock's critical political economy perspective (2000) are useful here to address the issues in a global context: while the first emphasizes the relationship between the state and the communication institutions with a focus on how much autonomy the media could have in the process of production and distribution of culture, the second focuses on the pattern of ownership and control over communication activities. The case in which the global meets China, the former could refer to the relationship between the state and the global partners that operate the communication institutions. It informs us of the basis on which the state will use their regulations, policies, practices, and strategies to facilitate or hinder the market benefit of the global and the process of global cultural production and distribution. Instead of naively pointing out how influential the global culture and Western markets are over China, the important issue of the needs of the locality (the nation/China) and how the local take in such global impact, and how the global respond to the local (national) need are examined. In this regard, an outline of a theoretical model that describes the political economy of culture applicable to cases where global capital enters a nation is necessary.

The second dimension in which global capital are players describes and explicates the possible forms of globally involved media partnership, alliance, or ownership, and the concrete cultural forms and content produced by the global to be consumed by the local audiences. While the details of the ownership, activities, and operations in this China case will be revealed in various chapters, the rationales behind why the cultural globalization-localization—from the joint Sino-global ownership to relaxation of control over global products and capitals—has recently taken place in a rapid speed in an authoritarian regime have to be addressed. As will be argued, the rationales in many of the journalistic reports and academic studies are often casually explicated: either asserting that China is giving in to international

pressure with unsubstantiated evidence or giving incomplete accounts that China could "well-control" the global operations in their own territory. At the conclusion of this chapter a model hypothesizing that the globalization of China as a former stage or as a precondition for China to globalize the world with its own Chinese cultural products is presented.

Aims of This Book: Global Capital's Rendezvous with China

Specifically, this book investigates the entry and then the localization of transnational media and cultural capital in the China market since the 1990s. The background of the global entry will be presented to better illustrate the changes and reflect the current situation regarding global presence in contemporary China. The adaptation of the global capital to devise new local strategies to produce programs and cultures palpable to the changing values of the new generations in China is explicated in parallel with the strategies of how the Chinese authorities have shaped, distorted, and even dictated the production, distribution, circulation, and consumption of culture. How the audiences in China explore, interrogate, and transform their values and identities in relation to the cultural consumption, particularly popular culture, construed by the global capitals in China is also discussed in conjunction with the global capital's profit motive and the PRC's nationalistic agenda. In short, this book addresses three main issues.

First, what are the corporate strategies of these global media and cultural capitals in China? How do they localize their business and construct images and culture products for the China markets? Through which ventures, channels, media, and alliances do they carry their Western, corporate, and capitalist business model, strategies, and ideology into China and at the same time cope with the various constraints imposed by the authorities?

Second, how do the cultural products produced by the global or coproduced by the global and the state reflect, challenge, or transform existing Chinese media and cultural regulations, conventions, norms, and values? In what ways do the authorities control the production, distribution, and circulation of such global culture in China? Are the global-but-locally produced cultures changing, complementing, or challenging the state and politics? In what ways is this Chinese globalization related to or a different phenomenon from globalization that has taken place in other parts of the world?

Third, how do the audiences consume and appropriate these culture

products for their own identities and culture? Given the appeal of popular culture, to what extent can we detect the impact of these global cultures on China? What are the social, cultural, and national implications of the consumption of this popular culture for the legitimacy of state and the stability of the Chinese society in the long term?

On the whole, this study not only explicates the localization of global capital in China but also prescribes the way by which global capital could devise their localization strategies in China. The formation, production, and coproduction of (global/national) popular culture in China are also a significant barometer for social change in China. In the detailed analysis, reference will be made back to the common assumptions—however often unexamined and unproven—of the society, politics, and culture of China. Very consciously, these assumptions will be validated with evidences collected and avoid lapsing into these faulty assumptions of the state, globalization, and the media. In terms of theoretical contribution, the significance of this study lies in reconceptualizing and reexamining the concept of globalization-localization, the relationship between the state and global, the incompatibility between nationalistic and capitalistic ideology, and also the dialectic between audiences' aspiration, popular culture, and the capitalistic formation and national control.

The political and theoretical position of this book is first a concrete empirical analysis of what happens in contemporary China. The analysis includes sociological descriptions of how the global commercializes the China culture, how the state takes advantage of the global partnership or the formation of the global-state complex to perpetuate their nationalistic control, and how the audiences might feel enlivened by the illusive popular culture. This is not a criticism of the global corporation or of crude capitalism and its activities related to the process of cultural productions in China. It is also not simply a criticism of the indoctrination imposed by government cultural pedagogy. Equally this book is not a normative critique of the political economy of China, as many other authors have dealt with this in detail (Zhao, 1998; Lee, 2000, 2004). Instead, with a dual role as a scholar and media practitioner, I've done a very down-to-earth analysis of the field using a web of relationships in the media, movie industry and the music industry. The experience, anecdotes, and cases are organized into patterns of knowledge that have theoretical implications. Thus, although the analyses are not politically driven, the implications of the analysis for the society, nation, and

global politics are nonetheless important.

Second, this is not a study—a cultural analysis of the production, distribution, and consumption of culture—entirely based on a neo-Marxist framework of political economy that examines the dominance of the economic base over the superstructure. The approach of cultural studies, which has strengths in the discussion of the overdetermination of culture and its influence back to the infrastructure, is important in the analysis. Thus, this book starts out with the assumption that the very idea of the split between the political economy perspective and cultural studies perspective is based on a false political dichotomy (Hesmondhalgh, 2002: 44–45). When it comes to the study of media and cultural industries that addresses the dual role of these industries as systems of production and as producers of text, we need to take into account both the politics of redistribution that is primarily an inquiry of political economy, and the politics of reception that connects to the community formation and cultural identification of the audience concerned. Ignoring either of these dimensions would lead us to lose the interdependence among the issues of production, hegemonic intent, pragmatic incompatibility between local and global, textuality, pleasure, desires, and consumption of culture, and the overarching political and economic constraints of the production and distribution. In this book, using this perspective of political economy as informed by aspects of cultural studies, the analysis attempts to establish links between the localization of the business strategies of the transnational media corporations and the ideological controls of the authorities to the audiences' interpretations of culture in the specific Chinese context.

Popular Culture and State-Market Relationship

The interconnectedness of the very circuit of (popular) culture is the key to the complexity of the industries to audience and texts in China's political economy (du Gay, Hall, Janes, Mackay and Negus, 1997). With the analysis of popular culture as a departure, we have to conceive of popular culture not as trivial mass culture functioning only to entertain and lacking in seriousness vis-à-vis critical and political contemplations in relation to the state and civic society (Modleski, 1986). Even the mass production of culture involving the most crudely conceived capitalism is deemed to result in circulation of symbolic meaning and ideology (Garnham, 1990: 155). Apart from the specific cultural forms, cultural products also create a sense of community,

crystallize imaginary identities, and create sentimental adventures (McClary and Walser, 1990). While all these reinforcing, complementary, or contradictory realms are worth unpacking, the task of understanding these relationships in the political, economic context is even more important. Many contemporary culture studies (Cullen, 2000; Storey, 2003) have demonstrated that our history and society have consistently invented popular culture that not only unfold discourses and the ideologies of the day but also in effect manufactures, manipulates, and distorts popular culture, politically as sources of nationalism, socially as representation of social relations in daily life, economically as products of transnational corporations and through the forces of the political economy of globalization. The political implication in the China case and other authoritarian countries are particularly noticeable. Chung-Tai Hung (1996) found in the history of China, as manifested in the period of Sino-Japanese War in 1937–1945, that the Communist Party was able to subtly refashion popular culture into a socialist propaganda instrument creating lively symbols of peasant heroes and joyful images of village life all the while galvanizing public support for their legitimacy. In a more contemporary example, Anthony Fung (2003) found that Andy Lau, an iconic Chinese singer, was turned into a symbol of Chineseness and used to bring different ethnic groups and Chinese communities together.

In the case where the potent global meets a powerful nation, we cannot simply assume the entry is an economic activity that is subject only to the rule of demand and supply. The relevance of potential contradictions to harmony and compatibility or incompatibility between the Chinese nation and the global is important. Whether the imported global culture, its values and know-how fit into the state ideology and the taste and spirit of the market is the issue. As for the relative importance of the ideology and market for China and for any globalization-localization to take place, a politico-economic modeling of the state-market relationship can offer a number of explanations.

Martin Staniland (1985) summarized how the state prioritizes the importance of ideology and market in terms of economism and politicism, which, though it relegates explanatory primacy to economic and political forces, respectively, explains why states of unequal developmental stages acquire and assume different degrees of economic (market) and political (state) importance. The former emphasizes that various cultural, political, or economic policies, decisions, and situations are outcomes of forces deter-

mined by a particular class or those who have the power to promote, priori-
tize, and maximize their economic interest—as in liberalist theory their
wealth in the market—whereas the latter suggests that political structures
bear their own vested interests, impose these political interests on any
economic outcomes, or even pursue political interests at the expense of
economic interests. By the same token, popular culture nourished under these
two polarized modes of priority of the state should also exhibit diametrically
different forms and representation manifesting different degrees and con-
straints (Caporaso and Levine, 1992: 16). What should be emphasized is that
such a framework does not presume that culture operates either on the logic
of economism or that of politicism. Rather, the conceptualization of the
state-market relationship usually rests on the inseparability of the market and
the state, and Staniland's conceptualization of economism-politicism forma-
tion refers to the differences in emphasis of one over another. This view of
inseparability of the two dimensions implies, first, in most situations, that
ruling authorities have to balance the political interests with economic
interests, and at its best able to reflect a perfect state-market relationship (see
Figure 2.1). Second, dependent on the nature of the authorities, the two might
be supplementary to each other. It may also be possible that there is a
contradiction between the state institution and the capitalist function as when
certain interests must hold sway (Offe, 1984).

Figure 2.1 A perfect state-market relationship

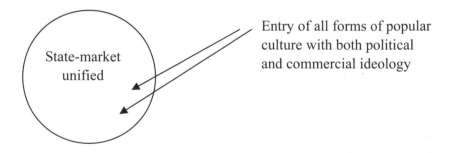

State-market
unified

Entry of all forms of popular
culture with both political
and commercial ideology

Should the authorities examined, as in many of the Western democratic
states, have the tradition to "enchant" the free market, when a new form of
culture and cultural production enters into the system, the checkpoint to entry
or the "screening" criteria for foreign culture will rest more on market and

economic considerations, rather than any political (ir)rationality and ideology. It is a kind of normative theory of economic development in which the state optimizes its economic policy in order to steer the system to a "common good." However, political economist Bruno Frey (1984) also points out that there are quite a number of states that are endogenous to the capitalist system, meaning that these states, mostly authoritarian regimes, have a higher political principle over economic interest, institutionalize their ideology to dictate the economy and sometimes ignore the market demand. In these states, despite the people's desire for Western consumption and the fact that the foreign investment that accompanies this consumption may also benefit the economy, the state would rather choose the stability of the status quo and inhibit influx of popular culture lest the values associated with it would challenge the state. Following the model that prioritizes politics over economy, we can conclude that culture that is allowed to disseminate has to meet the test of the regime's political agenda before it is given the approval to enter the nation (see Figure 2.2).

The framework proposed here represents the assumptions adopted for this study. Consistent to the logic of the framework, as found in most of the studies done about globalization in Western states, the primary consideration for the global capital, for example, Hollywood or Disney, is the market. Under such circumstances, the entry of nonlocal culture would be required only to pass certain minimal regulations established by the authorities of the state. So long as the value of the popular culture was not too destructive for the society, intruding upon others' basic political rights, or intolerable culturally to the society, the market plays an upper hand.

However, the China case may be different in that it demonstrates that there is a strong structural integration between the Communist propaganda, economy, and the party organization, and one that attempts to have a total, complete command over the people, culture, and the public demand (Griffin, 1979: 241). When global culture knocks on the door for entry, the PRC first evaluates the potential "risk" for its people, its revolutionary power, and the possibility of it being used to Westernize, globalize, and pervert China in some manner. For the global players, in the light of the state interests met prior to the market interests being considered, it would be counterintuitive to simply market into China cultural products that would topple the state. Rather, as their ultimate goal is profit, the most rational strategy is to court the authorities' approval for entry by meticulously shaping the malleable

cultural products in such a way that conflicts with the state can be minimized. Only by winning the state's consent can they start to think about profit in the market in the long term. Such framework informs us of the need to revisit the relationship between the state and the global, rather than directly jumping to a detailed interpretation of how the global influences, liberalizes, or threatens the Chinese society. Thus, in this analysis we examine how the global players devise local strategies—that will minimize its potential threat to the state—to make it eligible to enter into China and the consequences of the same which is that the cultural products imported are basically preselected to appear nondefiant to the state.

Figure 2.2 The relationship between popular culture and state-market complex in China

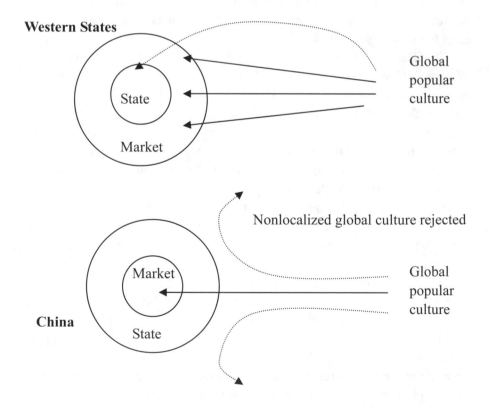

State and Global: Enemies or Partners?

Having said that the influx of culture into China must conform to the political rationality in the Chinese context, it is still too early to simply say that the imported cultures and the local ones are two "distinct, separate and opposing realities" along the cultural spectrum (Ang, 1996: 153), and that clashes between the global and state are unavoidable. In fact, culture exporters aiming to expand their volume of Western media and cultural corporations are obliged not to confront the dictatorship with cultural products full of democratic potential. In the hope of a smooth means of ingress, they self-adjust and refine themselves in concert with the requirements of state ideology. However, the global are not simply trapped by Communist control; nor are global media suddenly converted to ideological state interests. Considering the business nature of transnational corporations, as always, they have to behave and function with a calculative logic and pragmatic strategies to capitalize profits and vested interests. For the global media, political means to defuse the tension and maximize their economic interests is not unacceptable. Reconstructing their cultural products to be in tune with the state's interest, self-censorship and seeking active collaboration with authorities are common business practices. Studying Murdoch's STAR TV, Michael Curtin (2005: 171–173) found that the satellite TV services were responsive to the capricious political changes on infrastructural, political, and textual levels, and dependent very much on the political upheavals and internal politics in China. Global media's executions and decisions can be easily changed or reversed. In a study of the previous strategies of four foreign television operators (China Entertainment Television, AOL-Warner, News Corporation, and MTV) in China, Ian Weber (2003) also contended that successful transnational media corporation strategies are often bound by hegemonic order, with the success indexing as a function of the degree to which these global media enhance the PRC's ability to construct the "imagined world." The latter can be regarded as an advanced and modern discursive strategy for the authorities not only to perpetuate its hegemony for the Chinese at home and abroad but also to progressively model a strong Chinese culture as a nation. Summarizing the experiences of the previous global entries, we can observe that despite the high fences put up against foreign capital, transnational media tends to harmonize with the state's agenda, rather than to overcome them, bypass them or supersede them with international politics.

On the other hand, the PRC authorities of today should not be thought of as a mechanical body passively filtering the inflow of popular culture from without.

In contrast to the common perception that the authoritarian control and limited political freedoms in China might be stalwartly tied to a repressive economy (e.g., Derleth and Herche, 2005), the PRC is actually now more active in engaging with the global forces. The trajectories of state reform and the openingup of the market of the developing countries allows the state to articulate its needs and in fact benefit from the embracement or encroachment of the global capital and multinational media ventures. Whether globalization can do harm or bring good to the nation-state is highly dependent on the local response and need, modes of cultural accommodation, structural adaptation, and audience appropriation (Jameson, 1998; Storey, 2003: 112–114). By exercising its power through public culture—not only through stringent regulations and political censorship but also through rewards, economic incentives, or co-option—the Chinese state succeeds in several aspects: monitoring the global operations locally, safeguarding their national interest, and satisfying the public desires that the state can no longer ignore. While it is possible that the state will continue to defer the global entry, internally, compared to the global media, the state is also aware that their overly protected media and defunct cultural industries were highly deficient and inefficient, often due to overstaffing, overreliance on government subsidies, and the inflexibility of management as a result of the centralized controls (Gershon, 1997). From the perspective of the state, having recourse to the efficient global media is an opportunity to revitalize its own economy of the media. Thus, Curran and Park (2000) also suggest that despite the fact that there might be ideological conflicts between the global commercial media and the authoritarian regime, the state could cohabit, ally, and integrate with the global in different ways.

A crucial point in this argument is that the state intervenes and distorts the invisible hand of the market so that their risks can be minimized when the global comes, but that the authorities facilitate the global partners to subsist in the market and then make use of the global culture and the globally involved local market to pragmatically extend its hegemony, as suggested in Michael Curtin's analysis (2005) of localization of Murdoch's Newscorp and Anthony Fung (2006) on Viacom's MTV Channel in China. In a nutshell, the strategy is to subsume the market into state control so as to ensure the continued existence of hegemony. This thinking paradoxically is not too

different from the Western model of cultural industries suggested by David Hesmondhalgh (2002), who emphasizes the importance of the government institutions and authorities in pluralistic societies in regulating and policing the cultural-cum-economic activities and industries on media and various textual productions. In any case—whether the democratic states or authoritarian regimes—the pace and extent of globalization depends very much on the attitude, involvement, and intervention of the authorities. Specifically in the study of the interplay between state and global power, Yuezhi Zhao (2001) dissected the forces that shape this emerging integrated complex by arguing that under the push for China's accession to the WTO, the nation's integration with global capitalism through its bureaucratically controlled and market-driven communication industries became increasingly visible. The specific terms and conditions of this integration has meant that a newly reconstituted power bloc consisting of the bureaucratic capitalists of a reformed party state, capital of transnational corporation, and an emerging local urban middle class has assumed dominance of the communicative processes within and without. Zhao (2001) also argued the hegemonic process has been highly contentious and it is constantly mediated by both nationalistic and leftist ideological legacies of the Chinese state and emerging forms of social and cultural contestation. The process of how the state has managed the communicative exchanges and how the transnational corporate capital partakes in this complex process will be gauged and documented in this book.

When both the state and global mutually benefit in a symbiotic relationship, then we witness collaboration between the global capital and the state, resulting in what various scholars have described as the formation of media-political complex (Curran and Park, 2000: 14), state-market complex (Ma, 2000: 32), or a politico-economic integration (Thomas, 2001: 72). In terms of the relationship between capitalism and state, the tacit and sudden relaxation of the presence of the global in the Chinese market, or the "commercial turn" of the Chinese media to receive the global in this ideologically narrow context, will be an unprecedented development in which Chinese Communism is not the enemy of global capitalism. How the state and global start to converge, unite, and even reinforce each other will depend on how the global capital and culture localize or deglobalize. Cultural globalization framed in this way can be conceived as a dialectic embroiling simultaneously globalizing territorization as well as local involvement, accommodation, challenges,

and dynamics (Giddens, 1991). Meanwhile, in the highly mature capitalistic world ecology, the globalizing capitals maximize their profit and local advantages with decentralizing tendencies, making globalization more a localization process (Giddens, 1999). The latter is an ongoing means of deglobalizing by which foreign cultural products, contents, and texts are converted for local uses with local preferences for the local context. In the process, local media plays a special role to animate the localization of content as the agent of appropriation of the globalized content for their own people, in particular in countries where there is no direct link to the other worlds in terms of languages, culture, markets, and production infrastructures (Siriyuvasak, 2000).

The localization strategies can take different shapes. It can be, as Homi Bhabha (1994) espoused, hybridization in which the local are in active negotiation with the global to inscribe their everyday meaning into the global cultures, commodities, and conventions, resulting in copresence of local and global cultures. In contrast to the emphasis of mixed or creolized global-local culture (Pieterse, 1995), the localization strategy could be what Robertson (1995) described as glocalization that places more emphasis on the local interest and local empowerment. Glocalization in this specific context refers to the importance of implantation of the local elements in whatever culture is produced in the global context. When the local culture possesses globality after the acquisition of the national by the global, such culture, after rounds of transformation, insertion of local appeals, and metamorphosis into a unique culture with both local and global quality, can also go overseas. Although there is seldom theoretical discussion about glocalization—sometimes even being used interchangeably with hybridization—its essence will be examined in the actual analysis of the localization strategies of the global media in China. Under what circumstances the global media localize and to what extent the localization takes place and by means of what strategies the state receives the global are examined in the following chapters.

The Wolf Is Going Out?

Even when the detailed localization strategies are worked out, the study of the localization of global media usually leaves an ultimate question unanswered. Why would this authoritarian state voluntarily receive the global and even exalt the global cultures on their own territory? What is the

intention of the PRC state? What kind of role does the authoritarian state want the global to play? Suffice to say that the state has to yield to external pressure due to the agreement of the WTO and to conciliate the suppressed Chinese audiences who have strong desires for the taste of popular culture outside. Besides these deflected consequences, is there a guiding principle or national philosophy after all? To examine how the PRC could recoup what the globalization has cost to its own legitimacy sheds light on this national intent.

Currently, it seems that the metaphor used to describe the entry of these global players is "the wolves are coming," which presumes that these global players use cunning tricks, unscrupulous economic strategies, or ruthless political means to enter the China market for profits at any cost even if the impact over the local people and the nation is catastrophic. One has to be suspicious of this normative judgment of globalization, at least, in the Chinese context. Toby Miller's conception of the new international division of labor (Miller, Govil, McMurria et al., 2005: 111–172) as a result of Hollywood's global expansion is along this line of thought. Hollywood basically is thought of as an extension of capitalist domination and exploitation of countries by means of the United States' investment in the new network of coproduction, distribution, marketing, and exhibitions located in these peripheral sites. His analysis assumes that the "wolves always subjugate these non-Western sites" and that they are incapable of initiating their own agendas.

Various scholars who studied the Asian and Chinese media appeared to disagree with such neo-Marxist thought, if not the media imperialist thesis, then by "rediscovering" various alternative potentials of these non-Western loci. With a focus on Japanese popular culture, Koichi Iwabuchi (2000) stressed that the emergence of a strong interlocking relationship of production, circulation, and distribution within Asia has gradually created a stable inter-Asia cultural flow—to a certain extent an alternative to the West. In previous study about the homologies of the televised culture between Japan and Hong Kong, the local articulation and internalization of Asian regional culture constituted a strong resistance to cultural forces, including the global cultures, from without (Fung, 2007).[1] Espousing the notion that media globalization is an overstated claim on global media power, Michael Keane (2006) also suggested that Asian media not only possess the capabilities to survive as world factory but are also able to cope with the globalization with

their own legal or illegal strategies, namely, cloning, franchising, coproduc-
ing, and even establishing their own cultural industry clusters. Although it is
difficult to find a clear watershed, there is a paradigm shift in the Asian
academic literatures in the 1990s about the change. Before, under a strong
sense of protectionism, studies (e.g., Hong and Hsu, 1999) tended to suggest
that Asian media should block the entry of the invasive cultures via different
media channels. But after the mid-1990s, against the one-way flow of culture,
media products and services from a geopolitical center to the peripheral
regions (cf. Hamelink, 1983; Schiller, 1992), there has been a growing pool
of literatures (e.g., Wang, 1997) that witness that the Asian cultural policies
have moved from passive protection to an active promotion of the local as a
strategy to withstand the Western cultural invasion.

On the basis of these Asian evidences, it is too early to jump to the con-
clusion that the global players are really the wolves. As suggested earlier in
the reviews, the partnership between the state and the global capital in the
cultural production and distribution could have neutralized the threat of these
global players and disapproved the claim that the global players could only
do harm to the society. Recently Chinese scholars have come up with a
relatively fair judgment on the global players. Tsinghua University commu-
nication scholar Anbin Shi (2005: 35) used the Shakespeare classic *Taming of
the Shrew* to coin the increasingly bidirectional "wolfish" behaviors. While
the Chinese authorities attempt to tame, control, and regulate the unruly
global players' increasing participation in China's marketplaces by sanctions
and incentives, under China's own agenda of accession to capitalist global-
ization, the global media also attempted to "integrate the renegade Chinese
counterparts into a U.S.-led world system."

Cycles of Globalization and Glocalization

The crucial point discussed here should be the role of the Chinese state.
In recent years, first, we see a fundamental change in nature on the part of the
Chinese media: actively transformed from a party's state apparatus into a
"Party publicity Inc.," the primary organization goal of which is meant to
promote the party image rather than ideological indoctrination (He, 2000).
Media now learn to articulate public sentiments and to minimize possible
insurgence rather than to simply suppress attacks on stability. Second, thanks
to global collaborators and partners, the Chinese state is not very far away
from reaching the global scene. A recent study of the Chinese film industry

by Huating Wu and Joseph Chan (2007) in fact celebrates the coming of the Chinese Hollywood style blockbuster movie, suggesting that there is a reverse drift of culture from China to the global markets. In the face of globalization, the Chinese state has to accommodate the market forces to allow the media a certain level of autonomy, but during the process of commercialization, the commercial force also enables the state. It results in a situation in which the state and the market transform each other, and ultimately push China to a higher geopolitical stage, one that has strong new sociopolitical power (Ma, 2000: 28). This argument not only hints at the nation's determination to reform its media but also China's capacity to itself become one of the globalizing powers.

Globalized China and would-be globalizing China—there is one-way flow of culture as described in the process of globalization—that is from the global to the local—that represents just one side of the picture. The other side, which is usually undertheorized, describes how a nation, after having been globalized, could become a strong geopolitical region and outwardly export culture. It is a glocalization process that the globalizing country also possesses the global powers to export its cultural product with local characteristics. In other words, a formerly passive globally conquered site at a certain historical juncture and development stage could evolve into a globalizing force. Instead of conceptualizing globalization as the end of the process, the model framework suggests that the globalization and glocalization form a cycle of cultural flow. The model becomes not only a theoretical framework necessary to explain why the PRC engages in deep collaboration with the global that the whole world is witnessing, but also a guiding rationale for China to shore up its expansion of the Chinese media empire and culture both at home and overseas.

Should this model of the cycle of globalization-glocalization be correct, no one can say how powerful China would become. The totalitarian Chinese state might just develop into a more flexible authoritarianism by ways of and constrained by the economic reform (Lee, 1990). Besides the implication of an additional global power for world politics, China's mounting geopolitical influence also impinges upon the local politics and society. Despite the predominance of PRC political and economic control over its people, when China becomes one of the superpowers, it is not likely that the people of the state will be completely alienated from their right of citizenship. Nor can party or state bureaucratic set-ups continue to pay no heed to citizens'

preferences and desires (e.g., Shirk, 1992). With the global contacts, genera-
tions of reforms, and ultimately an international image as a globalizing
superpower, the changes in China—and many of the developing countries
that follow—should be far beyond our imaginations. The diluted Communist
tenet, the withering away of the paramount state ideology, the increasing
level of tolerance for diversity, and the emergence of individualistic and
social expression and aspirations are all possible consequences of this
reform.

Figure 2.3 Cycles of globalization and glocalization

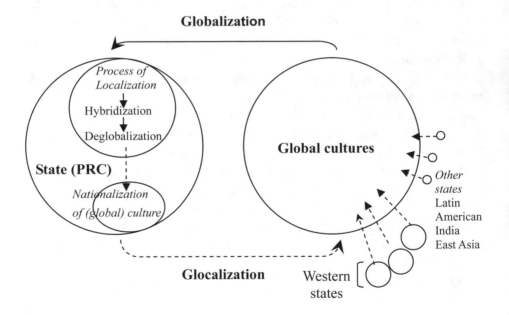

A Methodological Note

The methodology of the study included fieldwork of the cultural local-
ization of global capital in China and was conducted during the period late
2003–mid-2007. By means of multiple methods, data about the media and
related cultural industries in China were collected—including movie,

television, and music industries—and their other distribution networks related to these industries. These particular media are selected because in these arenas international participations in terms of content, investment, and distribution have been allowed. Since the production, distribution, circulation, and consumption of the related media products cover a huge area, Chinese cities sampled included Beijing, Shanghai, Guangzhou, Shumzhen, Changsha, Wuhan, Xiamen, Nanjing, Macau, and Hong Kong. The collection of data can be summarized into three main parts. First, as a participant observation study, media contacts in Hong Kong, along with industry and personal network contacts in the field, were used to access on-the-spot observations of the production sites and studios in major Chinese media. Audience activities, award ceremonies organized by the official organizations, the Chinese media and transnational media, concerts of singers and the media, and other fan events organized by different parties in all of these cities were attended. Access to editorial rooms and media studios assisted in acquiring the political baseline allowed by the media and the authorities. A research coordinator was responsible to monitor and go to these events for pre- and postinterviews while a Beijing student researcher was trained to participate in many of the Chinese fan groups, conduct observations and interviews, and record field notes at various media events and concerts.

Second, it involves in-depth interviews with personnel in different positions of various media and companies, including investors, managing or executive directors, directors for various content productions and promotions, distributors, musicians, and artists. The operations of the transnational or foreign media in China are examined by interviews from the televised media (Channel V, Xing Kong TV, and Phoenix TV of the STAR Group, MTV, and Nickelodeon of Viacom, China Entertainment TV), major transnational records (e.g., Sony, BMG, Universal, Warner, EMI, their distributors and other border-crossing Hong Kong and Taiwan music companies), international movie companies (e.g., Warner Bros. Pictures), media in neighboring Chinese communities (e.g., Hong Kong, Taiwan, and Macau media), and other foreign and international productions in China (e.g., concert producers, Taiwan– and Hong Kong–based productions and distribution agents). It should be noted that the transnational media companies all had very positive attitudes toward the interviews. Surprisingly many of these companies were very sincere and open to answering sensitive questions and some even actively arranged for researchers to go to different media events to observe

their production and publicity.[2] Strategies of this localizing global media to circumvent control or to collaborate with the PRC and the kinds of constraints and processes behind the content production that dictated, drove, and inspired the strategies were best revealed in these interviews. To gauge how the nation receives the global players, interviews with the managers, producers, and journalists from the major Chinese media were completed (e.g., Chinese Central Television, Shanghai Media Group, and many national, provincial, and city media). Party leaders in the Propaganda Department of the Central Committee of Communist Party of China, officials responsible for culture and arts in the Ministry of Culture or Cultural Bureau, and researchers and officials in the National Development and Reform Commission under the People's Congress were also interviewed. Altogether, over 150 formal interviews were conducted in this period; many of their names are acknowledged in the book, while a few of them were kept anonymous.

Third, many of the media texts—including radio programs, TV episodes, songs, MTV and award ceremonies—were taped for analysis. The interpretation of the content and symbolic meanings of the texts was discussed in conjunction with data in the interviews and participant observations to substantiate arguments. Apart from the primary data, Chinese secondary data such as research, marketing and government reports, news clippings, and legal documents were gathered for analysis. As mentioned earlier, this pool of Chinese references assisted in answering many of the unexamined assumptions of the Western studies on China.

Notes

1. The regional cultural force, as described by Fung (2007), is also conceived by the Hong Kong people as a barrier against the nationalizing ideologies and culture from the mainland China.

2. The major reason might be the fact that most of the senior managers of these companies emphasize their friendly relationships with the Chinese authorities.

References

Ang, Ien (1996) *Living Room Wars: Rethinking Media Audiences for a Postmodern World.* London: Routledge.

Bhabha, Homi (1994) *The Location of Culture.* New York: Routledge.

Caporaso, James A. and David P. Levine (1992) *Theories of Political Economy.* New York: Cambridge University Press.

Cullen, Jim (2000) *Popular Culture in American History.* Malden, BO: Blackwell.

Curran, James and Myung-Jin Park (eds.) (2000) *De-Westernizing Media Studies.* London: Routledge.

Curtin, Michael (2005) Murdoch's Dilemma, Or "What's the Price of TV in China?" *Media, Culture & Society* 27 (2): 155–175.

Derleth, James and Joel Herche (2005) Economic and Political Freedom and Market Alienation: A Comparative Study of Bulgaria, China and the United States. *Journal of Euro Marketing* 14 (3): 83–98.

Downing, John (1996) *Internationalizing Media Theory.* London: Sage.

du Gay, Paul, Stuart Hall, Linda Janes, Hugh Mackay and Keith Negus (1997) *Doing Cultural Studies: The Story of the Sony Walkman.* London: Sage.

Frey, Bruno S. (1984) Modelling Politico-Economic Relationships. In David Whynes (ed.), *What Is Political Economy? Eight Perspectives.* Oxford: Blackwell, pp. 141–161.

Fung, Anthony (2003) Marketing Popular Culture in China: Andy Lau as a Pan-Chinese Icon. In Chin-Chuan Lee (ed.), *Chinese Media, Global Contexts.* London: Routledge Curzon, pp. 257–269.

———— (2006) "Think Globally, Act Locally": China's Rendezvous with

MTV. *Global Media and Communication* 2 (1): 71–88.

——— (2007) Intra-Asian Cultural Flow: Cultural Homologies in Hong Kong and Japanese Television Soap Operas. *Journal of Broadcasting and Electronic Media* 51 (2): 265–286.

Garnham, Nicholas (1990) Public Policy and the Cultural Industries. In Fred Inglis (ed.), *Capitalism and Communication: Global Culture and the Economics of Information.* London: Sage, pp. 155–168.

Gershon, Richard, A. (1997) *The Transnational Media Corporation: Global Messages and Free Market Competition.* Mahwah, NJ: Lawrence Erlbaum Associates.

Giddens, Anthony (1991) *Modernity and Self Identity: Self and Society in the Late Modern Age.* Cambridge: Polity Press.

——— (1999) Comment: The 1999 Reith Lecture. New World without End. http://news.bbc.co.uk/hi/english/static/events/reith_99/week1/week1.htm. Accessed on June 1, 2008.

Golding, Peter and Granham Murdock (2000) Culture, Communications and Political Economy. In James Curran and Michael Gurevitch (eds.), *Mass Media and Society.* New York: Arnold, pp. 15–32.

Griffin, William E. (1979) Communist Propaganda. In Harold D. Lasswell, Daniel Lerner, and Hans Speier (eds.), *Emergence of Public Opinion in the West.* Honolulu: University Press of Hawaii, pp. 239–258.

Guo, Zhongshi (2003) Playing the Game by the Rules? Television Regulation around China's Entry into WTO. *Javnost: The Public* 10 (4): 5–18.

Hamelink, Cees (1983) *Cultural Autonomy in Global Communications.* New York: Longman.

He, Zhou (2000) Working with a Dying Ideology: Dissonance and Its Reduction in Chinese Journalism. *Journalism Studies* 1 (4): 599–616.

Held, David (1990) The Decline of the Nation State. In Stuart. Hall and Martin Jacques (eds.), *New Times: The Changing Face of Politics in the 1990s*. London: Lawrence and Wishart, pp. 191–204.

Hesmondhalgh, David (2002) *The Cultural Industries*. Thousand Oaks, CA: Sage.

Hong, Junhao and Yu-Chiung Hsu (1999) Asian NIC's Broadcast Media in the Era of Globalization. *Gazette* 41 (3/4): 225–242.

Hung, Chang-Tai (1996) *War and Popular Culture: Resistance in Modern China 1937–1945*. Taipei: SMC Publications/University of California Press.

Iwabuchi, Koichi (2000) To Globalize, Regionalize or Localize Us, That Is the Question: Japan's Response. In Georgette Wang, Jan Servaes, and Anura Goonasekera. (eds.), *The New Communication Landscape: Demystifying Media Globalization*. London: Routledge, pp. 142–159.

Jameson, Frederic (1998) Globalization as Philosophical Issue. In Frederic Jameson and Masao Miyoshi (eds.), *The Cultures of Globalization*. Durham: Duke University Press, pp. 54–77.

Keane, Michael (2006) Once Were Peripheral: Creating Media Capacity in East Asia. *Media, Culture and Society* 28 (6): 835–855.

Lee, Chin-Chuan (1990) Mass Media: Of China, About China. In Chin-Chuan Lee (ed.), *Voice of China: The Interplay of Politics and Journalism*. New York: Guilford Press, pp. 3–29.

——— (ed.) (2000) *Power, Money and Media*. Chicago, IL: Northwestern University Press.

——— (2004) *Beyond Western Hegemony: Media & Chinese Modernity*. Hong Kong: Oxford University Press.

Ma, Kit-Wai Eric (2000) Rethinking Media Studies: The Case of China. In James Curran and Myung-Jin Park (eds.), *De-Westernizing Media Studies*.

London: Routledge, pp. 21–34.

McClary, Susan and Robert Walser (1990) Start Making Sense! Musicology Wrestles with Rock. In Simon Firth and Andrew Goodwin (ed.), *On Record: Rock, Pop, and the Written Word.* London: Routledge, pp. 277–292.

Miller, Toby, Nitin Govil, John McMurria, Richard Maxwell, and Ting Wang (2005) *Global Hollywood 2.* London: BFI.

Modleski, Tania (ed.) (1986) *Studies of Entertainment: Critical Approaches to Mass Culture.* Bloomington, IN: Indiana University Press.

Mosco, Vincent (1996) *The Political Economy of Communication: Rethinking and Renewal.* Thousand Oaks, CA: Sage.

Offe, Claus (1984) *Contradictions of the Welfare State.* Cambridge, MA: MIT Press.

Pieterse, Jan (1995) Globalization as Hybridisation. In Mike Featherstone, Scott Lash, and Roland Robertson (eds.), *Global Modernities.* London: Sage, pp. 45–68.

Robertson, Roland (1995) Glocalization: Time-Space and Homogeneity-Heterogeneity. In Mike. Featherstone, Scott Lash, and Roland Robertson (eds.), *Global Modernities.* London: Sage, pp. 25–44.

Schiller, Herbert (1992) *Mass Communication and American Empire.* Boulder, CO: Westview Press.

Shi, Anbin (2005) The Taming of the Shrew: Global Media in a Chinese Perspective. *Global Media and Communication* 1 (1): 33–36.

Shirk, Susan (1992) The Political System and the Political Strategy of Economic Reform. In Kenneth Lieberthal and David Lampton (eds.), *Bureaucracy, Politics, and Decision Making in Post-Mao China.* Berkeley, CA: University of California Press, pp. 59–94.

Siriyuvasak, Ubornat (2000) The Ambiguity of the "Emerging" Public Sphere and the Thai Media Industry. In Georgette Wang, Jan Servaes, and Anura Goonasekera (eds.), *The New Communications Landscape: Demystifying Media Globalization*. London: Routledge, pp. 96–121.

Staniland, Martin (1985) *What Is Political Economy? A Study of Social Theory and Underdevelopment*. New Haven, CT: Yale University Press.

Storey, John (2003) *Inventing Popular Culture: From Folklore to Globalization*. Malden, BO: Blackwell.

Thomas, Amos Owen (2001) Global Media Corporations and the Nation-State: Balancing Politico-Economic and Socio-Cultural Globalization. *Global Business Review* 2 (1): 71–82.

Wang, Georgette (1997). Beyond Media Globalization: A Look at Cultural Integrity from a Policy Perspective. *Telematics and Informatics* 14 (4): 309–321.

Weber, Ian (2003) Localizing the Global: Successful Strategies for Selling Television Programmes to China. *Gazette* 65 (3): 273–290.

Wu, Huating and Joseph Chan (2007) Globalizing Chinese Martial Arts Cinema: The Global-Local Alliance and the Production of *Crouching Tiger, Hidden Dragon*. *Media, Culture & Society* 29 (2): 195–217.

Zhao, Yuezhi (1998) *Media, Market, and Democracy in China: Between the Party Line and the Bottom Line (History of Communication)*. Chicago, IL: University of Illinois Press.

——— (2001) Transnational Capital, the Chinese State, and China's Communication Industries in a Fractured Society. *Javnost: The Public* 10 (4): 53–74.

Globalizing China: The Case of Transnational Music Records

This chapter analyzes how China faces globalizing forces from without. In particular, as a case study, it traces the presence and development of transnational music record business that today is one of the widest foreign investments in China. Statistics revealed that in November 2003, the number of publication units and cassette/CD reproduction companies in China reached 320 and 169, respectively, with the capacity of manufacturing 1–1.5 billion cassettes or CDs every year. The number of production and distribution companies reached 1,000 with wholesalers numbering 100,000 (*China Press and Publications Journal*, 2002, February 2). A large volume of this business can be attributed to global investment, but the localization of the global record has not been without its trials and tribulations. In this chapter, an examination of the successes and failures of the various international music records such as Universal, Sony, EMI, and Warner is undertaken.[1] The transnational media penetration in China illustrates the political and economic constraints that the Chinese authorities impose on global players and highlights the changing attitudes of the PRC toward foreign capital.

It should be emphasized that in the China context popular culture, entertainment, and even leisure—and especially news—has always had a dual nature related to "political-economic integration," reflecting the inseparability of profits and political control. Accordingly, the discussion that follows departs from the major scholarly argument that the creation, circulation, and consumption of music genres and culture are highly circumscribed by the commercial logic of record companies and corporate business styles (Negus, 1999). Music industries and their commodities in China are both serving and subservient to that state, and even in contemporary China it is difficult to find popular music that is discordant with state ideologies. In the light of the fact that Chinese popular music has adopted the Western form and music structure, the selection of the music industry, as a departure, reflects the formation of global popular culture in China and the process of cultural globalization vis-à-vis forces of market localization under the umbrella of state control and monitoring. The historical analysis of the development of these global businesses in China reveals the political and economic limitations imposed on capitalist values, liberal thought, and ideology.

Globalizing from the Tangible to the Intangible

Globalization in China in terms of commercial and business relationships with the West probably started at the turn of the nineteenth century when the latter forced (through wars and subsequent treaties) the emperor of the Qing dynasty to open coastal ports for trade. Although seemingly harmless, the globalization of intangible commodities—including music, films, and TV dramas—in fact remains staunchly guarded and one of the last trade bastions defended by China. Until now, popular culture is still under the stringent control of the Propaganda Department of the Communist Party of China Central Committee and various administrative bodies of the PRC. Given the changing nature of the PRC, global capital is at a critical juncture in its attempt to transplant cultural products into China.

The relationship between modern Chinese music and Western capital has been consanguineous. Strictly speaking, the initial development of the Chinese music industry could even be regarded as a Western invention. In 1908, EMI's French company Pathe Marconi acquired local production facilities and set up Oriental (Dongfang) EMI Music in Shanghai. Despite the capital's Western origins, it laid the foundations for modern Chinese popular music, defined and moulded the early Chinese musical form and local aesthetics, and developed the prototype Chinese music that embedded nationalism and patriotism, which, ironically, also symbolized a kind of anti-Western sentiment. In their debut year, they produced the vinyl disc for the Beijing opera Dinjunsan, practically the first Chinese record in history (for a brief history, see musicchina.com, 2004, March 23, and Jin, 2002).

The pre–World War II period shaped global presence in China. The tripartite fusion of Western capital, employment of local cultural workers, and the promotion of the state was the precursor to the modern global-state partnership. Ideologically, it also demonstrates that commercializing forces from without and nationalizing control can be compatible, and occasionally and paradoxically, they can be harmonious. The exemplary case was in 1934 when Chinese musician Nie, Er joined EMI and wrote its debut *Mineworker's Song* for the movie *The Motherly Light*, the patriotic and working-class theme that was held in high regard by the party. In the same year, and with characteristic verve and patriotic flair, along with Chinese playwright Tien, Han, he composed the *March of the Volunteers* (Yijyongjun Jinxingju), the national anthem of the PRC. Before 1949, historical records in China showed that there were approximately 8,000 albums published and several million copies sold,

all catering to and for political purposes. Under the auspices of the state, these productions came under the oligopical control of three companies: Great China, Victory, and EMI.

Scholars (e.g., Hung, 1996[1994]) have documented the fact that the anthem was a subtle, yet important and effective means with which to galvanize the public against Japan during the Sino-Japanese War. When the production facilities fell into the hands of the PRC after the Communists' liberation of Shanghai, early founder and Communist musician Heluting soon produced the first movie with the thematic soundtrack album "Liberation Is a Sunny Day" released and broadcast live on June 6, 1949. The new regime continued to use modern music as a political tool to serve political purposes. Popular music in China was reserved for state use and as such has produced a sweeping historical legacy.

The Closure for Western Perversion

During the 30 years following 1949 the state totally dictated the public use of popular music, expelling the influence of the global players, which, under Western leadership and the prevailing cold war mentality, were deemed to be challenges to the Communist regime. During the Cultural Revolution, an article written by the China News Agency in *People's Daily* on June 2, 1966, summarized the policy of the PRC toward such cultural products. Its running headline "all worker and farmer soldiers picking up the forceful weapon of music … [and] engaging in a struggle of pro-Communism/anticapitalism in the cultural terrain" once again reaffirmed the advocacy role of music (He, N.A.). All forms of music were flattened into one single dimension constructed solely for revolutionary purposes. It also shut the door on global influence and completely eliminated those emerging forms of Western populism that had accompanied the Shanghai pop music scene since the 1930s. Of the latter, Shanghai singer Zhou, Xuan is probably the most well known icon who, in her vocal and musical style, elicited a kind of Western value of liberation and modernity, an ideology that was contradictory to Chinese governance. This Western "vulgarism," "hedonism," or "materialism" was collectively labeled "mimi ziyin" or "mundane voices." The 1930s and 1940s produced highly individualized tender melodies that were said to pervert the soul of the people, and were therefore classed as antirevolutionary (Netease, 2005, May 12).

Between 1949 and the 1980s, the concept of music records was simply

obsolete. It was a strategy to make the state completely immune to capitalism. As an explicit national policy, the state authorities banned all imported music with the noted exception of a small and controlled import of Russian classical music via the party organ International Bookstore founded in 1949. During that time, tangible goods for basic needs were imported through the former British Colony of Hong Kong, which is now a Special Administrative Region of China, while cultural goods were smuggled. At the Lo Wu border-crossing between Hong Kong and Mainland China customs officers dressed in PLA (People's Liberation Army) uniforms confiscated any music cassettes brought in by tourists and Hong Kong people. During the 1970s and 1980s the barriers imposed on outside global influence meant that the authorities reserved popular music as a tool for political campaigns and a social role for mobilization. Later, it was also used in a minor unofficial entertaining role within the establishment. A more important use was the composition, promotion, and performance of formal military (or *budui*) music in military music and dance troupes. These official performance units directly under the party leaders functioned to celebrate and enhance the unity of the army during public occasions by means of performance (interview with Wang, Fulin, Deputy Director, Haizheng Music and Dance Troupe, one of the most important military performance groups in Beijing on September 22, 2003). Close to such formal *budui* music, the nonofficial national Chinese music that are allowed to be circulated in the society, shown on television, and performed in public events and occasions are usually named as Meisheng (*bel canto* in Italian), literally meaning beauty voices. *Meisheng* in Chinese context are Chinese ballads—combining traditional and folk melodies, nationalistic theme and ethnic timbre—performed by classical vocal techniques. In these old days, when the modern popular form of music did not exist—or was simply not allowed to import—it could be marginally regarded as public entertainment. The main theme of these songs, however, could not stand apart from the official theme of glorifying ethnic unity, patriotism, nationalism, and comrade care. While these "high-taste," if not sanctimonious and bombastic, classics harmonized with the official needs, perceptibly, they were discordant with the grassroots need for emotive expression, enjoyment, and pleasure. As the public voices and the market become louder and more prominent, catering to and understanding the social need, in 1986 the Chinese authorities had to create a term "secular music" to accommodate the more popular form of music naturally mushrooming in the fragile society that just salvaged from the stormy Cultural Revolution (interview with Xu, Peidong, Executive President

of China Musician Association on July 28, 2005).

The term secular music was created to distinguish itself from other popular musical forms allowed to exist and detach the music from the "unscrupulous" Western forms circulating in China. In this sense literally, the word "secular" meant that the singer performed the song in a new, fashionable, layman style but that the connotations of the lyrics and the themes of the song must largely comply with the political status quo. Secular music could touch upon human love, wants, and sentiments, but, as a matter of fact, many patriotic and partisan lyrists and composers still preferred to tag on the secular songs that were grandiloquent and empty themes of ethnic unity, world peace, glorification of spectacular national scenery and development, to name a few. Institutionally, in line with the promotion of secular music, China also restarted its publication arm for music records, namely, China Record Corporation, in Beijing, Shanghai, and Guangzhou in the early 1980s (interview with its former A&R manager, Ma, Xiaonan, China Record Company on December 21, 2003). During this period authorities felt they could run domestic cultural industries independently from global influences. For the people, however, enclosed in a state where information and entertainment were disconnected from the West, there was a sullen discontent about the propaganda and demand for Western music and Hong Kong music smuggled through illegal channels burgeoned (Fung, 2007).[2] It was not until the PRC reopened the door for Western records that popular music synchronized with the local, mass, and folk culture again.

Reform without the Global

In reform since the 1980s individual ownership has been reestablished. People searched for novel orientations and inspiration. They sought individual directions for their lives and help in collectively readjusting to the rapid changes in society. To limit change and to control the potential political effects on the population, the state controlled the flow of foreign popular music. In 1979 Chinese authorities established the Pacific Audio and Visual Company and the China Record Company. This signified the cessation of the radical culture policy set during the Revolution and recognized changes that needed to be made to provide access to popular music in China. Almost overnight many new companies and organizations were formed (interview with Li, Qiang, Manager, New Era Audio & Video Company on October 5, 2003; Li, Guangping, President, Platinum Music on October 5, 2003; Chen, Luo, A&R,

Perfect Music Production on October 4, 2003). With a strong phobia of foreign music, the regime attempted to run the music industry on its own. Foreign music was thought to pervert the minds of the people, and divert people away from the socialist ideology. There was a folk adage circulated about public sentiment and the attitude of the regime toward popular music: the "day-time" party leader Deng, Xiaoping was most troubled by another Deng (Teng in Taiwanese Romanization), the Taiwan singer Theresa Teng—who in her songs talks about romance and love in a free country— commanded people's spiritual mind at night (Fung, 2007).

In 1981, in order to handle the ever-increasing import of audio products, the China National Publications Import Corporation (formed in 1973 and formerly the International Bookstore founded in 1949) had its name changed to the China National Publications Import and Export Corporation. This did not mean a relaxation of imports into China. According to those working closely with the Corporation—Guangzhou which pioneered the import of the first Hong Kong record in China around 1988—it set a limited quota for foreign entries and levied a high transaction cost for the "application." Essentially, it was a "censoring organization" that controlled the extent of globalism in China (interview with Liu, Zhiwen, Musician, Perfect Music Production and Wang, Zhihua, Chief Planner on October 5, 2003).

For public performances of the nonmainland Chinese artists, the controls were even more stringent. The first Western musicians allowed to perform in China were the UK band Wham who gave a concert in Beijing in 1985. This was a token gesture of China's open policy rather than the signal that a mature market was going to be developed. As late as 2003, a quota system setting the number of foreign performances still existed so as to minimize "contact." The Ministry of Culture even limited to 20 Hong Kong artists wishing to perform on the mainland (interview with Chen, Jixin, General Manager, Times New Century Culture Company on April 27, 2004). Without exception, to operate independently, a foreign production company had to first register locally with a premium of RMB5 million, and then locate a partner with a ranked licensed corporation specialized for the performance. Officially set up to issue performance licenses, the latter was basically a subsidiary of the Ministry of Culture (sometimes called the Cultural Office) created to monitor public performances. Officially, a lump sum total of RMB200,000 as an administration fee had to go to the licensed corporation and also the Ministry for licenses prior to launch of any public performance. At the apex of this system, in the mid-1990s, the black market rate (which involved the selling of licenses

through a few layered corporations) could reach RMB2 million. As well, only the top-ranked licensed corporations were allowed to run performances with overseas artists.

Depending on the artist's origin (longer for foreign and Taiwan artists), it could take around 1–10 months to get state approval (interview with Zhu, Derong, Director of Guangzhou Cultural Communication, a company for concert production in South China on October 26, 2003). There were also barriers in locating suitable performance sites, mainly stadium and sports fields, which could accommodate 9,000–20,000 since venues below that size were too small for the organizer to break even.[3] Apart from the high cost of rental (e.g., around RMB300,000 for a small stadium in South China), a certain percentage of tickets had to be "donated" to different governmental units (stadium management, fire department, the city office, etc.) to ensure a seamless management of the performance.[4] Despite a seemingly flourishing business of "importing" foreign artists, it was hard to break even for most concerts. According to Chen, Jixin, Director of Beijing New Century Performance Company, the largest commercial corporation of this kind in China (interview on April 26, 2004), the Taiwan pop diva and now a Warner Music artist A-Mei's concert could be regarded as the most successful one on the mainland, not only because of the ticket revenue of RMB10 million but also because it had a large sum of RMB8 million in sponsorship fees from Sprite for which she sang the theme song *I Want to Fly* (2000). The reasons for creating such a high threshold for foreign players are twofold. First, it deterred the entrance of the global capitalist who already had one foot in the door. Second, and more overt, the government continued to harbor hopes of developing their own cultural influence with the subsidiary arms of state-owned music record companies. To this end the authorities protected the infant business from the Big Five international music companies from the West, which, in the mid-1990s, had acquired all the local music labels in the two other largest Chinese markets in Hong Kong and Taiwan.

The Big Five in China

Since China began its open door policy in the mid-1980s, international players had seized every opportunity to gain territory in China and as of 1999 achieved dominance accounting for 55 percent of the total value of the market. Public figures in 1998 and 1999 showed that global records accounted for almost 90 percent of the total cassette tape shipments, at a time when CD

hardware penetration was still at a low level because of the lagging economic growth of households. The five major transnational corporations were SONY, EMI, BMG, Universal, and Warner.[5] How they transformed their business model to produce a hybridized music culture that at once minimized ideological conflict with the authorities and popularized the market is our next subject of concern.

Despite having a small sales record compared to international music business standards, with 1.3 billon population in China, transnational corporations have confidence that the China market will grow (interviews with the representatives of all Big Five companies between 2003 and 2005). To this end the Big Five started to reactivate their business in China in the 1990s. First, they had to secure their markets in Hong Kong and Taiwan. As a phase of panning their mainland market operations, the Big Five acquired all the major labels in Hong Kong and Taiwan, including the most prominent company Polygram. They attempted to take advantage of the proximity of their Hong Kong and Taiwan offshore offices to make liaisons with mainland singers and test the China market. For example, EMI, with their historical legacy in China, was the first British-listed record company that signed contracts with Chinese singer Xie, Xiadong and Mao, Amin in 1991, and Universal, Warner, and BMG oversee their mainland operations from regional offices in Hong Kong and Taiwan, since 1994 Sony and EMI have established small offices on the mainland. To distribute their products, the Big Five relied on semistate licensees that manufactured and produced CDs in China (interview with Kong, Jing, Manager, Sony Music, Beijing on September 22, 2003). These privileged licenses are either semigovernment-owned (e.g., White Swan and China Record) or private but state connected (e.g., Meika and Jingwen) distributors, and in China, these distributors are limited in number and formed an oligopoly for this special culture industry (interview with Xu, Jin, A & R, White Swan Music Company, September 19, 2003 and Hu, Xiaolu, Manager in Marketing Department, Jingwen Music on September 20, 2003)

The first phrase immediately created profits for these global players. As the hardware for producing CDs became more popular, however, this indirectly triggered an epoch of uncontrolled piracy, and more important, as mentioned in Chapter 1, many distributors served as double agents being legal merchants on the one hand and notoriously dubbing pirated CDs on the other. Accordingly, the global companies received less and less real revenue from the market. The second phase reflected a period during which the Big Five had to trust and rely on the state for ultimate protection. Companies started to

engage in a deep collaboration with the state so as to "feel" the state culture. For the state it singled out individual players for collaboration on a project-by-project basis. The exemplar was a three-year joint project specifically approved by the Ministry of Culture, between the U.S.-based Sony and Shanghai Audio & Video Publishing Press in 1997, which for the first time formally allowed the operation of a foreign music company in China. In this project, each year, each partner invested US$1 million and for that Sony was licensed to operate under the name Sony Audio & Video in China, in a period where joint ventures were not allowed, the global corporations localized by means of skimming off the cream of experienced local staff and mimicking the operations of local organizations. These "joint projects" more or less functioned as a device to incubate local artists, a business direction that matched with the larger agenda of opening China to the world (interview with Chen, Daoming, Former A&R, Sony Music China on December 22, 2003).[6]

Clearly, these joint projects were not considered ideal since they involved the traditional state-owned music companies. In the 1990s EMI also reconnected with Dongfang EMI, the China Record Shanghai Company, to enter the China market. In this decade, China Record Shanghai helped EMI to distribute its worldwide albums such as the Beatles and Queen, and prominent Chinese artists such as Faye Wong and Zhangyu. Although it got an initial taste of the market, it was not until August 2001 that the company gained substantial access to the mainland market. In 2001, it was a year that the state-owned enterprises, including China Record Shanghai, had to transform themselves from being a purely state apparatus to a more commercial kind of Western carrier like EMI. This was also a signal that the Chinese authorities were attempting to develop and manage their own production.

However, the formula of global-capital-local products was not successful. As the previous chief representative of Sony indicated, while local singers lagged behind the "modern attraction" as compared to those in Hong Kong and Taiwan, the project was reduced to dealing with copyright issues and reproducing Hong Kong and Taiwan music in China. For Sony, in practical terms the project was no different from its former prototype, where it saw itself as a kind of foreign representative stationed in China. The second stage was not a glittering path with which to open China's riches (interview with Chen, Daoming on December 22, 2003).

Big Five Partnering the Local

Although the Big Five have clear ambitions in the Chinese music market, success has been illusive. A strategic shift in thinking is required. To rationalize this continued global venture, these foreign investors have to accept a third route. This solution does not include the loss of control or willy-nilly subjection to the open market requirements under WTO; nor in it does the state act as an orthodox and pedant dictator setting barriers for dictating foreign entry. Instead, the new route symbolizes a symbiotic relationship between the foreign and the local as the way forward in the Chinese marketplace. It also represents an acceptable solution for the Chinese authorities, who at least portray an image of complying with the post-WTO realities. This marks the third phase for global ventures, which is the establishment of joint ventures between global records and state enterprises. This phase also fits well with the second reform of China in the 1990s and confirms the so-called socialist market logic of China. According to Wu (2004), the word "reform" no longer connotes the hackneyed party slogan for empowering the grassroots and the proletarian and now is widely understood as a stage to coalesce market capital and the state bureaucracy. In other words, it is an economic means, rather than political means, to eventually widen the control of the state. On a micro and a cultural level, the formation of joint music records between the state corporation and global records represents a perfect blending between Western music and Chinese culture; on a macro level, the state has to rely more on the forces of the transnational music companies to exercise their manipulation and control of the public. The use of commercial logic as a means to produce a tamed popular culture to serve the nationalist ideology could be seen as a joint alliance between the state and international capital. In other words, the state now appears flexible enough to partner with international capital, attaining a win-win situation for both parties.

In May 2000, Warner China entered the China music market by acquiring local record label Maitian and artist management company Pulai. This local marriage seemed well-planned as in 1999, Warner China used the term "brotherly label" to team up with Maitian to produce their existing local artists such as Poshu, Yepei, and Luolang. While Warner China specialized in music production, Maitian was involved in artist management. Like most of the local record companies, after the formal integration, Warner acted in the dual role as music producer and artist manager. With local Maitian professionals running Warner, this international firm was able to secure and cooperate with many

local sponsors to promote both sides' brands through the organization of a number of music campaigns (interview with Song, Ke, Vice General Manager, A& R, Warner Music [China]/Managing Director, Taihe Rye Music Company on September 19, 2003). This operational model diverges from past market paradigms that peddled foreign music to China. Another Big Five, EMI, in 2003 also partnered with Bushen, initially the distributor of local music production group Shanghai Yifeng Culture Communication to form the EMI-Bushen. EMI's local fusion can be seen as the first step for their ensuing localization strategy (interview with Shao, 1 Te, General Manager, Artists Management Division, EMI Music China on December 1, 2003, and Huang, Xiaomao, General Manger, Warner Music China on January 20, 2005).

For Sony, in May 2001, it partnered with Shanghai Investment Company, Shanghai Xinhui Laser Disc Corporation to establish the Shanghai Epic Music Co. Ltd. (in Chinese, Xinsuo). The joint Sony mainland capital enterprise was permitted to dole out music and entertainment products. To date, this is the highest profile foreign capital penetration in the Chinese music market. The Ministry of Culture approved them for the distribution business on an exceptional basis. This collaboration was undoubtedly a special permission in that it occurred before the implementation of "The Regulation of Audio-Visual Product Management" in February 2002. The Regulation specified that no foreign culture corporation was allowed entry into the music industry in China. Currently (2007), Shanghai Sony is still the only joint music distributor with explicit formal governmental approval (interview with Wu, Yue, General Manager, Sony Music China [also Managing Director of Epic, the joint company of Sony with local capital] on November 27, 2003).[7]

In 1994 Universal attempted to develop the local Chinese market (e.g., signing artists such as Maizijie) but this attempt ended in vain. At the end of 2000, Universal kicked off its joint collaboration with Shanghai Yifeng Culture Communication, Zhejiang Bushen Music Culture whose business was to provide Universal's existing global and Hong Kong artists a platform, arrange and produce local versions of the artists' albums, and market their albums and performance in China. One of their primary goals announced publicly was also the development of the local music market. However, the joint force soon collapsed when Yifeng's management personnel switched to EMI. Universal then remained virtually dormant with the exceptions of dealing with copyright issues and facilitating Hong Kong and Taiwan artists'

promotion in China. It was not until March 2003 that they joined forces with Starwin, a local music production and later with SMG (Shanghai Media Group) in 2004 (interview with Yang, Xingnong, Vice President, SMG on May 16, 2004, and Zhou, Ruikang: Chief Representative, Universal Music China on December 1, 2003).

The Legacy of Government Control

The question is why the Big Five, seen internationally as the most liberal, giant and free capitalists, risked being accused of ingratiating themselves with the government of China and made a complete about-face in its business thinking by partnering with the state or the state-owned companies. A possible explanation may be the stringent control of the state on every level at every city. It was only by forming an integrated commercial-state complex that the transnational capitals could circumvent all these practical, bureaucratic, and legal obstacles. In China, the production of culture is very restricted as all parts of its circulation are under the surveillance of various state authorities. All audiovisual products are centrally monitored by the Audio-Visual Office of the Ministry of Culture, while the News Publication Office controls all the licensing of publications and duplication rights. The music business is still regarded as a subset of the publication business. The promotion arm of the industry is also highly controlled as the State Administration of Radio, Film and Television controls all electronic broadcasting. Even though the music broadcast on radio does not fall within the juridical boundaries of the Ministry of Culture, content in the media is controlled by the State Administration of Radio, Film and Television and the Propaganda Department. All online and Internet media pertinent to artists' news, pop trends, music awards, music videos, and songs are also under the Information Industry Bureau.

External forces attempted to intervene and self-regulate this particular culture industry. Nevertheless, without the full enforcement and support of the state, all regulatory efforts were either boycotted or ignored by the industry players. Government actions could also be regarded as deliberate to curtail international operations. On October 5, 1995, with the approval of the National Copyright Office, registered under the Commercial and Industrial Executive Department, the office of representation of the IFPI was formally established in Beijing. The IFPI China was given legal right to protect and copyright all the works of their members in China and served as an ombudsman between the government and the authors for all copyright application,

communication, and consultation. It was also a step for various Chinese publication units to join the IFPI and thus allowed future copyright trade with copyright protection. However, in April 2005, there was an incident wherein IFPI China received a copyright fee from a local music company to produce a dubbed version of the song in China, even though the song belonged to an Asian music company called Butterfly that was not a member of the IFPI in China. This not only seriously discredited the China's IFPI but also reflected the fact that transnational companies in China have little protection (interview with the Managing Director of the Singapore-based Ocean Butterflies Music Beijing, Benny Bi on November 14, 2003).

The Strategies Revised

With the development of record companies, culture production in China has started to change. In retrospect, the music industries in China had no business model of their own, and for a period of time during the 1990s depended heavily on the media to promote their products. The record industries experienced a Dark Age in which they started to co-opt, bribe, and even pay radio stations to get their records played and popularized. Other important chains for business flow, which involved circulation, promotion, and distribution, were not developed. In this period, the government did not have the apropos regulations to standardize the industry and had partially abandoned the popular music industry for its hardcore propaganda. Ideologically, popular music is still under the strict control of the Ministry of Culture, and it was not until 2004 that the authorities decentralized its power to provincial level for approving public events relating to popular music (interviews with the strategic organizer of the Taiwanese singer Jay Chou's concert in Shanghai, Fan, Li, Marketing Manager, Zhenlong Culture Company on March 12, 2004, and concert organizer Anthony Ching, Executive Director, Guangzhou New Mind Culture Communication Company on October 5, 2003).

Under the current system, distributors enjoy a very minimal profit margin. Thus, to secure their markets, some of them have branched out to produce specialty music products and make use of their relative advantage in the distribution network. By doing their own production, private distributors turned themselves into publication companies and thus enjoying a stronger advantage in marketing. Flow and production has slowly formed, with many private distributors (e.g., Jingwen) gradually branching out into the production

business and even collaborating with program investors and copyright traders (interview with the Vice President and Marketing Director of Jingwen). With mutual interest in these productions, this strategy ensured that music copyright, production, and distribution, rather than competing against each other, formed a healthy and sustainable system. In the not-too-distant future, there might be some local companies that will start to extend their influence downward to invest in the retail market. As retailing carries the largest profit margin, the extension of production or distributor companies can significantly increase profit. With sales controlled, the circulation of the culture product is then complete.

This local strategy, however, was soon learned by international corporations. Sony and EMI are the first major corporations to form their own chains. Sony set up their own production lines in Shanghai, and distributed its CDs with its close partner Shanghai AV distributor. Although it seems that one is an international brand and the other is a subsidiary of a state-owned giant company, both investors have a state background. This means that Sony, with the state-related investment, could also be allowed to become one of the strong chains in China. For EMI, they made use of the China-registered local label Bushen to distribute their CDs. EMI, which together with Virgin and the Taiwan-based H.I.M., may be producing the largest and widest range of music products in China. In some of the major retailers in Beijing, EMI is able to secure shelf space exclusively distributing their products. These two successful cases have demonstrated the possibility of transnational corporations joining hands with the state, semistate, or private interests—albeit under close state regulation.

The kind of interlocking collaboration also occurs in media enterprises in China. In February 2004, the SMG was able to attract Universal Music to form an artist management company Shangteng Entertainment. The latter is responsible to organize music resources of Universal in China, ranging from launching music events or festivals, producing with other companies, developing new media, promoting and marketing other products, and even producing music-related products such as DVDs—which in the past Universal had no legal basis and/or channel for receiving remuneration for. Neither did they have the status or networks for acquiring investments from local companies. But now it seems that both transnational corporations and local media benefit (interview with Yang, Xingnong, Vice President, SMG on May 16, 2004).

What is significant in this cooperation is that a local media giant such as

SMG was able to gain extra cultural resources to compete locally. Given that the new generations in China continue to fantasize about things foreign, Hong Kong and Taiwan culture, various media corporations are willing to share the market with these international corporations using the most popular artists and popular products to attract this new audience. With their long-term cooperation and experience with transnational companies they will be able to produce culture on their own and do it to international standards.

Localization of Global Music Records and the Consequences

In 2005, the sales figures for music in China were only US$86 million while the global music market amounted to US$30 billion (Silverbullet, N.A.; *Hong Kong Economic Times*, 2007, April 26). As the Chairman and CEO of IFPI John Kennedy said in Shanghai that the Chinese market for the global players is "a picture of untapped potential" (Kennedy, 2006, May 25). Thus, despite initial setbacks, the Big Five never abandoned their Chinese conquest. Given the various constraints and controls, the imminent and future moves should include continuing to capitalize on the national policy that encourages joint ventures. With unbalanced returns, rather than retrenching their expenditures, the directors of these global capitals maintain that the only possibility to share the market in China is to continue to operate and collaborate (interview with Wu, Yue, General Manager, Sony Music China on November 27, 2003, and Chen, Yourong, the chief representative of BMG on May 17, 2004, and Universal Zhou, Ruikang in China on December 1, 2003). It would be the feasible means to this end as an interim strategy since it would be too late to wait for a complete transparent and mature market to emerge on its own. Localizing by collaboration is still the way forward. With the "push strategy" of the state for encouraging joint ventures, naturally, global records could respond by a positive "pull reaction": setting up various levels of strategic cooperation with the state corporations on the production level, local media on the promotional level, and local distributor on the circulation level. Also, training and signing up local music bands will eventually develop local tastes in addition to an affinity to the Western, modern lifestyle.

The entrance of global companies might not actually contribute to local industries as much as one might expect. On the contrary, as evidenced by the grievances of many local records, global records significantly threaten their survival since local private capital is often not bold enough to brave entry into gray areas and at the same time not attractive enough to be partnered by strong

national, local media, and the state, which has an urgent need to absorb international experience. Of course, on the whole, international investment in China contributes to the Chinese market, enhancing the production of modern popular music and increasing the national standards of the music industry. But in the long term, transnational corporations helped to nurture a market of cultural goods in China and, in essence, created culture industries with huge potential for the growth of GDP. In terms of the sensitive ideological and cultural terrain, transnational capital also directly helps standardize and systematize various kinds of ethnic and national music and helps market and package this music to the global world. For example, from 1998 to 2001, Sony Music and Shanghai Audio-Visual Publishing under the Xinhui Audio-Visual Corporation set up a joint project signing contracts with more than 10 local singers and published almost 20 albums to boost the local market. It trains personnel in this arena, speeds up local development, and expands creativity in music industry.

Why did China permit a kind of transnationality in the area of culture? Most people would mistakenly suggest that the WTO is a major push force: China benefits from foreign trade and its long-guarded fences on media and culture industries have to be torn down. As illustrated in Chapter 4, however, the authorities think well beyond the notion of a passive entry into China's markets. With the postulated third route in receiving the global, Chinese authorities will eventually be able to develop their media to compete with the other global media. In the short term, the immediate effect of transnational entries will be intensifying competition among the local media and other local productions. In the long term, competition leads to better commercialization strategies. Those culture industries that are flexible enough to detach themselves from a global mentality will survive in China.

This intangible experience is helping to reorient China's industries and a media that in the past had a state mentality. This process does not in and of itself relinquish China's power to control. Rather, nationalizing the state nowadays requires delicate and subtle strategies. In this emerging world, direct forces and suppression are less powerful than using a popular culture that has been prefiltered and depoliticized. International production in China might take on some Western musical forms and operations foreign to China. But in terms of content, the joint venture produces music and culture that are not deviating from national ideologies and traditional culture. Chinese youth experience this global-cum-national culture only after Chinese authorities are able to collaborate and negotiate with the international music corporations to

produce a "controllable" Chinese culture that does not undermine the legitimacy of the state.

Conclusion: An Incomplete Project of Globalization

Transnational music corporations are internationalizing the music industries and culture in China. Historical evidence and cases of failures of global music corporations as described in this chapter have suggested that localization of these companies have gone through a number of stages, from an exploratory stage of testing the governmental allowance of "globalness," through taking refuge from seeking joint projects with the local corporations, to the formation of the joint state-global-capital corporation. The latter produces popular music that carries a Chineseness even as it suggests aspects of Western modernity. Each of these stages reflects the national cultural policies of the PRC of the time, from an abhorrence of the West (especially during the Cultural Revolution)—and a savage repression of foreign records and the establishment of a market solely run by Chinese companies—to relying on the global capitals to develop their own culture and music market. This chapter also documents the global music experience in devising new strategies in the form of collaborative corporations and projects through piecemeal, impromptu, and provisional attempts to accommodate the national state agenda in China. To look at the broader picture, I would suggest that the state's receptive attitudes toward these transnational music records are just miniature testing grounds and rehearsals for more extensive fusion and collaboration between the state and global capitals. With such experience of global contacts, the state targets bigger media collaboration projects but these projects require more careful planning and cautious actions.

Notes

1. BMG is not included here because there is no representative office in China. I managed to interview their chief representative in China, Chen, Yourong.

2. Hong Kong popular music is not just an alternative for China's secular music; it also gave the public a perception of Western modernity.

3. In Shanghai and Beijing, there are also sports fields for 30,000 people.

4. For a stadium of 9,000 seats in South China, 1,000 tickets are needed and for a sports field of 20,000, 3,500. In Shanghai and Beijing, more tickets are given out, ranging from 5,000 to 7,000 for a sports field of 30,000 (interview with Fan, Li, Manager, Zhen Long Performance on December 1, 2003 and Zhu, Derong on October 26, 2003).

5. Although in other parts of the world, the Big Five have become the Big Four after Sony and BMG merged to become Sony-BMG, in China, the situation remains the same. This is because the prior agreement of Sony with the Chinese collaborator was solely an agreement between Sony and the state. In order to keep the agreement valid, Sony did not push for a renaming and reorganization of the company in China.

6. In retrospect, Sony created a pioneering test of the China market. In 1994, while legally not allowed on Chinese soil, they took advantage of a gray area (which is also a common practice for many international firms) and set up a representative office in Beijing.

7. In 1996, BMG also established offices in Beijing and finally became independent as a local label MMG in China. In 2005, when, globally SONY and BMG merged to become SONY-BMG, in China, the unification of the companies, however, did not occur. Thus, the BMG's representative was still independently looking for opportunities in China.

References

China Press and Publications Journal (2004, February 2). A Good Trend for the Development of Audio-Visual Electronic and Online Publication Industry in My Country. Cnave.com.
http://nanfang.cnave.com/news/viewnews.php?news_id=279&year=2004. Accessed on October 22, 2006.

Fung, Anthony (2002) Localization of Transnational Music Corporations in China. *Media Digest* (September): 2–3.

———— (2007) The Emerging (National) Popular Music Culture in China. *Inter-Asian Cultural Studies* 8 (3): 425–437.

He, Zhu (N.A.) Songs in "Cultural Revolution," China Elections & Governance. http://www.chinaelections.org/NewsInfo.asp?NewsID=99785. Accessed on February 7, 2007.

Hong Kong Economic Times (2007, April 26) The Potential Huge Digital Music Market Will Create New Room for Music Business Opportunity. http://big5.cnave.com:8080/news/viewnews.php?news_id=4041&year=2007. Accessed on May 17, 2007.

Hung, Chang-Tai (1996[1994]) *War and Popular Culture: Resistance in Modern China 1937–1945*. Taipei: SMC Publications/University of California Press.

Jin, Xiaojun (2002) *Everyday Popularity*. Beijing: People's Music.

Kennedy, John (2006, May 25) Unlocking the Music Market in China. IFPI. http://www.ifpi.org/content/section_views/view020.html. Accessed on May 17, 2007.

MusicChina.com (2004, March 23) EMI, www.musicchina.com/tbtj/show.jsp?COLUMN_TYPE=3&COLUMN_ID=0 5&INFO_ID=1163. Accessed on October 12, 2006.

Negus, Keith (1999) *Music Genres and Corporate Culture*. London: Routledge.

Netease (2005, May 12) Theresa Teng Is Leaving
http://ent.163.com/ent/editor/star/050512/050512_408358.html.
Accessed February 6, 2007.

Silverbullet (N.A.) The New Commercial Ecology Changed by the Internet: The Last Realm of Music Industry.
http://www.ciocto.cn/modules/articles/article.php?id=111. Accessed on May 17, 2007.

Wu, Guoguang (2004, July 31) Discussion on Reform and "Second Reform" *Twenty-first Century 28*.
http://www.cuhk.edu.hk/ics/21c/supplem/essay/0404065.htm.
Accessed February 9, 2007.

WTO, Politics of Control, and Collaboration

Upon China's entry into the WTO, there was an international expectation that China had to comply with the agreement to gradually open up its media to global capital. As a matter of fact, during this transitional period, China implemented new policies to deliver on this promise. Notwithstanding the negotiation process and the actual WTO agreement itself, the opening of the media in China for foreign players is not something that is specifically referred to. Global players were preoccupied with battles over their interests in banking, insurance, and the telecommunication industries, to name a few. Against the assumption that China was forced to open its markets, as an imperative preparation for globalization, the following analysis concludes that it was more of China's own accord and agenda to open the market.

Inordinate delays in opening the market would by definition invite international pressure. The PRC motive suggests that China wanted to control the conditions under which globalization took place. This could help the authorities increase the popularity of and mould the direction of their national media, and hence help in perpetuating its national dominance. Though at times quite intimidating, China's actions to protect its national interest are not so different from policies in other parts of the world (e.g., European Union, e.g., Sarikakis, 2005). All nations make some attempt to curb the effects of global media enterprises regarding media acquisition, concentration and centralization (e.g., Meier and Trappel, 1998). Empowering the nation's own media apparatus is an ideal *modus operandi*, and although admittedly only an interim solution, serves the purpose of slowing down the acquisition process.

Various studies (e.g., Fung, 2006; Shi, 2005) have demonstrated that media policy in China is still very heavy-handed in its control of global media. However, this in turn does not mean that the policies are static. Strategies can be controlling and at the same time beneficial for global capital; the two are not necessarily antagonistic. This chapter illustrates how the PRC has started to hammer out a cultural policy that is receptive toward global capital with the focus largely on the broadcasting industry (including television, radio, and film), and yet maintain its domination. Collaboration is the key for this emerging model.

Media Policy toward Commercialization

On November 28, 2004, the State Administration of Radio, Film and Television (SARFT) promulgated a new regulation entitled "the interim regulation for joint investment or collaboration on the production, operation and management of radio and broadcasting program." As a commitment of the PRC on accession to the WTO, China permits global capital to invest in Chinese corporations for production and distribution of audio and video products in China. The regulation, commonly known as "Decree no. 44," states that the share of the Chinese party in the joint business should not be lower than 51 percent, and that the scope of programming and content production includes all kinds of productions, films, television, entertainment and comics, but does not include news programming. Also implied in the Decree is that the PRC allows national or local media to be privatized with shares sold to investors.

On the pull side, as soon as the new regulation was released, major foreign media expressed their interest in investing in content production in China. Among those was the Hong Kong–based Phoenix Television, which currently relies on a private mainland enterprise Shenzhou Television to produce television programs for it since Phoenix can only involve itself on the business and broadcasting side. Should foreign capital be able to engage in local production, to a large extent they could regain control from the hands of the mainland controllers. For other global media investors, because global media are excluded from making television news programs, they consider supplementing the Chinese counterpart with programs such as children's cartoons, documentaries, music programs and entertainment, all areas which Chinese media currently have little experience of.

On the push side, the state has given the global media a clear signal by testing the waters of some of its cultural industries. According to the UK's *Financial Times* on November 24, 2004, the first mainland corporation to directly operate in the television industry, namely, Shandong, TV-net Media Development, was formally approved for listing on the stock market. Symbolically, the Shandong case could be a pioneering attempt to invite global capital to run the Chinese media business. In this case, it was not because the local television market lacked the capital to expand in the local market, as the television markets seemed to be in full blossom. For world-class productions such as for the movie *Hero*, however, capital in excess of RMB70 million was required. In this case capital subordinated

Chinese production to an international standard.

The Decree also caused other major global television program providers to speed up their China ventures including the children's program production company formed by Viacom's Nickelodeon and Shanghai Media Group (SMG) (which is the mother company of all electronic media in Shanghai), the Huasou Film and Television Digital Production formed by Sony Pictures and the national largest film distributor and producer China Film Group, and the joint company established by United States' Discovery Channel and China DTV production, which was in fact the pay and digital TV subsidiary production of CCTV just before the promulgation of the Decree. This listed Hong Kong–based Universal Holding company, which now operates on satellite television (specializing in tourism), and includes film and television production also used RMB550 million to exchange with Beijing's private-state joint company Asian Union Film and Media half of its ownership with the intent of entering the Chinese film production and television business.

Giant global film companies also followed the lead. In October 2004, Warner Bros. Pictures of the U.S.-based transnational media conglomerate AOL Time Warner also formed the largest local Chinese film production and distribution company with the former state-organ China Film Group and Hengdian Group. Such joint ventures mainly provided more entertainment programs and movies to the rising middle class, given that foreign import of movies is still under restriction in China (*Wall Street Journal*, 2004, October 15) up to 2004. There were reports confirming that there were twenty-two media joint corporations setup with eight domestic media companies approved in 2003 and fourteen applications from local media companies approved in 2004. Hollywood also publicly announced plans to spend US$150 million (Feng, 2005, July 6). The China media partners were seen very active in this process to locate suitable foreign partners. In 2007, the China Film Group also collaborated with Hollywood's Crest Digital to form a joint corporation to bring in foreign content to be channeled in digital platforms—including the Internet, IPTV, Video on Demand (VOD) and mobile networks—for Chinese family households. A complex in suburban Beijing of 15,000 square meters would be built to develop the technical standards of the platforms. The collaboration can be regarded as a testing ground of China to get a "taste" of the highly regulated content such as films and documentaries (Ci, 2007, April 11).

Although there is no guarantee that the establishment of a joint company

automatically results in joint content production (Nickelodeon has been waiting for a broadcasting license for two years after the joint corporation was set up) the practical movement of foreign capital carries two implications. First, foreign capital perceives that the current media policy creates an opportunity although China's attitude toward them is a constant up and down seesaw. Second, despite being skeptical of globalization, the state also needs foreign capital and expertise in the development of its own market and media industry. In retrospect, media in China used to be the mouthpiece of the party. In the last decade, with the advent of a relative relaxation of the media over entertainment programs, the ownership, structure and organization of the media was still located within the media itself. In addition to its role as a party organ the unprecedented incorporation into the private sector and infusion of global capital has transformed the national media into a profit maker. However, the commercialization of the media does not mean that the state has relinquished control of the media, but only that the state has started to gear its control mechanism through more advanced economic rather than political means.

Toward a Symbiotic Collaboration

Rather than serving up the previous political goals, the entry of foreign capital into the local Chinese media resulted in the emergence of competition, which eventually pushed ecological as well as ideological changes. At the same time the authorities have not given up control. According to the spokesperson of the SARFT, Zhu, Hong, the entry of global capital does not mean that foreign companies can march into the mainland by importing global brands and cultures that outweigh and eventually displace local brands. Instead, the new regulations aim at setting up joint corporations that are to a certain extent symbiotic. Apart from fulfilling international expectations in the short term, the enhanced and more mature media production generated from the joint companies paves the way for national media productions to, in the long run, export programs that meet international standards. The cooperation between the SMG and the National Geographic Channel of the News Corporation—with the latter providing free television production in exchange of advertising rights and revenues—and between the various provincial television stations and Viacom's MTV China to produce localized mandarin-speaking entertainment and cultural programs again exemplifies the ultimate purpose of the state. Rather than passively accepting it, the latter

proactively co-opted the international media and absorbed its experience. In the entire process, I would emphasize that many of the interviewees of these global players have sensed that the state can gauge, manage and calculate the degree and extent to which the global ventures are autonomous. When the pendulum swings to the extreme, the authorities exercise provisional measures to control economic rewards. Despite the fact that the state has conceded to global capital, when economic interests conflict with political interests, the state readily suspends market rule by abrupt political force.

Quite often, political intervention occurred in the form of interim order or media policy. In March 2005, the SARFT issued an overriding regulation stating that the majority of foreign companies can only share a co-ownership with one Chinese media enterprise, while excluding from China's media market those foreign media companies labeled as having "non-friendly" relationships. The authorities announced publicly to all media, "There is a strong ideological quality in broadcasting and television program production. [We have to] understand the political affiliation and background of foreign [investors to] curb the influx of so called 'incorrect' beliefs and cultures in these joint ventures" (Oursee.com, 2005, December 29). While in the past the state simply banned the undesirable media and "overseas pollution," now the state can impose economic sanctions to effectively compel global capital to follow various social and political norms. Using these measures, the state exercises a "relaxation" policy that does not sacrifice its continued control. But on the whole, despite occasional setbacks, the direction of the state is to encourage collaborations.

Forms of Collaborations

Based on the reported cases, there are roughly five forms of global investments (partly quoted from Li, 2005). Two similar and less risky ones are market investment and risk investment. The former involve acquisition of shares of the major cultural and media industries upon the incorporation of the media in the stock market. For example, Beijing Youth Media listed on the Hong Kong stock exchange in 2004 and indirectly foreign capital was then able to extend into the mainland media. The current state-approved QFII was precisely one of the ways for global capital to invest in the A-listed stock media in China (Zhang, 2005). While the first type involves share acquisition, the second focuses on the high-risk investment mainly on the hardware or software technologies of the emerging media such as digital television, net

TV, pay TV, 3G mobile and other internet infrastructure.[1] Obviously, the acquisition of mainland media shares and capital investment in their infrastructure does not give any controlling and voting rights to investors from outside China.

The third type was the establishment of independent private corporations that operated on media-related business, which, among all the business types are primarily focused on advertising and other interactive services of the mobile business. These corporations resembled an advertising or marketing company for a particular program, an episode, a period or an entire channel of broadcasting media.[2] They source advertisers, promote the programs or the channels, and share advertising revenues with host television or radio stations. In fact, before any official endorsement, many of the Chinese city stations have secretly sold their airtime to these global players, of course, not to satisfy the wishes of the latter. Despite violations of official orders, many of these channels in fact made a fortune by selling, besides the advertising rights of the airtime, the rights of content production to those eager global players at an inflated price. Formally, in 2004, Xing Kong Television under Murdoch's News Corporation was the first state-approved foreign in-de-pen-dent private corporation primarily selling airtime and the content of their corporation to advertisers. For these high profile trading of advertising rights, such investment still comply to official order and does not include any content production. Sfx's Clear Channel, the largest sports program content provider, is also in active negotiation with a subsidiary company of the Ministry of Culture to set up a joint company to similarly buyout time slots in Chinese media to air their sports programs (interview with Kenneth Chang, Chief Operating Officer, Clear Channel Entertainment on July 29, 2005).

The fourth type of collaboration is the joint project under the strategic alliance or partnership with the global and Chinese media. In the realm of the film industry, with such state-local-global capital, projects can be considered that would be too expensive for either a local or even a national movie to handle. For example, in 2002, for the film *Hero*, which was a joint investment by Beijing New Picture and Hong Kong's Edko costing US$31 million screened on the mainland with RMB250 million in (US$1 = RMB8) ticket sales, and extended to southeastern Asian countries with around 10 million, then further to the United States with US$70 million ticket sales in 2,031 cinemas (Fung and Chan, 2006). In 2004, the joint production among the China Film Groups, Beijing's Huaji Film, Hong Kong's Star Overseas and

United States' Columbia Pictures also produced the recording-breaking movie *Xiaolin Soccer* grossing US$70 million in Asia. The Chinese market also scheduled annual projects such as the joint CCTV-Channel V and CCTV, SMG, and MTV Music Awards launched in Shanghai and Beijing, respectively. According to their content directors, the entire production was arranged and compiled by Viacom's MTV with the final list of honors approved by high-level CCTV personnel. This form of global involvement touches upon content production, the most important issue for a global capital. Despite the sensitivity of the content production, because most coproductions involve high-level national media and political decisions, even if there were worries from the hardliners purporting to hinder global investment, for example, the Regulation of Foreign Affairs Operation and Management on Broadcasting, Television and Film System which promulgated on July 6, 2005 (Lee, 2005)—an order which forbade the leasing of state-owed stations or channels to global capitals—the collaboration never ceases.

Overall, given that the above mentioned types are either very marginal to content production or that the content are under the direct command of the officials, they hardly constitute the favorable atmosphere for nourishing a relatively free and autonomous space for program production that embodies private, individual interests. The impasse in these types of collaboration foregrounds the importance of the new media policy, which cannot simply rest on its ground-breaking policy of allowing the registration of joint global-local corporations. In fact, there were known cases of overseas media controlling the Chinese media through two share-holding methods. First, despite the Regulation of Foreign Affairs Operation and Management on Broadcasting, Television and Film System, these foreign media perilously ignored it by contracting out the entire channel either directly or through an advertising company to a foreign investor. Previous examples have been with more marginally influential media, mainly, city radio stations, which are less monitored by the state, and their unlawful cooperation with foreign party has been mainly for economic benefit. The most prominent example is the Beijing Universal Chief Advertising Company. It was an enterprise with Taiwanese background that was contracted to operate the radio music portion of the China People's Station in Beijing. Besides the advertising business, the Taiwan cadres in essence repositioned the entire arts and culture channel to a music station targeting the youth population. Second, with high-level negotiations or *guanxi* on the government level, global media such as Murdoch's News Corporation was granted the privilege to co-own in the

Chinese media. The STAR TV News Corporation owned Channel V (87.5 percent), ESPN (50 percent), and National Geographic (66.7 percent) and more than 30 city and provincial cable stations producing television content. It also owned 38.25 percent of Phoenix TV that primarily targeted the Chinese market. Thus, rather than the revolutionary idea of allowing joint ventures and share-holding, the significance of the new policy lies in its direction of formalizing the global-local content productions in the name of joint global-local ventures. It is both a gesture of the state to allow globally produced content to flourish in China and also actively provide a safe strategy for the global media to "get their feet wet" in content production. This new form of collaboration also allows global capital to contribute their expertise and knowledge in media production, albeit with the important exclusion of news programming.

The Politics of Access

With the global media gradually doing more content production, the local control of content has been subsequently loosened. The local controllers are gradually displaced by producers of these global companies although the final approval is largely in the hands of the former. In parallel, the agenda of national interest should give way to audience taste and advertising preferences. The new program format and content will comprise interests of all sorts, entertainment, culture and arts and may be embedded with ideologies new to the Chinese audience, namely, consumer rights, ideas of citizenship and the principles of democracy. Even MTV's program "the chart of glory," a program featuring and honoring Chinese and international artists, takes into account the popular votes or wishes of the audience, which can be regarded as an implicit form of populism, if not a kind of democracy itself. This space could never have been conceived without the forces or influence of globalization. The recent change of China's locally produced program to build in voting mechanism or local contest to satisfy the expressive desires of the public can also be regarded as an indirect influence of the trend of globalization.

With content production infused with liberal and Western thought, the last citadel of PRC propaganda moves from the production to the distribution of media content. The public broadcasting rights of these programs are now mostly in the hands of the thousands of national, provincial and city television and radio stations which are still regarded as consigned state and party

content censors. It is not likely the PRC would allow private media owner-ship in the short distant future. There is no hope for a global player to come to China to distribute their cultural products by-passing the media control of the PRC. But alternatively, now the joint media corporations could choose to distribute their content via the direct sales of VCDs or DVDs through private independent distribution agents in China. However, as Xu, Zhongming, the owner of one of the largest distributors, Jingwen, said, the distribution of foreign or local VCD/DVD in the vast mainland is a very risky business and few distributors are bold enough to market international content (interview with Xu, Zhongming, General Manager, Jingwen Music on November 17, 2003). Currently, the Discovery Channel programs are distributed by Jing-wen (in the form of DVDs) but this is perhaps the sole successful case of private business in China. Yet, seeing the huge volume of 1 billion DVDs/VCDs sold with an annual growth of 30 percent—and despite the issue of piracy and politics with the government, many of the transnational players have not given up the venture into distribution business in China.[3] Now the involvement of global players in audiovisual product distribution is still in an infant stage. In February 2005, after two years of negotiation with the authorities, Time Warner decided to enter the market. Warner Family Video Company and the state-owned China Audio-Visual Publishing jointly set up the China Warner Family Entertainment Company distributing DVDs and VCDs in China with their headquarters in Shanghai (Sohu, 2005, February 25).

The Case of Warner Bros. Pictures

To illustrate how transnational media juxtapose their commercial strate-gies with China's shifting media policy and political intervention, it is worth tracing Warner Bros. Pictures' partial success in the Sino-venture battlefield. Warner Bros. Pictures is chosen as the case study in this chapter because by far and away it is the dominant global venture in China. This is also because during the negotiations in the run up to entering the WTO, the film industry was the sole area challenged. The localization of Warner Bros. Pictures represents the strategies of how a global player can establish their business in China; it also manifests the ambivalent attitudes of the Chinese authorities to global media capital, and hence the diverse facade of controls and modes of collaborations, which, are occasionally contradictory. During WTO negotia-tions, China had long conceded that upon China's entry into the WTO, 20

U.S. movie imports would be allowed entry into China, the revenues of which could be shared between the Chinese cinemas and the U.S. companies involved. Additionally it was agreed that within the first three years, the right of distribution would be provisionally entrusted to Chinese distributors hinting that in the future foreign players can establish their own distribution network. In the negotiations, the "breakthrough" for the United States was China's concession to allow the United States to build cinemas with a 50 percent U.S. ownership. In the eyes of the authorities, the major problem is then how to, first, in the face of the outside competitors, protect their fragile and immature film industries, which historically operated as a state apparatus without much market support (Guo, 2002, January 16), and, second, how to let the transnational capital operate in the mainland in a way which did not erode the interests of the former national industries, and above all to operate in a manner which did not shake the political status quo.

A major reshuffle of this state industry first occurred in February 1999 when the State Administration of Radio, Film and Television incorporated the film related business, forming the China Film Corporation under the approval of the People's Congress of China. The corporation could be regarded as the reforming engine prepared to absorb the shocks related to the arrival of global capital. Its eight subsidiaries streamlined all the business operations, including production, distribution and screening. Also, the importation of filming hardware as well as the arrangement of filming sites was also under the jurisdiction of the Corporation. The conglomerate is in essence a pseudo-official unit that manages the entire industry. Based on Vincent Mosco's (1996) classification, it is a process of spatialization in which the conglomerate integrated companies vertically and spatially, eliminating deadlocks that were not conducive to its growth in the hopes of increasing the competitive power of the company. In the "second reform" of the film industry between 2003 and 2004 other local players were officially allowed to operate, ending the 50-year monopoly of China Film Group Corporation (formerly China Film Corporation). In October 2003, the PRC decreed the "Interim Regulation in Film Industry Operation Entry Requirement" which, for the PRC, pioneered the procedures and conditions for applications by global investors. Among these changes the most vital decision was to allow foreign companies to own less than 49 percent of the joint corporation film industry and for the very first time releasing control over content. In September 2003, the SARFT also promulgated "Interim Regulations for Foreign Investors on Theatres" and "China and Foreign Joint

Film Shooting and Production" further specifying the rules for global players on investments in Chinese theatre and filming operations. All these rules seemed to have paved the way for Warner Bros. Pictures under Time Warner Inc. to enter the Chinese market (Yang, 2004, October 30).

In October 2004, Warner Bros. Pictures (30 percent of share), the state-owned China Film Group (40 percent) and a local private filmmaker Hengdian Group (30 percent) formed the largest national Chinese film production and distribution company, Warner China Film HG Corp. The question remains as to why Warner Bros. Pictures was the "chosen one." One reason was that this global giant in fact actively assisted China in bridging the international conventions system on the film industry and thus it is logically followed that the PRC could rely on Warner to bring it out to the world. In 1995, Warner first introduced the sharing model with and for the China Film Corporation airing *Fugitive* in the national cinemas. Since then, China's cinemas followed the internationally compatible business formula of taking 42 percent (up to 50 percent depending on the movie) of the ticket sales while global productions could also enjoy 38 percent (not exceeding 40 percent) of the monetary benefit (interview with Geng, Xilin, Assistant to the Director, China Film Group on April 11, 2007).[4] In other words, global capital had helped to refix the socialist political order to a capitalist system of operation and connect China back to the international network. The decision to congenially partner with Warner is an extension of the policy. This understanding is important because it rationalizes the Chinese move to open its market to global power; otherwise the Sino-Western collaborations could be seen as the PRC's bowing to the international pressure or any formal or informal agreement accompanied with the WTO entry. Before China was connected to the global circuit, in which the operational convention was that Hollywood production shared a certain percentage of revenue when a movie of their production was distributed to a country, China was barred from legally importing movies from the seven international film giants, namely, Warner, Sony/Columbia, Fox, Metro-Goldwyn-Mayer (MGM), Disney/Buena Vista, Paramount, and Universal.

The Omnipotent State-Global Complex

Of course, Warner's actual participation in national cinema was also a partial fulfillment of the WTO promise for opening the China market to U.S. films. But practically, the Chinese counterpart really needed a global giant of

equivalent status to establish this collaboration. The formation of the new troika that was Warner China Film HG Corp. (unlike many other project-based collaborations) was not token. Before the second reform relented to global involvement, the China Film Corporation basically had the omnipotent power to handle importation of foreign movies, television programs and other audiovisual products as well as the rights of exporting Chinese movies overseas with its subsidiary branch Merchandising & Rights Licensing Company established in 1986. The Corporation was in charge of all operations involving overseas players. But now, the Warner China Film HG Corp. had inherited almost the entire rights for operations, production and distribution.

At this point, China's policy on the film industry for transnational companies is different from its attitudes toward global records as outlined in Chapter 3. For a long time the bottleneck for locally operating transnational records were restraints under the command of the national media and distribution network. Now the global film company was imbued with greater power, including handling imports, managing the shooting sites (in a town called Hengdian) and coproduction that is bestowed with the status of a national film, meaning no subsequent control in national screening. This is an active strategy planned government authorities (interview with Hu, Min, Manager, Warner China Film HG Corp. on April 5, 2007). The policy has elevated the status of the chosen global partner but has done so in a way so as not to denigrate the status of the China Film Group. It is in short the top-down policy of the state to enhance the formation of this state-global complex. At the end of 2006 the film *The Painted Veil* was the first experiment produced by an American director on Chinese soil under the auspices of the new corporation with Chinese funding. Although it was far from having a satisfying box office resulting in only RMB2 million ticket sales during the ten days of screening, the significance is symbolic. Global capital was the first company allowed to produce a film in China with virtually no Chinese surveillance.

This policy emerged not as one subservient to the WTO but as part of building a national empire which has the power to globalize. It was not created for the sake of commercial interests, but international influence (interview with Zhai, Yue, former assistant to the manager, Beijing Polybona Film Publishing on March 31, 2007). In recent years, with heavy investment, China has strategically marketed their movies overseas, sometimes airing in European and American theatres, and more commonly, making an effort to

attend international awards such as Cannes (*House of Flying Daggers*, 2004) and the Golden Globe Awards (e.g., *Xiaolin Soccer,* 2004), *The Promise*, 2006). In some cases, the China Film Group was involved, including *Xiaolin Soccer* (collaboration with Columbia) and *The Promise* (which is by far the highest cost Chinese film at RMB150 million), and in other cases big newly rising film companies such as *Kekexili: Mountain Patrol*, which is a coproduction between Huayi and Taihe Investment Film Company, a private company with close governmental ties and the United States' Columbia with a total investment of US$1.2 million. These movies help construct the image of a rising Chinese. By this open policy for global capital on film, China actually restates its national mission with a twist: globalization of the Chinese market is not incompatible with the contemporary Chinese national mission at all.

Swinging Policy for Global Cinemas

The policy for foreign investment on cinemas in China is highly complicated. There was almost a complete relaxation for global capital but it was only skin-deep. In a nutshell, a short honeymoon period for foreign investment after September 2003 under the banner of the "Interim Regulations for Foreign Investors on Theatres" overrode all the previous controls on cinema funding. It even deserted the previous policy in 2000 which only allowed foreign investors to own a maximum 49 percent of the theaters. As an incentive for global investment, the state lowered the registration fee from RMB10 million to RMB6 million. While in most cities Chinese control was still 51 percent, seven cities (Beijing, Shanghai, Guangzhou, Chengdu, Xian, Wuhan, and Nanjing).were selected as the testing ports for global capital which could hold 75 percent of a cinema accommodating 2,000 people (Feng, 2006). More important, the state was not so adamant about only allowing the Chinese owners to dictate cinema management rights.

Nevertheless, this period soon fizzled out as the would-be global cinemas triggered a row over the controlling power for cinema operations. A new policy in 2005 was then promulgated to regain some of the territories that the authorities had previously conceded to global capital. It could be argued that the flimsy excuse of retightening the policy was actually political pressure from the party. That might be true, but it was more probable that the authorities "felt" the problem of a nonlocalizing global capital would eventually harm the formation of the global-state complex. During the two years when

global capital commanded the cinemas, they incurred huge losses (RMB5 million in 2005) upon the Chinese partner and a Property investment company Dalian Wanda because, in the deal, the latter was responsible for investment in the cinema while the management was from Warner Bros. (*Economic Observer*, 2006, November 21). The new policy convinced Warner to return to state monitoring.

Once global players have "autonomy," they get deflected away from the original purpose of localizing business in China. Given the right to manage the joint operations, the Warner cinemas operated entirely on the Western model. This caused an intense conflict with the local partner, resulting in collective resignations of 16 staff and the former deputy CEO of the Warner Bros. International Cinema. The imposition of Western management did not always fit with the norms of the Chinese audience. In this case the audiences began bringing in their own food and drinks rather than buying the overpriced ones in the cinema complex. They also tended to stay in the complex for the entire day with a single ticket and while audiences could barely reach one-third of the seating capacity, Warner insisted on coscreening in 7 theaters with 2,300 seats (Wang, 2006, November 28). In December 2005, after less than two years of cooperation, the two joint cinemas in Tianjin and Wuhan were renamed from Warner Bros. to Dalian Wanda. The renaming from Warner Bros. to Dalian Wanda essentially means the management right of the cinemas goes back to the local Chinese investors, formally ending the joint Sino-global cooperation.

However, as the Chinese authorities have previously pushed and are still promoting joint global cooperation, it appears that the sudden pull out of Warner contradicts to the Chinese policy and direction of the Chinese media policy. To explain this, I would suggest that the termination of the cooperation was not purely triggered by political decision or intervention. There was a practical drawback to Warner's Western model at a time when they were not compelled to localize: the realistic concern for the Chinese authorities was that the global-state complex could not benefit from the market, thereby deviating from the original purpose of the state to steer their previously political apparatus to a market-oriented media which would have the capability to compete with global powers. It was no longer an ideological issue, but a failure to match national policy to eventually globalize.

A Brave New World

Many scholars (e.g., Lee, 2003; He, 2000; Zhao, 1998) argue that the media controls in China are in a constant oscillating stage, sometimes tight and sometimes loose. This seems also to be the case for the Chinese film policy toward global capital. But to look deeper into the issue, this argument is not entirely correct. Unlike the old days in which various policies are dictated by internal political struggles, today's policy is more underpinned by the national mission. The state's attitude toward Warner in this is quite consistent. The state is not at odds with the global so far as the latter marshal the state out of the past and step onto the global stage. The sudden reverse in policy to reclaim power back from Warner can be regarded as a conscious attempt not to let the global-state complex lose control. The intervention is also an effort not to let a single high profit joint global-state endeavor from deteriorating into another defunct state enterprise suffering from economic inefficiency. With a vigilant eye on the joint project, the state in fact attempted to lead the former back on track.

After Warner returned shares of the cinema back to the state—and they were formally acquired by China Film Group—the state soon rewarded Warner the privilege of joint cooperation with Warner China Film HG. In any sense, Warner remains the most significant global player in the Chinese territory and more important one that the state trusts. As a global player, their determination has not curbed by this oscillating policy setback and they have been observant and ever alert to the state's agenda. In the eyes of the authorities, as Hu, Min, Vice General Manager, Warner China Film HG Corporation indicated, "it is not likely" that the state would seek another global power at this stage (interview on April 5, 2007). The state continues to require a global player to modernize and partner itself into a brave new global world. The success of Warner China Film HG then depends on whether this new state-global complex can distinguish itself from the outmoded state-owned film corporations to successfully touch the sentiments of the Chinese populace.

Conclusion: From Resistance to Collaboration

This chapter illustrates evolving Chinese policy in the face of an opening Chinese market. Upon entry into the WTO, China has made concrete, positive changes and although it appears to oscillate between control and relaxation in the area of foreign media investment, changes in this area are

not simply China's concession to global power or tokens to fulfill its duty as a member of the WTO. From the PRC's point of view, the Chinese media will continue to absorb the Western mode, experience, management and operation and the strategies of the global media. At this point, the PRC's strategy has changed, from passively setting up barriers with which to curb global cultural importation, to actively and strategically embracing the changes to create a beneficial situation for its own media. Instead of continuing control, the authorities chose to collaborate with foreign media companies.

The global media has now begun investment in China and accelerated its localization process. Given the transparency of formal channels by formal decree, laws or interim agreements, there is now no need to challenge the PRC in international politics regarding the market. Neither do they need to risk stepping into the Chinese market without formal approval. The temporary relaxation of the media policy and the subsequent formal, case-by-case collaboration of the Chinese media with the global media capital has been a win-win situation for both the authorities and for global capital. For the state, with the hidden agenda to incubate its own media, the authorities have devised a policy to co-opt the global capital that will indirectly shelter the growth of the national media. After various forms of trials, the most stable is a kind of state-global joint corporation or complex which, as illustrated with the film industries in China, then becomes a meta-national power. From the view of global capital, they understand that the state must act to swiftly accelerate localization. The newly formed China Warner Film HG is the embodiment of a strategy designed to marry the national media with the major global media on an international level.

Notes

1. These new media are of higher risk because they were controlled by many other departments besides the Ministry of Culture. The change of policies was frequent and often unpredictable.

2. The control over the entire channel is more frequent in the Guangdong radio stations.

3. In fact, the only prominent international player that partakes in the distribution business is EMI that operates with its music distribution arm PSH Typhoon.

4. In ticket sales, besides the profit tax, 5 percent has to go to a government fund for the development of the film industry in China.

References

Ci, Mingzi (2007, April 11) China Film Group Announced Cooperation on Digital Media with Hollywood. http://www.runsky.com/news/2007-04/11/content_948208.htm. Accessed on April 24, 2007.

Economic Observer (2006, November 21) The Retreat of Warner Bros Picture: Don't Operate for the sake of the Policy. People.com.cn. http://mnc.people.com.cn/GB/54823/5068856.html. Accessed on December 12, 2007.

Feng, Jie (2006, November 8) The Big Retreat of Warner Bros Pictures, A Big Shock of the National Market http://www.cnwnews.com/Html/info_qygz/2006-11/8/1843548048.html. Accessed on December 13, 2007.

Feng, Weining (2005, July 6) Qiongqing Morning Post Quoting *New York Times*: Hollywood Investing 1.2 billion in China Film Market. Sina.com.hk. http://movie.sina.com.hk/cgi-bin/mv/nw/show.cgi?id=37407. Accessed on April 24, 2007.

Fung, Anthony (2006) "Think Globally, Act Locally": MTV's Rendezvous with China. *Global Media and Communication* 2: 22–88.

Fung, Anthony and Joseph Chan (2006) Toward a Global Blockbuster: The Political Economy of Nationalism of *Hero*, International Film Workshop on Hero: Anatomy of a Chinese Blockbuster. University of Nottingham, Ningbo, China, April 13–15.

Guo, Qubo (2002, January, 16) What Is the Impact of WTO Entry for Chinese Films? Filmse.com. http://www/filmsea/com.cn/focus/article/200201160006.htm. Accessed on May 1, 2007.

He, Zhou (2000) Chinese Communist Party Press in a Tug of War: A Political Economy Analysis of the Shenzhen Special Zone Daily. In Chin-Chuan Lee (ed.), *Power, Money, and Media: Communication Patterns*

and Bureaucratic Control in Cultural China. Evanston, IL: Northwestern University Press, pp. 112–151.

Lee, Chin-Chuan (ed.) (2003) *Chinese Media, Global Contexts.* New York: RoutledgeCurzon.

Lee, Don (2005, September 21) China Gets Tougher on Foreign Media. *LA Times,* http://www.danwei.org/breaking_news/disney_and_news_corp_in_tears.php. Accessed on July 10, 2006.

Li, C.J. (2005, July 31) Foreign Investment in China's Television Industry. New China Media Workshop. http://211.147.225.32/gate/big5/www.jxtb.gov.cn/news/files/0501/050123_09 2928.php. Accessed on June 13, 2006.

Meier, Werner A. and Josef Trappel (1998) Media Concentration and the Public Interest. In Denise McQuail and Karen Siune (eds.), *Media Policy: Convergence, Concentration & Commerce.* Thousand Oaks, CA: Sage, pp. 38–59.

Mosco, Vincent (1996) *The Political Economy of Communication.* Thousand Oaks, CA: Sage.

Oursee.com (2005, December 29) Foreign Media Discover China: An Eventual Start. http://www.oursee.com/html/waizi/2005_12_29_02_15_552.html. Accessed on June 11, 2006.

Sarikakis, Katharine (2005) Defending Communicative Spaces: The Remits and Limits of the European Parliament. *Gazette* 67 (2): 155–172.

Shi, Anbin (2005) The Taming of the Shrew: Global Media in a Chinese Perspective. *Global Media and Communication* 1 (1): 33–36.

Sohu.com (2005, February 25) The Entry of Warner Family Video Landed into China; Hopes to Increase Sale Volume of Audio Visual Product. http://yule.sohu.com/20050225/n224435688.shtml. Accessed on May 16,

2008.

Wall Street Journal (2004). Warner Bros Formed the First Joint Film Venture in China. http://republicmedia.org/archives/000133.php. Accessed on April 24, 2007.

Wang, Lin (2006, November 28) The Truth Why Warner Withdrew from China. *Economic Observer.*
http://www.226e.net/article/78/Article25716_1.htm. Accessed on May 12, 2008.

Yang, Linhua (2004, October 30) Warner Bros Entered the Sensitive Area of Chinese Film Industry. http://news2.eastmoney.com/041030,191037.html. Accessed on May 2, 2007

Zhang, Yanyan (2005, January 10). 12 Cultural Industries Will Be Listed in the Stock National and Foreign Market within 5 Years.
http://finance.sina.com.hk/cgi-bin/news/show_news.cgi?ct=china&type=eco nomy&date=2005-01-10&id=101363. Accessed on June 13, 2006.

Zhao, Yuezhi (1998) *Media, Market, and Democracy in China: Between the Party Line and the Bottom Line.* Urbana-Champaign, IL: University of Illinois Press.

A Tale of Two Localizing Global Capitals: MTV and Channel V

This chapter analyzes case studies of how the transnational media operate in China with Channel V (the Rupert Murdoch owned music channel for STAR TV and News Corporation) and MTV. These companies are the only two giant media that are allowed to operate "full scale" in the PRC where ideological control is still a significant barrier to foreign capital and joint business ventures. The chapter describes how transnational culture corporations have been extending their empire in China by two similar but somewhat different strategies of localization. Following interviews with Channel V Newscorp and Viacom MTV personnel, onsite observations of their program productions in Beijing, Shanghai, and Guangzhou (South China), and textual analysis of their programs, this chapter illustrates how the two giants juggle economic and political constraints to localize their business.

Most academic studies assert that authoritarian governments operate with clearly demarcated barriers to prevent "Westernization" and are therefore reluctant to relax the entry of foreign capital into the culture industry, but this chapter argues that the state apparatuses in China, namely, CCTV and SMG are now flexible enough to work closely with global capital to produce local popular culture. In other words, from a political economy perspective, the Chinese media have started to tune in to global capitalism to maximize its profit and market. However, this does not mean that the party organs have abandoned either propaganda or their ideological mission. The post-WTO free market situation in fact finds that the state via the Chinese media has availed itself of the opportunity to partner with foreign media to promote the nation's image and culture. In this sense, the political and economic forces of the state have combined with global capital in a symbiotic relationship. The state works to accelerate the localization of transnational culture while the latter promotes it. Apart from the same partnership found in the global music and transnational media industries, this chapter examines a media business that although guaranteed huge market is not very much driven by commercial decisions. Rather, popular culture and the operations of these transnational capitals are often the consequence of political negotiation and compromise decisions. Through this cooperation, the state is not only able to popularize its ideology and culture but also create a benchmark for other culture industries that are intent on capitalizing the China market.

The Political Factor of China Entry

With the saturated market in the West, global transnational corporations have been eyeing the potential in the China market since the 1990s. Summer Redstone (Viacom) and Rupert Murdoch (News Corporation) are undeniably the first two—and still the only two—media moguls to pioneer the China market. Murdoch, who owned the third largest media corporation in the world (after Time Warner and Disney)—including Twentieth Century Fox Studios that has occupied the largest film market, major cable networks and television channels, 175 magazines and newspapers—chose to enter China by acquiring the STAR Group in Asia. In 2004, Newscorp had a global revenue of US$7.84 billion with a net profit of US$822 million (Daurat, 2007, February 8). China revenues are believed to be a small fraction of this total empire.

STAR Group's presence in China is marked by three major entertainment arms of Channel V China (discussed in detail in this chapter), Xing Kong Satellite Television (which is the Chinese HBO and shows both Chinese and Western movies), and Phoenix TV. Phoenix TV is a subsidiary of Murdoch's STAR Group that owned 38 percent of its shares and the operation is in fact managed by its partner Chinese tycoon Liu, Changle, CEO of Phoenix, who had close relationship with the Chinese authorities. By allowing his Chinese partner to own controlling share, Murdoch managed to have a subsidiary of its News Corporation break even in its fifth year of operation. STAR's entertainment channels are now being broadcasted on Guangdong's cable network and Chinese audiences can also watch programs from five of its channels, including the Channel V music channel, the Star sports channel, Star Cinema, ESPN, and the National Geographic Channel.

Viacom also first entered China through its major entertainment arm. As the top global media player in broadcast and cable television, radio, outdoor advertising, and online with Viacom.com—covering content creation, distribution of entertainment, news, sports, music, and comedy[1]—it chose popular music via MTV Asia to enter the China market. MTV Asia covers three regional channels, MTV Mandarin, MTV southeast Asia, and MTV India, which, according to MTV's official figures, reaches over 124 million households in 21 territories. In China, Viacom derives the biggest part of its revenue from advertising, followed by the consumer products division and digital media mainly via its MTV Channel. In 1996, it was reported that it had a revenue growth of over 20 percent and Asia counted for 15 percent of

the entire group's global revenue, though the amount represented a tiny fraction of the company's annual US$6 billion revenue (*South China Morning Post*, 2006, July 3).

Since the 1990s, Viacom's Chinese language MTV (Mandarin) inaugurated on April 21, 1995, which along with its precursor Channel V from Murdoch's News Corporation are still the only two foreign-owned music channels in China. These media giants give the transnational media a glimmer of hope for their own China entries. Following their lead, U.S. AOL-Time Warner acquired China Entertainment Television (CETV) in June 2000 and eventually sold a 64 percent stake in the TV company to Asia's richest man and the ninth richest man in the world, Ka-shing Li's Internet, publishing and advertising group, Tom.com with a return of US$6.8 million. This business history suggests that, without the close working political relationships with China (as Li has),[2] the entry of transnational media into China can be problematic.

Murdoch paid his first visit to China in spring 1985. In the early 1990s, with Hong Kong as springboard, he started to extend his empire into the Chinese world. In 1992, Newscorp acquired 50.1 percent of the *South China Morning Post*, the most influential English language newspaper in Hong Kong and a regional icon, and in 1993, he used US$500 million to buy 63.6 percent of STAR TV, purchasing the company in full in 1995. The smooth acquisition of this China-targeted media (STAR TV transmits into China from Hong Kong) signified China's implicit approval of foreign capital's influx into the Chinese culture market (Fung and Lee, 1994). After the acquisition in 1994, News Corporation ceased broadcasting the BBC World Service Television to China via STAR TV. This was a period in which the BBC featured China's violation of human rights. The move was Murdoch's conciliatory gesture after he angered Chinese authorities by remarking that the PRC was a dictatorship. The latter caused Beijing to tighten controls on private ownership of satellite dishes, which, in the hands of its previous owners the Li family, was a nonissue. Considering China's policy on the foreign media and despite cultural critics who are against "media toadies," from a political economy analysis Murdoch made a legitimate commercial decision. Transnational corporations that seek to operate in China are challenged and must on occasion subordinate principles and ethical values. More recent cases involve Microsoft and Internet giant Yahoo that had to meet PRC political demands. In June 2005, Microsoft had to censor its blogs to comply with Chinese local restrictions and censorship on the Internet. In

September 2005, Yahoo was reported—ironically widely on the BBC—for supplying information about a journalist's e-mail account to the Chinese authorities that led to his arrest for allegedly "divulging state secrets" (BBC, 2005, September 7).

In 1993, Rupert Murdoch made his second pilgrimage to China and negotiated with the China Film Group. At the time China had a quota of 20 foreign films per year and he was able to secure part of this for Fox's film market. From 1995 to 2001, it was estimated that the 11 movies shown in China were worth RMB624 million. What is monumental in terms of localization is not the amount of monetary return that Newscorp received; a key factor in such global ventures is the political affirmation that the Chinese authorities bestowed. On December 11, 1998, when the former party leader Jiang, Zimen met Rupert Murdoch in Beijing, Jiang publicly praised Newscorp's role in "enabling the world to know more about China and enabling China to know more about the world." The political affirmation boosted Murdoch's confidence in the US$42 billion STAR Group. This confirms the theoretical model suggested in Chapter 2: that without prior political "clearance," there is no viable commercial activity.

For Viacom, the political pilgrimage to China started in 1999. What is ironic is that in the same year, Viacom spent US$37.3 billion to merge with CBS, the network in which the Chinese President Jiang, Zimen accepted an interview with Mike Wallace on the program *60 Minutes* in August. Jiang himself mentioned repeatedly this unprecedented interview in front of Chinese reporters. Then, in September 1999, in the midst of China's vicious crackdown on the dissident Falungong movement, Chairman and CEO of Viacom Sumner Redstone visited Shanghai for a seminar hosted by *Fortune* magazine—owned by another global giant Time Warner—and more importantly keynoted by President Jiang. Up until 2004, Redstone, the 81-year-old media tycoon, had already visited Beijing and Shanghai four times. During the fourth visit, he closed his partnership deal with Shanghai Media Group. After the visit, to the delight of the Beijing government and reversing the entire egotistical American discourse on China, Redstone portentously asked for the media to harness its coverage of China:

> As they expand their global reach, media companies must be aware of the politics and attitudes of the governments where we operate... Journalistic integrity must prevail in the final analysis. But that doesn't mean that journalistic integrity should

be exercised in a way that is unnecessarily offensive to the countries in which you operate. (Schechter, 2000, May 30)

Given that China forbids foreign news carriers operating on the mainland, Viacom's news network was guaranteed an audience. Redstone, however, chose MTV Music Television as the less politically sensitive medium for the China market. Since its inauguration in 1981, it has extended its arm internationally to more than 340 million households in 140 countries via 31 localized TV channels and 17 Web sites. China is perhaps the latest and the biggest market to come.

Music Television: Channel V and MTV

For both global players, music television was the main vehicle chosen for China entry. For traditional political economists (e.g., Hamelink, 1983), there is an unease regarding the seemingly unilateral foreign intrusions that could amount to cultural imperialism. As a matter of fact, though, music video was not new for the Chinese audience. CCTV—the official mouthpiece of China—uses music video, mainly folksongs called "main melody," to bombard the population for the sake of propaganda and despite switching to some "soft" forms with singers in military costumes, glorifying national unity, multiculturalism and patriotic gaiety are not uncommon in these music videos—a legacy from the Cultural Revolution where the state apparatus Shanghai and Beijing Film Studios compiled video tracks echoing the monolithic communist theme of proletarian struggle. In the local music business in the 1980s–1990s—despite setbacks and unpopularity—producers clung to the hope of using comparatively high budgets (up to RMB200,000 for an album of 1–2 selected songs) to produce music videos for CCTV public airing (interview with Zhou, Yaping, senior music producer on November 6, 2003). Thus, what Viacom and Channel V brought China represented a popular version of what had previously been an official and fading medium. Global corporations believed that the Western-packaged music video could create market opportunities with the new Chinese generation.

At the outset, Channel V was a joint testing and experimental vehicle for major global culture corporations seeking to crack the China market. It was originally owned by the major music labels, largely by one of the Big 5, UK's EMI. It also meant creating another global music channel to compete

with Viacom's MTV Channel, which was primarily owned by American Universal Music, another Big Five music corporation. As one of the major nonnews platforms to enter China, Newscorp had to fine-tune its position and strategy (interview with Li, Dai, the former managing director, Channel V China on December 20, 2003, Gia Pai, Production Director, and Eric Li, Marketing director of Channel V on March 16, 2004). Now, it is one of the 23 media brands in entertainment and information of the STAR Group with 6 branches covering 53 countries including India, Australia, Korea, Thailand, Taiwan, mainland China, and the International Channel for the Western market. Channel V China (subsequently called Channel V) began to extend its services in China in August 1995, a period when China was still ambiguous about foreign satellite broadcasts. In 1998, as Murdoch developed a trust between the leadership and the corporation, Channel V collaborated with different local television channels to produce programs such as V entertainment news, Chinese Music Top 20, and V Face to Face. It also joined 40 local cable and satellite TV stations to form the "National TV music network." In May 2002, it moved its headquarters from the former British colony of Hong Kong to Shanghai, a milestone that formally announced the presence of Channel V in Asia.

Following Channel V's successful Chinese entry in the late 1990s, MTV experimented with more or less the same format in China, and thus in the early days they made a public impression that they were a copycat of Channel V. With reception confined to three-star-ranked hotels and restricted districts for foreigners and overseas travelers, this strict policy initially was an impediment to MTV Channel. Before the formal establishment of MTV China in 2003, they secured their base in Singapore with MTV Networks Asia in 1996 and the MTV Asia Award as an annual big media event for artists in Asia.[3] Consistent with Redstone's explicitly friendly attitude toward China, and despite bringing in Western programs, MTV restrained itself from campaigning against the state for a complete restriction-free acceptance in China. Rather, they used their successful Korean experience of localization in creating animated Korean characters strongly embedded with indigenous cultural elements to replicate the strategy in China. Their programs were mainly Western elements sandwiched between Chinese television programs, the main 60-minute MV program MTV Global Village (Tian Lai Cun), MTV Star Profile (Mingxing Dangan) featuring movie artist anecdotes, MTV Chart of Glory (Guangrong Bang), a synopsis of movie and music charts across the globe, and MTV Learning English (Xue yingyu) that teaches "cool" English

with MVs. This programming mixed Chinese and Western music videos at a 7 to 3 ratio for the China, Hong Kong, and Taiwan markets (interview with Marilyn Wu, the Marketing and Communication Director of Viacom China on April 23, 2004). With the global slogan "think globally, act locally," together with a localization strategy successfully implemented in many parts of the world,[4] namely "local people, local program," MTV sold their made-in-China indigenous, but modernly syndicated programs to stations in different Chinese cities.

When global capital arrived in China in the late 1990s, prior to the authorization of joint companies, the more plausible localization model was joint collaboration on production. It was on this basis that MTV Channel and Channel V localized in China. The advantage of such a collaboration was ostensibly the clearance of bureaucratic obstacles such as regulations governing production and the distribution of foreign companies and licenses concerning public performances that are the core elements of the entertainment industry, hence enhancing the efficiency of the localization of foreign capital (Gershon, 1997). Collaboration with the state also reaffirmed their "status" in China. Nowadays, such collaboration evidences the fact that they are highly regarded by the Chinese authorities. Channel V cooperated with the official CCTV media to launch the annual Channel V Music Awards in Beijing. MTV also cooperated with CCTV to produce the CCTV-MTV Music Awards in Beijing and later with SMG to produce the Style Awards in Shanghai.

Politics of Cultural Localization

The entire problematic of the localization of these global media companies hinges on the ability to produce content in a foreign nation. In general, such localization takes place on two levels. On the one hand, the transnational corporations cooperate with the local/national culture and ideology to work closely with the local media. The localization involves working with the party organs such as CCTV and SMG, and also the other media partners (e.g., Netease.com for Channel V, Sohu.com for Channel V) to establish some form of global-state alliance. On the other hand, the cultural content produced involves mixing Western and Chinese style and using form and ideologies in different ways. Channel V and MTV Channel employ different strategies to accomplish localization.

The resulting content must be popular, modern, and trendy but a more

decisive paramcter is that the political ideology brought along with the foreign culture must be acceptable. Global media must take into account both capacities. First, it involves the know-how to produce content that fits the local tastes. Commercially, it involves the importation of foreign music videos from Western and other Asian cities—which carry Western values, music forms, and styles—but it has to be produced in the Chinese language. Second, the localized program should acquiesce to the baseline set by the authorities for the airing of politically provocative content. For global capital, they cannot risk testing this baseline lest the antihegemonic content—which in other Chinese media reflects the degree of liberalization of the Chinese authorities (Chan and Qiu, 2001)—becomes the swan song of the state-global collaboration. Interlocking control mechanisms for the transnational media involves three main areas, namely, the source of capital, the reception, and the content (Tang, 2003: 6). What the authorities offered to the two global players was no less than an exemption, though not complete and nonlimiting, to this control. The companies sought to extend these privileges by localizing their business, becoming commercially viable and at the same time adhering to a strict political standard.

However, it was a mammoth task requiring a number of twists just to locate the principles. For Channel V, initially starting out with a strong team of Taiwanese producers and executives, they located their headquarters in Taiwan, a hub for Chinese Mandarin music. The strategy was to have a Taiwan music focus with a small Hong Kong taste. The non-Chinese foreign media content from "free and liberal zones" were thought to be as revealing and popular as the alluring charms of "mundane voices" or pop music from Taiwan and Hong Kong. Looking back on this premature decision, even the person-in-charge who imported such foreign content nowadays also agrees that such dislocation of content from the market and the culture was a true Achilles' heel. The taken for granted notion that people who lived under an authoritarian regime must covet foreign, nonlocalized content was proven to be a misconception. In 1995 Channel V quickly changed track and started to include in their "dislocated" local content a program named "Very Chinese" that featured Chinese bands, mainly Beijing rock and roll music and new rock (interview with Shao, I Te, the former production manager of Channel V and the former manager of EMI, Beijing office, December 1, 2003). While this program had a strong appeal for those looking for alternatives, it represented a tiny portion of the overall imported content. What was lethal, as it turns out, was that the tastes and urges inherent to rock and

roll is exactly what the Chinese authorities find intolerable. Even today, fading rock and roll band legends are not allowed to be thematically featured on Chinese television. This also explains why there was no mention of transnational records (Chapter 3) nourishing the local music industries by using rock and roll.

Channel V gradually recognized the need to readjust their strategies to center their attention on creating a kind of nonconfrontational Chinese music culture appropriate for the China market. This new approach was not peripheral to other Chinese regions. With the motto "Made in China, It doesn't work without you" (zhongguozhizao, meinibuxing), Channel V, instead of bringing foreign content, produced localized music by developing local content with local staff. The production of local culture also involves the expertise and experience of overseas staff and relies very much on the commonsense wisdom of local employees. Thus, making an astute move, Rupert Murdoch also relinquished the chief executive officer of Channel V to a Chinese with the idea of giving back the Asian sky to Asian—a clearly thought-out localization strategy. In 2003 the production department hired 17 people with half the number coming from the mainland. The staff caters to different cities using diverse promotional and marketing strategies with events ranging from college settings to some mini-indoor concerts.

With local personnel having an in-depth knowledge of the regional cultures in China, the promotional activities of Channel V have been growing more "micro." A major annual event is a multicity series called Channel V Face to Face, where fans gather and Channel V provides a platform for the audience to meet their idols in person. In each city, Channel V partners with the local station to produce the show. Programs are then broadcast on respective local channels (interview with Gia Pai, Production Manager of Channel V on March 16, 2004). For Viacom, its initial step was the same as the current Channel V strategy of reaching the China market through political means and bypassing legal barriers with official relationships developed by its chairman and CEO. Li, Yifei, the chairman of MTV China, sees their route to localization through collaboration with the local capital and local media (Li, 2003: 178), in particular, dealings with those having the official status necessary to bypass various legal barriers. In 2003, it finally received permission from the authorities to operate a Guangdong television channel. It also became the first international media allowed to reach audiences through direct broadcasting.

However, before their formal license for MTV China was granted, they experimented with a new localization strategy. MTV Channel indigenized their programs under the motto of its transnational empire "content is the king," a slogan championed by Redstone. Notwithstanding this approach, Li, Yifei cautiously steered the China operation in producing foreign-cum-Chinese products with "Chinese characteristics." With their huge pool of music videos overseas, MTV repackaged them into its four program formats and used a Chinese VJ to present the theme for each program. In terms of form, the content is Western videos sandwiched between Chinese ones. In terms of ideologies, the symbolic meaning and values associated with the localized MTV program is still not local. This is done so deliberately to sell MTV as a modern symbol of the capitalist West. For example, MTV Global Village is a typical 60-minute program used to introduce foreign popular music infotainment to the Chinese audience while MTV Star Profile is a program that spotlights internationally renowned movie stars. Star Diary features daily the sometimes splendorous and sometimes spendthrift lives of movie stars. Like other MTV international channels, MTV in China presents itself as a youth brand targeting 15–34-year-olds and caters to this group using global modernity. With MTV as a Chinese platform for youth (interview with Silvia Goh, Creative and Content Director of Viacom China and Marilyn Wu on April 23, 2004)—and its slogan of "good music is right here on MTV"—it inevitably promotes consumption.

Before their formal direct broadcasting in April 2003, these syndicated programs were then channeled through various networked local, regional, and provincial stations. This may well be the right strategy to catch up with Channel V. In keeping the international standard of management structure, they relied heavily on local staff for cultural production. In 2004, 85 percent of Viacom personnel were mainland Chinese while the rest were mainly from other Chinese communities such as Hong Kong and Taiwan (interview with Marilyn Wu on April 23, 2004). These local people were to "feel" the degree of government control so as to skirt around sensitive content in the programming. To use the analogy from the director of Marketing and Communication Director of Viacom "[In China], hoisting the red flag [celebrating Chinese] festival is needed" (interview with Marilyn Wu on April 23, 2004), and only the local staff could recognize under what important Chinese occasions the red flag should be raised (Fung, 2006). In other words, these local staffs are a more accurate barometer of the cultural vagaries and the correct responses to them.

Channel V now works using the same business logic, however, with slight differences (see Table 5.1). As Murdoch noted, Newscorp comes to China mainly for the entertainment market, and thus Channel V is one of the flagships that needs to create and pioneer this type of popular culture in China. However, Murdoch also mentioned that

> Localization means that in China we must be Chinese. It's as simple as that. We must cater for, must respect Chinese culture, and we must cater for Chinese tastes. We want to bring them a lot of entertainment, a lot of fun, amusement, and enjoyment. We want them to turn on our channel everyday and be happy, and be stimulated too by the programs. (Tang, 2003: 63)

While profit-making is essential, the process and steps in producing the "proper" popular culture that respects the Chinese local context is equally important. Therefore when Channel V's director As Li, Dai said, Channel V is "not only to provide the best music, but also to locate a mission in life, and create an influence [among Chinese], one that should follow the needs and desires [of the generation]," that influence must refer to positive values that maintain the stability of the status quo (interview with Li Dai, Managing Direction of Channel V on December 20, 2003). Inasmuch as the need for cultural and political sensitivity for the content as well as its extensive down-to-earth promotion and palpable contacts with the new generation, the strategy of "localization of culture" for Channel V is also more careful and complex. Apart from hiring local staff for the local Chinese language program, they felt the compelling need to connect with the state-owned local media for an exact evaluation of the authorities' limits and tolerance. Since 1999, the Phoenix TV experience involved local direction, decisions, and management. The local staff worked closely with the personnel in southern Guangzhou Television to produce the Channel V Face to Face program. While Channel V invested in programs and lined up sponsors, the television team basically produced the program. This kind of partnership with the local production unit reflects the current Chinese television policy that separates production from broadcasting. While the former can be relatively free for creative programming, external liaison, and even partnership with foreign companies, broadcasting acts as a gatekeeping device for national ideology (interview with Ning, Xiaozhou, Director, Guangzhou Television Station on October 6, 2003).

Table 5.1 Comparison between Channel V and MTV Channel in terms of localization strategies

	Channel V	*MTV Channel*
Similarities	Production of local program	
	Hiring of Chinese staff	
Differences	More collaboration with local stations and audiences	More focus on program to be broadcast via local channels and direct broadcasting
	Mainly Chinese locally made music videos	Chinese music videos sandwiched between Western music videos

Hip-Hopping China

When talking about localization, a significant question is just what elements of the Western culture can be indigenized. Hip-hop is the music that channels are selling to China. For Channel V, the apex of "celebrating" hip-hop is the annual music awards ceremony organized in collaboration with CCTV and the SMG—the controlling companies governing all Shanghai broadcasting media. It is also a coherent theme for MTV's classic cooperation with CCTV, the annual CCTV-MTV Music Awards (and in the MTV Style Awards organized with SMG and CCTV6[5]). For analysis purposes, the music awards, the Tenth Anniversary Channel V Music Award, and the Sixth CCTV-MTV Music Award in 2003 were chosen for comparison. In both awards, if any core Western theme is named, the element of hip-hop is most obvious. Despite the requirement for state collaboration, in which selling national ideology is the primary objective, these events are able to package hip-hop in a way that is acceptable.

Hip-hop is an apolitical approach to localizing Western content. It is a catalyst that accelerates the integration of Channel V, MTV, or simply Chinese music videos into society. The hip-hop music presented in these two music awards was capable of bearing both political meanings and commercial values. According to the production manager, Channel V aims at creating and defending a new cultural taste for Chinese youth and hip-hop is one of the major means in achieving this (Yang, Yue, Vice Manager, Artist Management Division, MTV China on July 28, 2005). As this strategy

involves preaching American or global modernity in China, it is essential that it should not overtly support political purposes. So long as the state perceives that it is not incompatible with state policy and nationalist ideology, the strategy remains viable. Ostensibly, an overdose of "improper" hip-hop may cause irritation or worse but an "optimal" adjustment deems it to be acceptable. It is in this context that hip-hop culture in China is tuned.

Hip-hop music is a style encompassing clothing, dances, music, and lifestyles and, quite often, such tastes reflect different classes of people. The class connotation is often reflected in the lyrics or in reggae music. It follows that the forms of consumption and practices are then an articulation of a specific class stratum and this is more or less a capitalist manifestation of culture (Bourdieu, 1987). The poverty, violence and drug taking and trafficking that are reflected by the rough language forms in hip-hop are intrinsically antihegemonic and appealing to many people in Western society. In China youth culture hip-hop style is apolitical and non-antisocial; it takes the form of hip-hop clothing, music, and lifestyle but is not a protest of politics and society. While the state allows foreign capital to operate, they are expected to produce a product that is both predictable and acceptable.

In Chinese hip-hop, the joviality of love and romance and the bliss of ethnic harmony and festivities of important Chinese occasions are celebrated along with the ecstasy of consumption. Rapping in China does not include a growing discontent, defiant animosity, and explosive expostulations about the social evils of Chinese society. Occupied with consumptive hedonism, individualistic narcissism, and materialistic pursuits, apolitical hip-hop music actually functions to soothe social upheaval and maintain the status quo (for a detailed discussion of the audience, see Chapter 6). In this sense, the cultural tastes in China are not merely cultural expressions simply hooked to capitalist profit and capital accumulation but also an expression bounded strongly by official agendas. The emerging cultural tastes, which can be described as apolitical and materialistic, actually fit into the prevailing government agenda on youth. This explains why the state has long endured a large dose of hip-hop on the music awards and many of the Chinese music video programs. These music channels have already desensitized and depoliticized political hostility in the popular culture.

Music Award: Juxtaposing the National with the Global

Hip-hop is one of the many elements used for expressing Western modernity in these awards. However, given that the awards are coorganized with the state media, the foreign media have to devise their own measures to express Western modernity. They have to integrate Chinese tradition and popular musical form and style, juxtapose the national with the global, and accommodate both the communist ideology and Western modernity.

In line with other international channels Channel V and MTV award brandings—the awards held in China possess a strong Western style. If you discount the location, one would easily conceive that this is an international event held in the West. MTV uses a stage backdrop composed of a collage of light boxes with a colossal blue television that has a sharp MTV logo placed in the foreground. As for Channel V, the 60-meter wide stage extended a runway decked with glossy light boxes to allow for extensive hip-hop dancing. Coincidentally, in both awards, standing spaces around the stage are reserved for fans to dance and yell. Audiences could stand up and dance in tune with the hip-hop dancers on the stage. Although a state joint venture, these global players completely transplanted their Western form of performance, production, design, and music without the interference common to performances on other formal state occasions. In contrast, all existing state-endorsed Chinese music awards such as the China Gold Record Awards organized by the China Record Company in November 2003, the Award of China Institute of Light Music (which models the American Grammy Award) in December 2004, and the popular music session of the China Young Singer Television Competition by CCTV in May 2004 retained some traditional folk songs, patriotic acclamations, and national hymns amidst the supposedly secular pop music events (Fung, 2006). This is precisely the kind of archaic, passé, and nontrendy style that the state intends to avoid when they embrace global partners. They understand that these carnivals are not to venerate the party. Rather, in this global-state fusion, the state uses Western modernity to target the new generation in ways they cannot.

Channel V: De-Westernizing Global Culture

Although using identical Western style of strategies, companies differ in many aspects of their localization strategies in terms of considering the ideologies of the state. The music awards are sites where we can observe these important differences. They also reflect different corporate philosophies.

For Channel V, the strategy is quite clear-cut. Besides the Western packaging, hip-hop style and Western musical instruments, including keyboards, drums, trumpets, and guitars, all the performers under the spotlight, including the singers whom they pay tribute to, were Chinese. Channel V has simply rejected the idea of using international artists in this performance. In this sense, the cultural localization of global elements is more complete as if the global and the Chinese state combined to form a new genre of pop culture. The 8,000 people at the Shanghai Grand Stage (Shanghai Gymnasium), however, could not see a balance between the East and the West, and China and the global because no English-speaking performance or artist was featured. Instead, the award was hosted by 20-something Chinese educated VJs, Wilber Bo, the Black (Heiran), and Li Chen who wrote the rapping lyrics, sang and danced in hip-hop outfits, and even coacted in a fancy musical extravaganza in honor of Elvis Presley. Wilber Bo is a hip-hop prince and an American-born Chinese who has absorbed and even devotedly reveres the pop culture he represents. Taking Wilber Bo and the entire awards format as a form of cultural text, the organizers attempted to de-Westernize the global culture and then recreate it as Chinese culture, retaining the same degree of modernity in the process. In other words, via the state-global collaboration, the Western forms had metamorphosed into genuine Chinese popular culture. Perhaps we could regard this strategy as a kind of de-Westernization of global elements or deglobalization in the process of localization.

The act of diverging from a pure Western model of honoring English-speaking music bands and artists to feature only Chinese artists is coherent with the theme of Channel V to feature the Chinese culture and develop a new Chinese cultural taste. In the Tenth Annual Awards, Channel V also invited award winners of the past decades to perform. Again, instead of bringing Western music ingredients into the Chinese communities, Channel V launched the "Future music Angle—U and Me," the theme as well as a global voting mechanism to broaden the influence of Chinese music overseas.

Equally important is that the newly formed Chinese culture is not the one that purely belongs only to the PRC. The Chinese popular culture produced is intent on smoothing out differences among Chinese in different geopolitical and geographical locations. In the show, not only singers from the mainland were credited. It also set out two categories of awards, namely, the Chinese award, and the "Hong Kong and Taiwan Regions" award—symbolizing

Chinese unification. On Channel V performing stages were representative icons from the mainland (Poshu and Hanhong, respectively, the most popular mainland Chinese female and male singers), Hong Kong ("Beyond" the most influential HK band of the 1980s), and Taiwan (Ah Mei) celebrating the unparallel unity of the Chinese, at least, in the realm of popular culture. The Taiwan singer Ah Mei, who had boldly advocated Taiwan independence, was once barred from performing in the mainland. But now this formerly "detoured" artist has been rerouted to the "right" track—and with the prerequisite that she still had a popular appeal—and she was welcomed back to the Chinese stage. The awards show, however, was not a conscious and calculated exchange of political interests, although for the public and observers, it did signify the Chinese preference for a repentant Taiwan over one with unflinching courage and resoluteness against the PRC. This kind of diplomatic agenda is subtly read into any public occasion organized by the state.

The overall effect of the integration of hip-hop music and dance with Chinese icons, including local composers, local bands, and Chinese folksingers, is decidedly odd for Westerners but good for local development. The artist who presented the most popular female folksinger award was dressed up in a Western evening skirt garnished with radiant and burnished silver decorations. Folk songs glorifying the culture, ethnicity, and nationhood—which are completely missing from the commercial business—could be regarded as a very strong signal that the commercial program has acceded to some demand or other. While other commercial stations may regard it as a great departure from mainstream tastes, Channel V dared to integrate the political and the popular—though the jury is still falling out on agreeing whether the amalgamation has been successful or not. While Americans may think watching folk songs about nationalism on music television is strange, this integration seems quite proper in the current Chinese context.

MTV: Hybridizing the West and China

As a stark contrast to the Channel V Music Awards, the CCTV-MTV Music Awards refrained largely from featuring a strong political overtone in the popular culture it constructed. Understanding that the joint organization could not exclude the political symbolization, they attempted to balance Western modernity and Chineseness and commercialism with political ideology. This strategy was an active search for optimal balance and a kind of hybridization of Western and Chinese images. It highlighted hip-hop and

popular music culture and was sometimes schizophrenic as it presented Western modernity with fleeting glances of state ideology.

This approach was definitely achieved by a compromise between the two working parties involved. According to the content producer, MTV would first propose the list of awards and the program rundown, and CCTV would endorse it and fine-tune it. This endorsement ensured that the hybridization between CCTV and MTV has weighed both the mainland Chinese and Western artists and the Chinese-style ballad and Western hits. Implicitly, the presenters of the awards were representatively balanced between MTV spokesperson Sha Li and CCTV presenter Dong Qing. Guest of honor to deliver the awards was NBA "Magic's" Steve Francis, an African American—who was a metaphor for the "giant" West—and was balanced by and partnered with a female singer Weiwei, the Chinese icon who performed the theme song "Asian Championship" (yazhou xiongfeng) at the Tenth Asian Olympics in 1990.

Unlike other MTV's Asian Music Awards and other International Awards, MTV switched from the global model of assigning great importance to Western music bands and artists to one equally honoring Chinese culture, songs, and artists. The MTV awards in China had to reproduce more or less the same lists of awards for many mainland artists such as Poshu and Hanhong. But to keep its consistent global strategy, MTV also brought in Western artists to highlight their Western profile. Whitney Houston and Gary Gates were invited to China and given the international special contribution award and the most popular international singer award, respectively. The hybridization strategy—without de-Westernizing the popular culture—can be described as a two-edged method of localization: MTV keeps its corporate identity and, above all, their unique and popular appeal for the Chinese audience, and it can, at the same time, meet the Chinese demand of producing a program with Chinese characteristics. This ensures the latter—though political, serious, and polemic in nature—might not contradict too much with the modish and sensational attraction of the Western performance by incongruously mingling politics within the commodities so to speak. The overall effect of systematically separating and balancing the East and West, and placing the politics in between the popular entertainment, is quite exceptional in Chinese society.

Neither the importance given to traditional Chinese folk songs and classic Chinese songs was reduced nor were the nationalistic and patriotic moods diluted in the MTV awards, and in fact they were more apparent in

the MTV Style Awards organized with SMG and CCTV (Fung, 2006). The appeal of love, sex, and freedom is still the main selling point in hip-hop, reggae, and the entire discourse. This balance between Western modernity and Chineseness represents the formula for maximizing capitalism and Chinese nationalism.

Inseparability between Economics and Politics

In summary, the two different strategies of the two global players demonstrate a common phenomenon in China. There is no separation between market and politics, and between money and ideology, as illustrated in the theoretical framework in Chapter 2. Before any monetary benefit is seen, global players should first of all meet the political threshold that the state has demarcated. Transnational corporations operate in China, not only under economic constraints, but also with some degree of political obligation. Quite often, this involves more political negotiations than business meetings. For instance, long before its formal approvals from China came in April 2001, MTV Channel pledged to work with CCTV to combat the spread of AIDS in China, at a media symposium organized by the United Nations in China. Redstone went on to say that this "social responsibility" is a value that outstrips the profit factor of Viacom's landing in China.[6] In March 2004, as a contribution to education in China, partnering with Tsinghua University, Viacom also ventured into nonmedia business to help China develop platforms for digital technology. They also actively helped enhance global dialogue with the government; for example, in 2002, they coorganized with the SARFT the twenty-first century media development symposium and established the Sumner Redstone scholarship at the Chinese National Music Academy.

In this regard Murdoch's Newscorp was as active as Viacom. In March 2005, News Corporation donated office space, supplies, and office support staff time to help China organize the Special Olympics East Asia in Beijing. In addition, in 2004, in lieu of the traditional practice of giving out "mooncakes" during the Chinese Mid-Autumn moon festival, a symbolic Chinese custom to maintain client relationships, STAR TV adopted Ping Gu Special School in Beijing by making a RMB40,000 contribution to the Special Olympics. As well, many News Corporation and STAR staff members in Beijing partook in voluntary service for various Special Olympics events (Special Olympic East Asia, 2006). For the global media, the successful entry

into China presupposes that they have precipitated a smooth sailing from the state. When the public gravitates toward apolitical popular culture, is immersed in consumption and seeks individual satisfaction, the state continues to reign with power. In the process, it is the power of globalization that drives the internal stability of hegemony in the country, and it is the transnational media that begets the criticalness of popular discourse.

Music Channels as Benchmark

The tale of these two localizing global capitals provides future exemplary models for others to follow for the production of localized Chinese popular culture. The model is neither just to avoid political content that would challenge the authorities nor to simply gauge the political standards of the day. But what it does suggest is that they actively accommodate Chinese agendas. Being flexible and proactive, they create a Chinese solution that is normally beyond the ability of the government to develop. Given the massive influence of music videos to the new generation, the global players can actually help the PRC produce a popular culture that does not depart too much from its economic (market) agendas and that squarely incorporates the national agendas of the authorities without presenting any threats of confrontation and without the presence of overt foreign imperialism.

So far what appears most problematic to the legitimacy of the state is the emergence of alternative and uncontrolled public spaces that can be counter-hegemonic and disrupt social stability. Now that the global-state collaboration can help bring back music—mainly the lyrics of it—to a "manageable zone," the production of popular culture under the umbrella of these "privileged" transnational media corporation in China helps the state to define what *the* elements of popularity are. They also benchmark what kind of culture can be produced. While the state allows foreign capital to operate, they operate to produce a predictable and acceptable Chinese culture. With the presence of the global partner and their new cultural forms, Chinese youth feel like they are experiencing an unfettered modern culture.

This has eased authorities' worries that there might be ideological incompatibility between the global culture and the local political culture (officials from all levels of operations in the industry including marketing, distribution, and production have noted this fear). From the PRC's point of view, rather than rejecting popular culture, they prefer to count on global partners to promote the government (interview with Li, Dai, former manag-

ing director of Channel V China on December 20, 2003). This is Chinese authorities' effort to integrate and consider the market as well as the policy. While transnational corporations are ready to change their global mentality—not to harass China with principles like democracy, freedom, and human rights—the new generation of ruling class of the Chinese authorities is also willing to advance their thoughts and ruling strategies to receive accommodating global partners. If we ask what the state fears most, the answer will not be foreign corporations but the unpredictable flow of popular culture that is not self-coproduced and self-initiated. The authorities will maintain this interlocking control mechanism and the existing form of collaboration to ensure that other cultures entering China are properly managed.

The Hope for Generation Z

After illustrating the various political constraints (and also opportunities) facing the global media, one could inevitably ask the following questions. Could these music channels serve as profit centers for the global media group in the future?

Can media moguls benefit from the China market? If yes, what is the expected profit model for global capital? At this moment in time the transnational media can benefit from widening their influence in China. For example, with the assistance from the Chinese media, MTV could convey their programs to a massive audience via CCTV 3, a station for variety and entertainment shows, and the English Channel CCTV 9. The annual CCTV-MTV Music Awards could then reach 9 percent of the total Chinese audience (Cunningham, 2003: 189). In Shanghai, partnership with SMG allowed their annual MTV Style Awards to reach the wider audience via SMG's subsidiary, the Oriental Satellite TV (Dongfeng Satellite TV). However, Viacom has already invested US$10 million in the China market. It is estimated that its China revenue is around RMB40–RMB50 million[7] and that amount suggests that to date the MTV channel has yielded no immediate financial rewards for Viacom. That revenue is not able to offset the huge operational costs in China and, in particular, hosting the MTV-CCTV Annual Music Awards. For the entire Viacom group, the cost just for relaying CCTV9 to the United States reaches RMB20 million. Nonetheless, this does not mean that the company has made the wrong strategic move by coming to China.

Nonetheless, given the fact that their programs are confined to selling

and packing music videos, in spite of the increasing revenues from advertisers and sponsors, these media are not in any sense a cash cow. For Viacom, according to a public interview of their managing director Li, Yifei, profits did not even offset the huge operational costs and all the corporation could hope for in the near term was to break even. There are strong reasons to believe that the media tycoons have their work cut out for them in terms of thinking about the China venture in the long term. Rupert Murdoch had once responded to an interview in China (Tang, 2003: 62), explicitly saying that News Corporation is not set up to draw money out of China, but to invest in it. According to this he stated that their cultural business is "little more than commerce." Upholding a more long-term goal rather than realizing and redeeming the profits in the immediate future are more what the company is about. Rather, Murdoch himself mentioned that "bind[ing] the society together" might be a prior mission for any commercial investment. This friendly gesture invited international criticism. In 1998, Murdoch was said to have personally forced his publishing house HarperCollins to cancel a memoir by Chris Patten, the last Hong Kong governor—a democratic reformer who was highly critical of China (BBC, 1998, March 1).

However, putting aside the intangibles related to critiques, it is not hard to see that the trustful relationship Murdoch built up over the years could be rewarded with more promising revenue opportunities in China. On the business side, it is a wise strategy. From an investment point of view, this period could be regarded as a stage of capital accumulation and the development of trust and goodwill is what they do at this stage. They represent the preconditions for profit-making in the Chinese context where guanxi or relationship is important. No one guarantees profit but all business partners believe that the intangible capital gained today can be used to realize profits in the emerging market in the future.

In 2006, Murdoch with a lump sum of US$580m (£332.85m) acquired Intermix Media, owner of MySpace.com, the fifth most-viewed Internet domain in the United States and owner of other sites. There were reports hinting of the possibility of MySpace.com joining forces with successful Chinese social networking portals like Sohu.com (SOHU), Dudu.com, Mop.com, or Baidu.com (the Chinese version of Google) to target the new generation in China of wealthy mostly net-savvy kids[8] (Businessweek.com, 2006, September 21). Even though there were a number of laws (not mentioned in this book) promulgated by the Ministry of Information Industry (MII) of the PRC to control Internet-related business, Yahoo! (YAHOO), one

of the U.S. Internet companies, is allowed to own 40 percent of China's Alibaba.com. According to a survey in May 2006 by CINNC, a nonprofit administrative arm and regulatory platform of MII founded in 1997, Alibaba.com's Taobao.com had already garnered 67 percent share of consumer-to-consumer purchasing in China. Given STAR's honeymoon relationship with China, it is also very likely that Murdoch can loosen up regulations for MySpace in China.

For Viacom, since 2003, with the foundation of MTV Networks, its subsidiary Nickelodeon has directly collaborated with the state-owned Shanghai Audio-Visual Publisher to distribute DVD and VCD versions of some popular cartoons: Charissa (Shaonu Xinlu), Kenan He Keer, and Cousin Skeeter (Shigete Biaoge).[9] In March 2004, Viacom successfully extended its influence by broadcasting their cartoons in China. It was a pioneering plan for CCTV to partner with an American children's network, Nickelodeon, to provide 386 million Chinese households access to Nickelodeon on a daily basis on their children's channel CCTV 14 (*China Daily*, 2004, January 8). It can also be regarded as China's open policy for children's cartoons as CCTV also started to accept American format cartoons. The debut on CCTV was the original American series Nickelodeon's Cat Dog. Before that, in 2003, CCTV collaborated with Walt Disney to broadcast its full-length animated movie masterpiece "The Many Adventures of Winnie the Pooh" on Channel 14.

On the one hand, in the case of adoption of foreign cartoons, it should be noted that the collaboration was not a simple hybridization of Western and Chinese content, as MTV often does. CCTV's broadcast of Nickelodeon's cartoons is simply an imposition of Western culture on the audience. Of course, it is not likely that antihegemonic ideology can be found in these imported cartoons. But the prerequisite for the state to entrust the global partners to pass them the "safe" content must be their previous experience of cooperation and the "goodwill" that the transnational corporations have accumulated. On the other hand, the state's adoption of foreign culture is not a satisfaction of external pressures. Nor is it an obligatory requirement of the WTO. Rather, it is the policy of the PRC. The consequence is a spin-off of the state's agenda. When the state has a specific need at a particular moment, then there is an opportunity for the global partners. Viacom seized the chance to push Nickelodeon. Newscorp might do the same for MySpace one day. The state's need always spurs the chemistry of collaboration between the global players and the PRC.

What these transnational media corporations look for in China today is

their future. Hip-hop is what teenagers like and Nickelodeon and MySpace are both a part of the emerging Chinese popular culture. If the existing Chinese Generation X, or the Generation Y, in their adolescence do not bring profit to these transnational media corporations, then Generation Z may be the ones ready to accept innovative, or even contradicting, ideas with the motto "anything goes" will. When the state is able to retour the new generation and enjoy a completely new popular culture without reference to the historical past of trauma, they reign safely.

Conclusion: Model for Chinese MTV

With a huge emerging and uncharted cultural market in China—particularly a market with the young generation who yearn for entertainment—the global media chose to enter the China market with its music branches. From an investment point of view, it might not be a cost-effective strategy. This is because compared to their other media, music is not a big contributor to the bottom line. Evidence suggests that the transnational media corporations had no plan to cash in on a short-term basis. Rather, they met China with courtesy, not only by shunning Western imperialist notions bent on liberating China with Western concepts of democracy, freedom, and human rights—but also cooperating with the state apparatus to produce modern popular culture.

Externally by collaborating with the local, regional, and national television, and internally absorbing local talents, these global corporations localized through the production of Chinese language programs. In the two case studies of Channel V and MTV, the companies had two strategies for globalization. While Murdoch's Channel V tends to de-Westernize the global culture in the process of localization, Redstone's MTV Channel hybridizes Western modernity and Chinese ideologies. The former strategy focuses on constructing a modern Chinese popular culture by dissolving the Western form and styles into it, but at the same time, attempts to detach it from the global ideology and influence so that the final output is a genuine Chinese product. The latter keeps the Western thread in the locally produced popular culture so that the signature of Western modernity still registers in the minds of the Chinese audience. To place the two strategies along a framework of politicism versus economism, it is suggested that although both consider the dual constraints, the position of Channel V is more political whereas MTV is somewhat more economic.

In terms of success of localization, it is too early to tell which one is superior. But what is clear is that both strategies are legitimate and effective means of localization as they have survived the partisan censorship, ad hoc sanctions, and vicissitudes of the joint global-state projects and activities. The triumph of these global media is that along with the state media they have successfully implanted a new sort of popular culture in China. Other transnational media and corporations have yet to localize Western products and music, while the two global forerunners are participating in the production of a "right and suitable" culture for the market and above all benchmarking the political standards for those that are sure to follow.

Besides the global players, there are two more active players: the state and the audience. On the one hand, the state now appears more flexible in handling globalization. When global capital brings in the foreign elements, the state receives them and transforms them into elements that are conducive to its stability and governance. The new culture produced is evocative of the modernity that contemporary Chinese society lacks. On the other hand, the audience becomes more demanding than they used to be. Imbued with the national pride as China rises as a global power, the new generation no longer is satisfied with a mere transplant of foreign culture. When Western modernity is annexed to Chinese culture in this way, it speaks to both their individualistic material pursuit and to their emerging nationalistic ego.

Notes

1. Viacom's well-known brands include MTV Channel, the children's channel Nickelodeon, American Television Network production CBS, Paramount Pictures, the audiovisual chain Blockbuster, and the publisher Simon & Schuster, Nick at Nite, VH1, BET, Infinity Broadcasting, Viacom Outdoor, UPN, TV Land, Comedy Central, Country Music Television, Spike TV, and the Showtime movie channel. Under the umbrella of these businesses, Viacom owns 19 television stations and 1,300 theaters, and together with all its assets, in 2001 had an estimated worth of US$87 billion, ranking it eighty-fifth in terms of value by *Fortune*.

2. In the 1980s, Li was invited by Chinese leader Deng, Xiaoping to become a member of the board of directors of the China International Trust and Investment Corporation to support Deng's economic reform initiatives and open-door policy.

3. To be globally competitive as a transnational media corporation, the MTV gambit is to localize their business and musical tastes with the establishment of regional music television channels, which besides the American MTV Channel, comprise MTV Asia, MTV Australia, MTV Brasil, MTV Europe, MTV Latin America, and MTV Russia (cf. Gershon, 2000).

4. Eighty percent of Viacom's production was made outside the United States (Cunningham, 2003: 188).

5. They are the two global awards (out of seven) made by MTV International in China.

6. For example, MTV also created a Chinese version of its AIDS information portal "staying alive."

7. Li, Yifei, Managing Director of Viacom, said in a public event that their revenue came largely from advertising, and the dependence on advertising seems to be declining (down by more than 50 percent).

8. The same report also said that Baidu.com's stakeholder Google is a competitor to Newscorp.

9. Nickelodeon used to rely on a local company Tanglong that had the legal rights to distribute the program to different Chinese television stations. Its famous programs include animation Nicktoons, variety and game shows, as well as adventure and news magazine shows.

References

BBC (2005, September 7) Yahoo "Helped Jail China Writer." http://news.bbc.co.uk/1/hi/world/asia-pacific/4221538.stm. Accessed on May 21, 2007.

———— (2008, March 1) Rupert Murdoch Faces Authors' Revolt. http://news.bbc.co.uk/2/hi/world/analysis/61122.stm. Accessed on May 22, 2007.

Bourdieu, Pierre (1987) *Distinction: A Social Critique of the Judgment of Taste.* Cambridge, MA: Harvard University Press.

Businessweek.com (2006, September 21) Murdoch's Mission to China. http://www.cvca.com.cn/cvcaMonthly/detail.asp?ArticleID=85&sYear=2006 &sMonth=9. Accessed on May 28, 2007.

Chan, Joseph and Jack Qiu (2001) China: Media Liberalization under Authoritarianism. In Monroe E. Price, Beata Rozumilowicz, and Stefaan G. Verhulst (eds.), *Media Reform: Democratizing the Media, Democratizing the State.* London: Routledge, pp. 27–46.

China Daily (2004, January 8), Children's Channel Now on Air. http://www.china.org.cn/english/Life/84262.htm. Accessed on May 30, 2007.

Cunningham, Richard (2003) Globalization of Content, Implementation of Localization. In Shiding Tang (ed.), *Innovation Co-operation: The Summit Forum on China TV Development.* (In Chinese). Beijing: Huayi Publication, pp. 186–191.

Daurat, Cecile (2007, February 8) "Borat" Leads Revenues Gained for News Corp. Bloomberg News. http://www.iht.com/articles/2007/02/07/bloomberg/bxnews.php. Accessed on May 30, 2007.

Fung, Anthony (2006) 'Think Globally, Act Locally': MTV's Rendezvous with China. *Global Media and Communication* 2: 22–88.

Fung, Anthony and Chin-Chuan Lee (1994) Hong Kong's Changing Media Ownership: Uncertainty and Dilemma. *Gazette* 53: 127–133.

Gershon, Richard (1997) *The Transnational Media Corporation: Global Messages and Free Market Competition.* Mahwah, NJ: Lawrence Erlbaum Associates.

Hamelink, Cees (1983) *Cultural Autonomy in Global Communication.* New York: Longman.

Li, Yifei (2003) The Operation of Global Capital and MTV's Localization. In StanChina International Research Center and China Forum Academic Committee (ed.), *The Capital Market Operation of China's Media.*(in Chinese). Guangzhou: Nanfang Daily Press, pp. 169–183.

Schechter, Danny (2000, May 30) A Letter to President Jiang Zemin. MediaChannel.org.
http://www.mediachannel.org/views/dissector/china.shtml. Accessed on May 21, 2007.

South China Morning Post (2006, July 3). China: Viacom Sees Steady Growth in Tough Mainland Market. MediaAsia.
http://72.14.235.104/search?q=cache:Ng42UFUmSc4J:www.asiamedia.ucla.edu/article.asp%3Fparentid%3D48444+revenue+Viacom+in+China&hl=zh-TW&ct=clnk&cd=2&gl=hk. Accessed on May 30, 2007.

Special Olympic East Asia (2006) News Corporation CEO Rupert Murdoch Thanked by Special Olympics Athlete Judy Yang.
http://www.specialolympicseastasia.org/English/News/articles/RupertMurdoch.html. Accessed on May 28, 2007.

Tang, Shiding (ed.) (2003) *Interviews with Senior Administrators from Global TV Operations.* Beijing: Huayi Press.

Global Media Partnerships

Chapter 5 stresses some degree of "fusion"—from hybridization to deglob-alization—between the Chinese authorities and transnational media during the period when the latter localized their content in China. This chapter highlights some prominent examples of global partnerships that by and large did not bring with them Western values, modernity, and a dominant culture. Rather, these global-national alliances led to variants that are in stark contrast to the Viacom or News Corporation models. Phoenix Television (Phoenix TV), one of the very exceptional news affairs–based television stations, owned 50 percent by Rupert Murdoch, is one such variant that has had to survive in China with its own strategy and business model. The second variant is CETV, a nonnews and entertainment model that was once under the control of AOL-Time Inc. and is now Chinese owned. Apart from the globally involved media, this chapter will also examine Sun Television (Sun TV), a Hong Kong nonglobal variant. This special foreign television broad-caster illustrates the obstacles that localizing nonentertainment Chinese channels face when entering the China market.

The television stations discussed in this chapter differ from the previous examples of music channels like MTV and Channel V because of their extended range of comprehensive programming. To offer more integrated and wide-ranging programs in China can be a mixed blessing. The advan-tages include being able to target a wide range of audiences; however, this power to sway the public through documentary and news programming makes the authorities highly sensitive to their penetration and power. Oper-ating in a context in which the Chinese authorities still cling onto the Com-munist tenet of manipulating public opinion, these variant cases face strong political and economic problems. Ironically, because of the kind of content these variants carry, they actually have very minimal collaboration with the Chinese authorities. The PRC is more concerned with those players that hold what amounts to an inherently intransigent attitude. A typical example is news, in which journalists and editors adhere to the principles of objectivity, fairness, press freedom, and freedom of speech as unbending ideals. These media workers can act as intrepid martyrs even while their editorial bosses and various Chinese authorities attempt to intrude upon their work. Thus, it is not the imminent pressure from without that dictates to the China-operating media. Rather, in anticipating the conflict, it is the media's internal micro-management that attempts to avoid this potential ideological clash.

In addition to the political economy of these variant television stations, this chapter will touch upon some other forms of transnational media. These include the Hong Kong–based print media *Phoenix Weekly* that is circulated in China, the multimedia and outdoor media Tom Group, and the global Internet giants Yahoo and Google that are now operating China versions of portals that are freely accessed in China. These emerging but immature forms of transnational media, however, represent exceptional cases of successful foreign investment penetration, and although generalizing conclusions for those to follow would be premature, highlighting the complexities of these entries into China is nevertheless instructive. In sum, no matter what kind of media are involved and what forms of global investment do we refer to, a central thesis in this chapter is that the PRC is willing to see an increasing presence of a diversity of globalizing media and cultural industries in their own territory. However, this takes place not only under the superior command of the authorities but also is articulated into a Chinese context in a way that is favorable to the authorities.

The Internationalizing Sky

Media globalization is an important strategy for the transnational media. Few media could survive in their home base without branching out to other regions. China was not immune to this global trend, and as early as 1993, realized there is no impenetrable border. On October 5, 1993, under the leadership of Premier Li, Peng, State Council of the PRC implemented the first systematic regulation to regulate the reception of foreign satellite television channels, namely, Order No. 129 Provisions for the Administration of Ground Satellite Television Broadcast Reception Facilities. In early 2003, SARFT promulgated a more mature Order No. 22, namely, the Measures for the Administration of the Landing of Foreign Satellite Television Channels. This systematically legalized the reception of foreign television in the mainland. It was a milestone that reflected the PRC's determination to allow global capital a share in China's cultural market and came only after its commodity market had been open for many years. Chart 6.1 is a 2003 list of 30 foreign channels that were allowed to legally broadcast in three-star or above hotels and special government offices. These channels could be roughly classified into two main groups: the real transnational media corporations and regional television. The former includes a large number of American channels such as CNN, HBO, and Cinemax under the AOL-Time

Warner, AXN under Sony Entertainment, MTV under Viacom, Channel V, National Geographic Channel Asia, Xing Kong TV, ESPN, and STAR Movie International under News Corporation, Bloomberg TV Asia, CNBC Asia Pacific and Hallmark Channel, and a few European media providers comprising BBC World, France-based Eurosportnews, Television Francaise 5. For the second group, it is composed of two Japanese television program providers such as JETV and NHK World Premium. The remaining others are basically border-crossing television located in Hong Kong and Macau. It seems that besides China, Asian media have a growing interest in China, and in 2007, in fact, besides Japanese channels, Malaysia's Celestial Movies and Singapore's Channel Newsasia entered the country bringing the total foreign channels to 31 (for a more updated list of channels, please refer to People.com.cn, 2007, January 17). As illustrated in Chapter 5, Asian media are to a certain extent becoming a regional competitor against the American and European media. As for the Hong Kong and Macau media, they are longtime regional powers that export programs to various parts of Asia and Western countries such as the subsidiaries of the Hong Kong–based Television Broadcast Limited, the largest television program exporter in the world and the interim springboard for Chinese media owners who aim at the advancing China market (e.g., Sun TV and Phoenix TV).

The increasingly international market, however, does not mean that there is severe competition among all the regional and global media players. Most reputable non-Chinese-speaking channels in the China market serve merely as a concomitant of China mania—being present in China, rather than targeting for profit. BBC and CNN, Cinemax, AXN, and HBO are typical cases in point. With the vast majority of the population watching Chinese programs exclusively, these media only serve the 150,000 expatriates working in China.[1]

The real long-term business plan is the China market itself. As they have scattered focus in terms of content, they seldom compete among each other; nevertheless, their presence and localization might create some shock to the Chinese local and national media. The fresh Chinese content fills in some gaps that their counterparts in China cannot offer. In this sense, they might be described as having some stimuli for the local, provincial, and national Chinese media for reform, and yet they are not powerful enough to dominate the Chinese media system.

Chart 6.1 Reception of foreign satellite television in China since 2003

Serial No.	Satellite TV channel	Ownership/ Affiliation	Country belonged	Remarks
1	CNN (Cable News Network)	AOL-Time Warner, Inc.	United States	
2	Home Box Office (HBO)	AOL-Time Warner, Inc.	United States	HBO Asia has five channels under its multichannel strategy (HBO, HBO Signature, HBO Hits, HBO Family, and CINEMAX).
3	CINEMAX	AOL- Time Warner, Inc.	United States	HBO Asia is the television arm of HBO Pacific Partners, a joint venture of Paramount Films, Sony Pictures Entertainment, Time Warner Entertainment, and Universal Studios.
4	CNBC Asia Pacific	General Electric Company (GE)—NBC/ Dow Jones & Company, Inc.	United States	CNBC Asia launched in 1995. In late 1997, Dow Jones & Company and NBC announced the merger of their international business news channels, resulting in a merger of CNBC Asia with Dow Jones' Asia Business News NBC Universal is a media and entertainment company formed in May 2004 after the merger of General Electric's NBC with Vivendi Universal Entertainment (part of the French Media Group, Vivendi SA. GE now owns 80 percent of NBC Universal with the remaining 20 percent owned by Vivendi SA).
5	MTV Mandarin	Viacom Inc.	United States	MTV Mandarin is a 24-hour music channel that combines Mandarin and international music programs. There are two divisions of MTV Mandarin, namely, MTV Taiwan and MTV China.
6	National Geographic Channel Asia	News Corporation*	United States	In September 1997, the world's first National Geographic Channel was launched in Europe and Australia. In July 1998, National Geographic Channel Asia was established in partnership with STAR TV with the latter mainly serving as a distributor. Today the channel is available in over 143 countries, and can be watched in more than 160 million homes and in 25 languages.

Continued on next page

Chart 6.1 *(Continued)*

Serial No.	Satellite TV channel	Ownership/ Affiliation	Country belonged	Remarks
7	STAR Movie International	News Corporation*	United States	
8	ESPN	ABC Sports/ News Corporation	United States	In 1984, ABC made a deal with the majority stake holder Getty Oil Company (later purchased by Texaco, now ChevronTexaco) to acquire ESPN. ABC owned 80 percent share, and sold 20 percent to Nabisco. The Nabisco shares were later sold to Hearst Corporation, which still holds a 20 percent stake today. In 1986, ABC was purchased for US$3.5 billion by Capital Cities Communications. In 1995, Disney purchased Capital Cities/ABC for $19 billion and hence owned an 80 percent stake in ESPN at that time. Although ESPN has been operated as a Disney subsidiary since 1996, it is still technically a joint venture between Disney and Hearst. It was announced in 2006 that ABC Sports would be totally integrated into ESPN, using ESPN graphics, music, and production.
9	Channel [V]	News Corporation	United States	
10	STAR Sports	ABC Sports/ News Corporation	United States	
11	AXN Channel	Sony Pictures Entertainment	United States	
12	Discovery Channel	Discovery Communica- tions, Inc. (DCI)	United States	Discovery Channel was launched in 1985 as the flagship channel of Discovery Communications, which today offers 29 network brands in 33 languages. Discovery Networks Asia was launched in the region in 1994 as a division of Discovery Communications, Inc. (DCI)

Chart 6.1 *(Continued)*

Serial No.	Satellite TV channel	Ownership/ Affiliation	Country belonged	Remarks
13	Hallmark Channel	Crown Media, Inc.	United States	In 1994, RHI Entertainment, Inc., an independent producer of movies-of-the-week and miniseries in the United States, acquired Hallmark Cards that aimed to expand its business to family entertainment. In connection with the buyout, Hallmark Cards formed Hallmark Entertainment, Inc., to own RHI Entertainment. In June 1995, Hallmark Entertainment, Inc., expanded its business with the formation of Crown Media, Inc.
14	BBC World	British Broadcasting Corporation (BBC)	UK	
15	NHK World Premium	Hippon Hoso Kyokai (or Japan Broadcasting Corporation) (NHK)	Japan	
16	JETV	Japanese Entertainment Television (JETV)	Japan	
17	Phoenix Movie Channel	Phoenix Satellite Television Holdings Limited	Hong Kong	
18	Phoenix Chinese Channel	Phoenix Satellite Television Holdings Limited	Hong Kong	
19	TVB8	Television Broadcasts Limited	Hong Kong	
20	TVB Galaxy	Television Broadcasts Limited	Hong Kong	

Chart 6.1 *(Continued)*

Serial No.	Satellite TV channel	Ownership/ Affiliation	Country belonged	Remarks
21	Sun TV	Sun Television CyberNet- works Enterprise Limited	Hong Kong	
22	NOW TV	Pacific Century CyberWorks Limited (PCCW)	Hong Kong	PCCW is the largest telecommunciation enterprise in Hong Kong. It was established by Richard Li, the younger son of Hong Kong tycoon and billionaire Ka-shing Li. Its involvement in the Hong Kong's media started with the acquisition of Hong Kong Telecom in August 2000, which was formerly known as the Hong Kong Telephone Company (founded in 1925 under the former Britsh colonizer).
23	Macau Satellite Travel Channel (MSTV)	Macau Media Holdings (formerly Five Star Television Company)	Hong Kong/ Macau	In September 2002, Macau Media Holdings (formerly Five Star Television Company) acquired 6.5 percent of Sun TV that owned the MSTV.
24	Five Star TV	Macau Media Holdings (formerly Five Star Television Company)	Hong Kong/ Macau	Five Star Television Company was established in April 2000 by a Chinese media owner Liu, Yang and an American Chinese Liu, Chi by direct investing in the sole Macau satellite operator, Cosmos Satellite Television Company Limited at that time. The headquarters, however, are located in Hong Kong.
25	Macau Satellite Asia TV	Macau Asia Satellite Television Company Limited (MASTV)	Macau	It was established in June 2001 in the Special Administrative Region of Macau.
26	Television Francaise (TF5)	TV5Monde	France	

Chart 6.1 *(Continued)*

Serial No.	Satellite TV channel	Ownership/ Affiliation	Country belonged	Remarks
27	Phoenix Infonews Channel	Phoenix Satellite Television Holdings Limited	Hong Kong	
28	Bloomberg TV Asia Pacific	Bloomberg L.P.	United States	
29	Xing Kong Television	News Corporation	United States	
30	Eurosportnews	Le Groupe Bouygues	France	Eurosport was launched in 1989 as a joint venture between the European Broadcasting Union and Sky Television. Eurosport eventually came under the ownership of French consortium, which comprised the TF1 Group, Canal Group, and Havas Images. Since January 2001 it has been completely owned by TF1. TF1 was privatized in 1987 with the investment of Le Groupe Bouygues

Note: Details of some of these television stations are not written here in the remarks and their developments are to be explained in greater detail in the text.

* Although the founder Rupert Murdoch created and incorporated in Adeliaide, Australia, the company was reincorporated in the United States after a majority of shareholders approved the move in Novemeber 2004. Now it is in general considered as an American corporation.

As radical as these programs might be, foreign media are bound not to steer too far away from the limits imposed by the authorities and in accordance with Order No. 22, these foreign media have to comply with a total of 19 strict regulations including the denial to convey programs, including news programs that might hinder national interests and threaten national unity. The Chinese authorities are not willing to yield their control of the market, nor are they willing to have their own defunct media replaced per se. The stimuli triggered by these foreign media are seen as useful tools to positively reform the state, and as role models for commercializing the Chinese media (which will be analyzed in more detail in Chapter 7).

The Global Chinese Alliance: Phoenix TV

Phoenix Satellite Television, initially known as the STAR TV Chinese Channel, acquired by Rupert Murdoch's News Corporation in 1993, is the first and also the most influential among all the variants. In 1995, today's Phoenix's major shareholder and CEO, Liu, Changle, signaled interest in creating a "global Chinese television network" covering not only Chinese in China, Hong Kong, and Taiwan, but all those overseas. In March 1996, STAR TV was relaunched as the Phoenix Satellite Television and became the largest global Chinese television in the world (under STAR TV and Liu's Today's Asia Company covering more than 30 countries in the Asian-Pacific Region through AsiaSat1 24 hours a day).[2]

The driving force behind this station is its owner, a former People's Liberation Army (PLA) colonel and an official of China National Radio who is known to have been involved in making propaganda during the Cultural Revolution. Liu has maintained good terms with the PRC, making Phoenix one of the few stations that could cover sensitive political news and Hong Kong and Taiwan. Although Phoenix's headquarter is located in Hong Kong, its operation is largely on the mainland, and to a certain extent, it can be regarded as the first private and independent television station in the PRC. The intriguing question is why the authorities are content to have a Chinese news channel owned by a transnational media mogul.

No one really knows the insider story but one interpretation is that the only satellite available for television broadcast at the time was AsiaSat1, which was controlled by News Corporation. Liu had to rely on a foreign mogul to build his Chinese media empire. An alternative interpretation might be Murdoch's privileged position as the earliest global player to win the trust of the mainland authorities. Liu's entry into the China market under the auspices of an advantaged global partner seems to be a credible and pragmatic move. Unquestionably Murdoch's STAR TV, broadcast in putonghua, which started in limited areas of China in the mid-1990s, was handpicked by Liu to become the archetype model for Phoenix TV. In 1998, it launched its encrypted pay movie service through Phoenix Movie Channel. In 2001, Phoenix also started the more critical Infonews Channel and the American and European Channels. The latter enters the cable TV system in North America and many countries in Europe, as does a global 24-hour News Channel, covering more than 90 countries in the world. In 2007, while other foreign satellite televisions are preoccupied with the issue of China entry,

Phoenix received permission to transmit their encrypted signals to the mainland through the PRC's own media satellite. Like other television stations, Phoenix counts on advertising revenues for profit. In 2005, Phoenix enjoyed a total revenue of HK$1.034 billion with an annual increase of 7.8 percent (Financial Times, 2006, August 21), but most of the revenues came from a few mainland clients that marketed their products overseas through the Chinese Channel. The Infonews Channel and the Movie Channel, because of limited accessibility, have to be financially subsidized by the Chinese Channel.

Though not considered state television because it has its headquarters in Hong Kong, Phoenix boldly assumes the role of being the first global Chinese television to target Chinese worldwide. By this, according to Dalian Zhong and Wenhua Yu (2004), it means to extend the spatial meaning of Chinese, from a geographical locale to, politically and culturally, all geopolitical spaces that Chinese reside. Based on this same notion, Phoenix has thus often referred to a media reporting and narrating with *the* "Chinese perspective" over events, debates, and controversy and global issues emphasizing "let the voice of Chinese be heard," counterbalancing the Western hegemonic discourse, and ultimately aiming to construct an equal power relations over international communication. Quite ironically, this close-to-nationalistic production could not be achieved by the PRC's state organ CCTV, but falls under the mission of this global Chinese joint media outside the PRC's territory.

Phoenix has transformed an abstract, imaginative, and obliquely experienced concept—the Chinese as a nation—into a plethora of televised images. For both Chinese on the mainland and overseas, the nation's existence is no longer an imagined community, but one that can be sensed and experienced directly.[3] A strategy of Phoenix therefore is to construct global media events (Dayan and Katz, 2006). Famous media hypes include the Global Chinese Pageant, an annual beauty contest for all Chinese worldwide, World China Forum, a talk show to investigate how other non-Chinese view Chinese issues, and some one-off highlights such as the 1997 classic *Flying over Yellow River*, a reality show featuring 15,000 fans watching as a renowned film actor and singer jumps a roaring river canyon on a motorcycle. These events crystallize the global Chinese audience using a globally planned strategy. Recent programs such as the 2000 *Millennium Journey* (a documentary of the ancient civilizations of mankind from Greece, Egypt, Babylon, India, and back to China), in 2003, *Going into Africa* (an adventure program

coorganized with CCTV to give ethnographic reports of African tribes, culture, and customs during the 100 days' journey), and in 2005, *Zhenghe's Western Journey* (a historical examination of the Chinese following the Chinese diplomat Zheng's footsteps in the Meng dynasty 600 years ago are all quality programs that communicate broadly to pan-Chinese audiences.

Phoenix, as a news and information channel, gained its popularity by showing vivid reports of life and world events, a move that obliquely pinpoints the deficiency of all the state-owned Chinese media that delays and filters world and Chinese reports—and even blacks them out. The report of the terrorist attack on the Twin Towers on September 11, 2001, was a turning point for Phoenix. The stunning images and footage from Phoenix quickly garnered people's enthusiastic support for Phoenix worldwide. While the world was preoccupied with feeds from the English-speaking CNN, Phoenix manifested the tragedy on the spot with its own reporters narrating in Chinese language to an all-Chinese audience. What is important is such reporting reflects an alternative perspective to the dominant Western dis-courses. Thus, featuring itself as the first and only Chinese-CNN, Phoenix's reputation continued to grow with its live reports in Afghanistan in the midst of American bombings in 2001, in Baghdad during the Iraq War in 2005, and other Chinese highlights such as the former premier Jiang, Zimen's summit with American President George Bush in 2002.

Despite being seen as the Chinese-CNN, its CEO emphasizes that he had not intended Phoenix to be a replica of CNN or Fox (Zhong and Yu, 2004: 40-42). Liu offered that Phoenix might "cook" with the same ingredients but the method of cooking is entirely their own. Their key is to employ a Chinese angle to interpret and report the world and Chinese events. Thus, in the reports of the Iraq and the Gulf States, Phoenix is one of the few exceptions in the world (apart from Al Jazeera Channel) that offered a firsthand third-party report on the war without American filters. Its willingness to report alternative views, and subsequently supplement them with prodi-giously talented star critics in talk shows and infonews programs offering incisive and often profound political and social commentaries, made Phoenix a trustworthy and credible channel for the audience. This, of course, was in direct contrast to the censored practices of the official media.

On the mainland nowadays, in the eyes of the mainland Chinese audi-ence (although not Hong Kong and Taiwan audiences), compared to the Chinese media, Phoenix not only excels with its global insights, but also

becomes the only icon of comprehensive, nonpartisan, and impartial Chinese media. While people still have to read between the lines of what the traditional news anchors mean, Phoenix reporters boldly cover sensitive political Chinese issues and extend audience awareness to other Chinese communities such as Hong Kong and Taiwan. In contrast to CCTV that always carries patriotic and jingoistic remarks, and celebrates national and ethnic unity, in the eyes of the entire Chinese audience Phoneix appears rational, objective, and balanced in reviewing and discussing China's problems and international issues related to China. As well, in a media environment where people had never witnessed the open and hearty responses of Jiang, Zimen regarding the standard, outmoded newscasts of CCTV, Phoenix's coverage of an approachable leader's vibrant, amiable, and open back-and-forth questioning and answering with the American audience definitely captured Chinese public attention. However, although most of the Chinese public, including some senior media personnel, have high praise for Phoenix's news coverage, only very few of them actually have access to watch Phoenix regularly. Broadly speaking, the popularity of Phoenix on the mainland is as social discourse and as phenomenon. For the people it somehow reflects both the public's stalwart support for an open, free media, but in general it reflects the public perception of the stalemate regarding Chinese media reform.

In 1999, the National Statistic Bureau publicly released a report on Phoenix viewership. Its Chinese channel reached 41.78 million households, and 13.1 percent of the population. Its reach in major cities such as Beijing, Guangzhou, Shanghai, and Chengdu approached 20.1 percent. While recent statistics have not been released (also problematic to measure because of many illegal receptions), an educated guess from an insider argued that Phoenix in 2006 had outperformed other Chinese competitors, ranking just below the state-supported CCTV and the entertainment-focused Hunan Satellite TV (Panwilder, 2006, November 16). Phoenix has built a brand name as an independent and professional Chinese television network with newsworker and media commentator celebrities delivering what is perceived to be a truthful, efficient, accurate, and fair broadcast.

Notwithstanding Phoenix's relative superiority, Phoenix is not free to report. In China, Phoenix is equally bound to avoid touching on the very many Chinese political taboos. These restraints have gradually reduced as China's politics becomes more tolerant to dissident ideas. Till today Phoenix shuns directly covering the Dalai Lama's public statements about the sovereignty of Tibet overseas, Taiwanese news that advocates any form of

independence, and in Hong Kong the democratic camps' declarations and activities that call for a referendum regarding the chief executive and a quicker pace of democracy in this former colony. Thus, for Phoenix, while it can touch upon social, economic, and political issues in China, it self-imposed a news blackout during the local Hong Kong half-a-million-people demonstration on July 1, 2003, the anniversary date for China's resumption of the sovereignty over Hong Kong.[4]

Order of the Phoenix

An important theoretical question is just why Chinese authorities allow a globally involved media to engage in "internal affairs." A nonstructural argument is simply that it is the personal preference of political leadership. Phoenix not only meets with the public tastes but has also become the "cup of tea" for many Chinese leaders. Like other audiences, Chinese leaders regard Phoenix as a window of nonwatered down and nongarbled Chinese information. Phoenix staff know that Chinese leaders watch Phoenix every day, and when these leaders travel outside the country for diplomatic visits, arrangements have to be made to erect special reception devices to capture Phoenix signals (informal talks with Phoenix staff).[5]

But beyond finding clues useful for global participation there is a more structural reason to consider. Phoenix may well be justified as an auxiliary power built under the auspices of the Chinese authorities. As an independent media, it enjoys its legitimacy. Because it's part of the state power, the state guarantees its survival, and in the case of crisis, the station can be con-scripted into the Chinese united frontline to defend against trespassers. The very unique role of Phoenix is revealed by the very naming of the station; idiomatic in nature, it manifests the relationship between the state and the station. The Phoenix, according to both Chinese and Western mythology, is an immortal bird with shinning gold and red plumage. In the West, in particular, in connection to Christian symbolism, the bird represents resurrection. From the Chinese layman's point of view, in the era of globalization, the birth of a new phoenix or a new television network is a fresh new hope to them and to the nation; being invincible, it dares to cover controversy and contemporary events. It is the fresh philosophy of the Phoenix that marshals Chinese into a new China. In the Chinese tradition, yet, the Phoenix (fenghuang) is the most-respected legendary creature second only to the dragon that represents the king or the leadership. From the

authorities' point of view, the Phoenix is ascended to serve an important role for the entire nation, but the precondition for the ascension is to be subservient to the party leadership. In other words, the television station in some sense can be characterized as the Chinese verison of the Order of the Phoenix—an inheritance from the Greek warrior tradition. Though the warriors are not part of the state, their missions do not deviate from the state too much, and in the end, they also defend the status quo. (Perhaps China's Harry Potter fans might not realize that *Order of the Phoenix* as it appears in one of the Harry Potter series is also a cabal of very noble and elite students in the Hogwarts School of Witchcraft and Wizardry who secretely operate against the authorities' wishes, and yet are finally harmonously united with the school to fight against the evil wizard Voldemort.)

Given its semi-independent position of the order from the state, and also its joint global and Chinese operation, it enjoys a double advantage during its reporting. On the one hand, as a Chinese media and one that is somewhat accepted by the Chinese authorities, Phoenix has an equivalent status to other national Chinese media, enjoying a privileged access to national events and meetings with party leaders. The bureaucracies and Communists would otherwise deny their entrée and turn down interviews if Phoenix were only a foreign medium. On the other hand, when Phoenix claims to be an outside and Western-owned media, it is obliged to comply with international rules and journalistic professionalism, thereby being able to blamelessly deny propaganda requests by the authorities. As Phoenix gradually rises as a reliable channel and an alternative to state propaganda, even pompous officials seem to be very pleased to accept Phoenix's invitation for interviews that yield outspoken comments. As part of the large state structure, these officials are obliged to befriend and "revere" the journalists from CCTV's and other official media's journalists. But many an official would begrudge being ignored by Phoenix in that their interviews reflect the standing status of the officials. Thus, the news on Phoenix, even of the same official events and conventions reported by other state organs, appears to be more comprehensive and objective, richer in content and modern in its appeal.

Given that the political question seems solved, financial survivability is now of high priority for the station. As a television based in Hong Kong and engaged with the problem of mainland reception, Phoenix TV has to find ways to extend its reach to the Chinese audience. Similar to MTV Channel and Channel V of the same News Corporation Group, Phoenix collaborated with different local, provincial, and national newspapers, magazines, radio

stations (e.g., Beijing Radio) and television stations (e.g., CCTV) to launch various media events in different cities. Such cooperation was subtly allowed in March 2001, when Phoenix pioneered to jointly broadcast with a provincial television station, Tianjin Television, and then the implicit approval of this state-private collaboration was further confirmed by the involvement of CCTV. The collaboration was soon expanded to broadcasting overseas when in November 2001, the director of CCTV, Zhao, Huayong and the CEO of Phoenix, Liu, Changle signed an agreement to establish a joint company with each party owning 50 percent of the shares. Phoenix has had success in the American market with the assistance of the two major American satellite companies DirecTV and Echo Star since January 1, 2001, and CCTV hopes to rely on Phoenix to extend its influence over the Chinese in the North American market through CCTV Channel 4.

For Phoenix the collaboration gives them a more unimpeded path to cover sensitive Chinese events, which, for Phoenix alone, would otherwise be very problematic. The collaboration can be seen as an open legal loophole for this non-Chinese media to walk on restricted sacred land. At the same time, since Phoenix is able to present, comment, and interpret the news and information with their well-known star presenters and commentators, it does not lose audience appeal even though the same information is broadcast by the state media. For the state, the rewards of this collaboration are overt. With Phoenix as an imagined competitor, the out-of-touch state media had to speed up its process of reform specifically on the realm of news reporting. Before the 1990s, the use of standardized "facts" and political overtones, sound bites, and news feeds from centralized sources of the state was a common practice. As part of the united front, all Chinese media were coerced to offer the same version of stories with strong political overtones, and possibly with distorted and hidden facts. Accountable only to the party, news focused more or less on politics with little personal relevance and as such news was mostly planned and arranged. There was no on-the-spot reporting. To minimize political risks news was delayed and often repeatedly considered before it was released to the public. Propaganda was still the only and primal mission of the national media, live news broadcasting—understandably the most direct means of revealing the "truth"—was simply out of the question precisely because the live images could be substantial proof that refuted the mendacious state mouthpiece. In the entire newsmaking process, the New China News Agency and CCTV

served as the news gatekeepers for the printed media and television, respectively. Partly because of political obligation and partly because it is the dragonhead of information release, there was no compelling reason for CCTV to change its practices.

However, now there is comparison with Phoenix offering timely news with a different perspective on the spot and in the planned media events. As the growing global audience has widely realized the desirability of professional live reporting, the state had no choice but to renounce the old Ruritanian politics of the media. CCTV naturally is the essence of their entire reform. While, internally, the state still maintains CCTV's special position in news releases on some important national occasions, it has to widen its coverage, speed up its reporting process, and produce news with quality. In March 2003, for the very first time, it attempted to "catch up" with Phoenix by conducting international reporting on the spot amidst the Iraq War. Now in many of the national events such as the People's Congress and the National Congress of the Communist Party, CCTV is able to give timelier reporting. In sum, the state's construction of a semiopen competitive environment under the pretext of relaxing control of Phoenix could be regarded as a strategy to benefit its own media. Phoenix in this sense is a catalyst for the process.

CCTV versus Phoenix

From the state's point of view, although bringing in global media has macroadvantages, for individual media, Phoenix is a direct challenge, eroding their legitimacy and audience size. This is particularly so for the major state mouthpiece CCTV. CCTV is still far behind Phoenix in terms of capability in reporting both internal and international news, making the latter (as noted earlier) an important news source for government officials. Internally, under a looming national ideology, CCTV is still reluctant to rush to release sensitive political news. Even though CCTV claims a commitment to live reporting on news in the daily newscast and on news commentary programs (Meng, Wang, and Ni, 2005), what the audience sees on the screen are older images of the scene, leaving a considerable length of delay for the censors to expunge "improper" content (informal talks with CCTV staff). In other countries, in spite of the widespread ramifications its habitual practices and reliance on official versions of information deprives this state media of the necessary professional practices to obtain firsthand information. Although

it has moved toward a more efficient practice in general, for various reasons, and even with reforms, the giant state organ cannot be reincarnated in the form of a modern media like CNN or BBC. CCTV staff would not comment about their competitive relationship toward Phoenix; however, Chinese audiences who were habitually coerced to watch CCTV for many years indicated that the presence of Phoenix is a major change posing a threat to the legitimacy of the state organ.

Based on interviews and observations, CCTV and Phoenix are in a "love and hate" relationship with the balance slightly tilted toward the latter. CCTV's collaboration with Phoenix does improve its public image and CCTV also benefits from its own reform in response to the emerging competition from Phoenix. For this, it manifests an intimate relationship. However, the antagonistic relationship between CCTV and Phoenix is more overt. According to the figures released by the SARFT, in 2006 CCTV still had a monopolizing power with 8 of its channels in the top 10 national viewership list. However, this official rating was itself questionable since it was based on a set of chosen samples mostly taken in old city areas. With many households moving to newly built bourgeoisie districts, the official figures are suspect.[6] Besides, the official statistics do not take into account legal or illegal foreign television broadcasts like Phoenix. In some of the households in small townships in Shanghai, with the reception dish available in the neighborhood, rich people had already given up watching CCTV and switched to Phoenix TV. The rise of this foreign TV in China is now a warning signal to CCTV and other state-owned television stations regarding their uncompetitive policies.

Thus, there is no surprise that CCTV attempts to pressure Phoenix through various state departments. Occasionally, rumors were circulated that CCTV used tricks to suppress the influence of Phoenix. In an anonymous interview, a Phoenix staff working on the news affairs revealed how CCTV tends to stifle Phoenix. Not long ago, Phoenix was notified by the Propaganda Department of the Party that CCTV had requested Phoenix utilize the official sound bites when party leaders were interviewed with a view toward "unifying the voices" of the country. Obviously, Phoenix denied this intrusive practice right away, and given that the political leaders of the PRC have high regard for the station, CCTV may not be able to "bully" them so easily in the future.

The somewhat protected position of Phoenix, however, does not mean

that the state is not suspicious of this global power. Controversial and touchy coverage always has the potential to muster public support, the consequence of which might be devastating for a seamless governmental policy and absolute party leadership. The state does attempt to diminish the influence of Phoenix during some critical moments. More likely these are periods before the central committee of the CCP conference, the two conferences (namely, the National and Provincial People's Congress, and the Chinese People's Political Consultative Conference) in which the state suddenly returns to the normally unobserved regulations about satellite signal transmission to prevent public reception to suppress public discourse and dissidence about important party and government decisions. The most large-scale measure to clamp down on the foreign television signals was the several month period before October 2007, in which the Seventeenth National Congress of the Communist Party was held in Beijing. Without prior notification to the users, many provincial cable televisions that had made a fortune relaying this foreign signal to selected districts was forced to turn off the Phoenix TV to households. Phoenix did not realize there was a ban until they received complaints from users about the injunction on its affiliated Web site Phoneixtv.com.[7]

In the light of the potential dangers of global media, the authorities' attitudes toward Phoenix seem to be switching back and forth. When political leaders need to understand Chinese politics and society, issues of Greater China and international affairs through Phoenix's media representation, or when it makes use of it to expedite the national media reform, then the pendulum swings to the liberal side. But in cases of political controversy, they tighten the reins. In the short term, it is not likely that the Chinese authorities would like to suffocate the survival of Phoenix. Rather, given that the reforms of CCTV and other national media seem stalled—further reforming would require detaching them from the state ownership, which would seem unlikely—the Chinese authorities would like to keep this competitive global Chinese media intact. But the state would prefer the preservation of the status of Phoenix to be done with a stronger involvement of red capital and, that is, to dilute the global involvement in this special medium. Therefore, it is possible that the state through its soft power to convince the owner Rupert Murdoch to retreat from Phoenix, which is in fact a rumor circulated among the international media. What happened in June 2006 was already a slight retreat from Phoenix: with the pretext of exploring multimedia business of Phoenix, China Mobile (Hong Kong) spent HK$1.2

billion to acquire 19.9 percent of the shares from Murdoch, and it has replaced Murdoch to be the second biggest shareholder of Phoenix (next to Liu).

From a global player's point of view, a small station of 110 staff in an office of less than 3,000 square meters in Hong Kong has gradually evolved to be a global Chinese media that now encompass an entire building. Murdoch, who is rich in experience in dealing with the Chinese, may realize that he himself is the greatest concern of the Chinese authorities. Suffice to say that nobody knows whether there is an undercurrent of discontent in the collaboration between Murdoch and his Chinese counterparts. And in this entire cooperation, it is not Murdoch but Liu who maneuvers the station anyway, so it is not improbable that Murdoch would actively dilute his influence by letting shares of this emerging empire go in order to placate the Chinese authorities.[8] In this regard reliance on his entertainment-oriented STAR Group might be a safer strategy.

Phoenix Weekly: The Exceptional News Media in China

In relation to Phoenix TV Channels, its weekly publication *Phoenix Weekly* is worth discussing. As Phoenix's headquarters is in Hong Kong, its affiliated publication is naturally a nonlocal or an international publication to the Chinese authorities. Like Phoenix that aspires to the Chinese-CNN, *Phoenix Weekly* resembles the Chinese version of *Time* or *Newsweek* only in that it puts more emphasis on Chinese issues apart from general analysis of international news and affairs. With regard to this news magazine the important question centers on the extent to which the Chinese authorities would accept the operation of a foreign news medium in their own territory, and the role that it plays in the Chinese market.

At this point, because of its nature as a news magazine, *Phoenix Weekly* is an exception to the rule. The PRC has banned the distribution of print medium news. Since 1988 the PRC has long opened the door for the joint publication of China-edition foreign magazines; it only allows magazines about fashion, entertainment, or leisure to enter the nation and the publication of the Chinese versions of these magazines must comply to a local-foreign content ratio, with roughly 70 percent of the magazine covering local content aside from the Chinese language requirement (anonymous interview with an editor). International fashion magazines *Elle, Cosmopolitan, Marie Claire,* and *Vogue* are precursors of these ventures that tune local content with a

"Chinese orientation." However, the circulation of the "more-Chinese" *Phoenix Weekly* is more complex. This is because, first, *Phoenix Weekly* is a news magazine, and in China, there is no precedence for print covering political news and commentaries. Second, as a matter of fact, despite locating its editorial department in Beijing, the Hong Kong–based magazine is not a Chinese (local) edition of a foreign magazine. Considered simply an imported international magazine owned by foreign capital, the Chinese authorities have to exercise discretionary rights to allow its distribution and circulation in the mainland. Its status would be similar to the German-based Bertelsmann AG, a global print media company that received exceptional permission from the Shanghai Foreign Trade Committee in February 1995, to jointly work with Chinese Technology Book Company (under the Shanghai News Publishing Bureau) to create Bertelsmann China for importing foreign books and magazines into China. The philosophy of this foreign print media, including *Phoenix Weekly,* is clear, as the president of Bertelsmann Direct Group put it in essence, "Our mission is also to establish trust with the authorities of the host country…" (Bettina, 2002).[9] Once again, these foreign printed media demonstrate that compliance to the authorities' demands is the basic rule in their localizing. Simply put, without this privileged arrangement with the authorities, they could not operate in China.

Currently 80,000 out of 100,000 copies of *Phoenix Weekly* are circulated in the mainland China (statistics from an informal talk with a *Weekly* reporter, no official statistics are released), which is a moderate figure compared with the most well-known Chinese edition of the fashion magazine *Vogue* that has a circulation of 300,000 in the PRC. Given the large numbers of daily, evening post, weekly and monthly magazines in China, the competition in China is extraordinarily keen. To locate a market niche is a must, or else the medium is deemed to fail. For a news magazine like *Phoenix Weekly*, a complaisant state-owned attitude would spell ruin. A slightly critical angle is needed to differentiate it from other local media. In terms of content, *Phoenix Weekly* attempts to look as if it's different from television, but nonetheless makes some connection so that the reputation of Phoenix can be carried over to the magazine. Quite often the printed medium covers the more sensitive issues that are not available to the broadcasting media. Obviously, being circulated in China the magazine hesitates to examine political taboos, for example, to expose corruptions of officials by name and engage in various activities associated with muck-raiding. The latter might be quite legitimate in Hong Kong and in Western settings, but this "professional" legacy seems

to have been truncated even though many of their journalists have been educated overseas. In order to lull state suspicions the magazine must uphold certain unbendable principles, for example, the unification of Taiwan and a firm derogatory stance against Falungong. Being compliant to the state on big principles, in return, the authorities have implicitly given room for mild criticism as verbalized by a reporter, the informal rule is "it is perfectly ok to say a system or an administration riddled with corruption, but not to pinpoint individuals."

Innuendo is a common strategy used to maintain an optimal stance while not recklessly testing the tolerance of the state. For example, the *Weekly* used "The Last Noble" as the title of the cover story to describe the forgotten party leaders and patriots, and even the vicissitudes of this aged clan of the Taiwan's former ruling family in New York (Issue 239). While the focus of this sympathetic coverage was about the fading rulers in Taiwan, readers were reminded of the fates of their venerable aged party leaders who are also disappearing. Another example is the report on the "pilgrimage" of the premier of Vietnam to the Vatican City (Issue 247). While political rows between the Roman Catholic Church and the Chinese authorities on the issue of the autonomy of the Chinese Catholic Church endure, the positive tone of the coverage highlights a possible model for China to restore the diplomatic relationship between the church and the socialist regime. Although there is no proof of this indirect influence, in the messages from readers in the Phoenix Forum Web site (phoenixtv.com), *Phoenix Weekly* as well as the television have already been takenup by a populace eager for an alternative angle on topics that are sensitive in nature in China.

As a foreign news media, *Phoenix Weekly* has demonstrated that localization may take a different route (from other media). Print media are less likely to seek collaboration with the state authorities in that the collaboration means surrendering key editorial rights to the Chinese authorities and thereby degrading the print into another mouthpiece of China. Nor can the print media go localized by publishing the so-called Chinese version because then the entire media would conform to the thorny set of regulations that "normalize" the mainland printed media industry, a situation in which the *Weekly* will lose its critical edge. Thus, it can only survive case by case depending on the maintenance of the special deal with the authorities. Without a massive opening up of China, it is improbable that global entry of printed news media will be allowed in the not too distant future.

Sun TV: The Border-Crossing Model

Among all global-capital involved media, Phoenix TV and its magazine's success might be atypical cases. Sun TV is also a Hong Kong–based television network with similar red capital background and with the same strategy of reaching the mainland audience via satellite signal, but without proceeding to localizing its production in Beijing as Phoenix did, Sun TV developed its own edge and it could become a huge financial burden for its owners. In March 2000, Sun TV was founded by a former CCTV female presenter Yang, Lan when she and her husband Wu, Zheng, through acquisition and renaming of a listed company in the Hong Kong stock market, set up the Sun Cyber-networks Holding Limited. Under the Holding, Sun TV started its operation via satellite Asia 3S since August 2000, and after only one month after its setup, Sun TV received permission form the SARFT for its frequency penetration. Sina.com (which is the Latin origin of Sino meaning China) in October 2001 acquired 29 percent of the Sun TV. The acquisition, at that time, was regarded as a synergy of Sun TV and Sina.com to offer crossover multimedia and broadband content (Sina.com, October 2, 2001). After the acquisition, Wu was appointed as the chairman of the Board of Director of Sina.com. The latter is the largest Chinese news portal with 95 million registered users and 450 million hits daily, but being a Chinese corporation, it has to comply with the Chinese rule to source all news from the official *People's Daily* or Xinhua News Agency without using their own reporting team (Xin, 2002).

In the shadow of the semiofficial news source and investor Sina, we do not expect that Sun TV can be in any sense antihegemonic and critical in nature. What is paradoxical, however, is that Sun TV brands itself as a documentary channel—more or less aspiring to be the Chinese Discovery Channel—supplemented with programs about intellectuals' biography, finance, and the history of China.[10] With a large dose of Chinese culture—documentaries on contemporary society—this Chinese medium is faced with a serious dilemma. Interpreting the content with a strong political stance will undermine its objectivity while a radical version will harm its relationship with the authorities. The safest kind of program on the channel is probably those dubbed Chinese versions of Western documentary programs that fill in some of the timeslots. Sun TV possesses the sole broadcasting rights to the televised dramas for the American A&E Television Network, Discovery Channel, and also movies from Starz Entertainment. The question

is to what extent a channel that largely stakes its credibility over factuality and documentary fame can function compatibly with the political stance that it takes.

As for reception, Sun TV coverage in mainland China was as difficult as Phoenix but it is still legally received in hotels, and if audiences are willing to risk it, they can also unlawfully intercept the signal for household use. Nonetheless, except for frequent changes of ownership, the market share for Sun TV has shown no signs of improvement. In the year when Sina acquired Sun TV, the value of Sun TV shares was multiplied by 20 times, but after 3 years of operation, the accumulated loss amounted to HK$200 million. The founder Yang, Lan described her "ideal" of setting up a unique Chinese documentary channel as her biggest setback in life (Shen, 2005, November 21).

Reception may be a problem but the crux of it for Sun TV is its lack of market differentiation and an overwhelming reliance on its "Hong Kong advantage." In fact, it claimed that in 2000, 35 million households in major Chinese cities could watch Sun TV.[11] Outside mainland China, Sun TV also reached Hong Kong households via Cable Television and covered 680,000 and had the potential of 4 million Taiwanese via the Taiwan Knowledge Channel. As a foreign television station based in Hong Kong in the late 1990s, it did have the appeal of Western modernity and capitalism associated with this former British colony (Fung, forthcoming). However, along with the change of internal television programs, economic growth faltered as it struggled to make cross-border television a commercial success. In 2000, when audiences in South China were offered either outdated television dramas or propaganda from the provincial stations, they turned to the two Hong Kong terrestrial channels, namely Television Broadcast Limited and Asia Television, that in total accounted for 70 percent of the Guangzhou (the major southern Chinese city) market. Quite likely, Sun TV was able to share some of the viewership. But since October 2005, owing to the formation of the Nanfang Media Group, reform has driven the industry (which will be further discussed in Chapter 7), and the ratings of the two mainland provincial stations (32.4 percent viewership) for the very first time in history exceeded that of Hong Kong (30.3 percent) (National Bureau of Broadcasting and Television Development and Research Center, 2007, August 2). In other words, the local televisions have regained territory from foreign television. This also suggests that mainland audiences nowadays are very

selective in choosing stations. Party propaganda is definitely not their cup of tea, but neither is the mysticism associated with foreign and Hong Kong television just across the south border. Now Sun TV and other foreign televisions have to search for a real content formula to ensure their continued survival.

With documentaries as their branding, it seems that Sun TV is trapped in an impasse. A foreign television necessitates carrying a unique content from without so as to compete with other Chinese stations. However, being a television station partially owned by another Chinese media (e.g., Sina), it cannot deviate too much from the political norm to offer critical political commentaries in their documentaries, not to mention including any news programs in its programming. In 2003, its owner Yang, Lan resorted to selling 70 percent of Sun TV, and Yang and Wu also publicly announced the setup of a nonprofit Sun Cultural Foundation that holds 51 percent of their holding company for Sun TV, and completely retreated from the management of Sun TV. The controlling right of Sun TV was then passed to the major holder Xing Mei Media and its affiliated company Strategic Media International Limited. Xing Mei was the former Hong Kong–based entertainment company StarEast,[12] and its Jet Television has secured Chinese entertainment programming in Taiwan, Singapore, Malaysia, Australia, New Zealand, the United States, and Canada. Nevertheless, in 2006, due to continued deficits, the latter was sold to a listed Hong Kong company TideTime. Without a face-lift of its branding, Sun TV was still not seen escaping from its misfortune. In a nutshell, the case of Sun TV demonstrates that the challenges for transnational media go far beyond entry. The content is still king and commercial considerations for the content is as essential as is a political stance for survival in this new terrain. Sun TV still faces the formidable task of locating its market niche and doing so in a brave new world where both the state and audience are more demanding.

CETV: Entertainment With(out) Boundaries

CETV chose an easier route for its China entry. In stark contrast with Phoenix TV and Sun TV who entered with an emphasis on news and documentaries, respectively, the orientation of CETV is 24-hour entertainment; no news programming or documentary were ever inserted into any time slot of their programming. Founded by a Singaporean Chinese, Robert Chua, in 1995, CETV chose Hong Kong as its headquarters. Several years earlier in a

radio interview in which Chua and this author both served as commentators about the adoption of Western television programming in Hong Kong, Chua (behind the microphone) mentioned his enthusiasm about plans for creating entertainment programs he believed were marketable in Chinese settings and had fewer unpredictable parameters. His idea remains germane in that CETV with its entertainment branding has so far not encountered any political hurdles. At least, the authorities do not treat CETV as if it were a mutinous child in need of strict disciplining. Although CETV has since changed hands, the founder's idea of selling entertainment to the Chinese is an unchanged strategy for television.

In these early days, despite the fact that Chinese audiences are almost overwhelmed with Western information through various different channels, CETV, as a border-crossing television, must continue to strive for an optimal balance to produce a "standard" of entertainment programs for the China—being not too vulgar and boorish in the eyes of the authorities, but not too squeamish in the eyes of the consumers—is a delicate but necessary skill to be acquired. Again, the image of CETV as Hong Kong television for Chinese people had a considerable appeal to the mainland audience, but that lead may not last long. Beaming cross-border to the populous areas in South China (Guangdong area) is still a divided market where mainland reception is highly restrained. In addition, CETV was hamstrung by low subscriptions and low advertising revenue. CETV then became entangled in serious financial problems. Quite coincidentally, on the verge of bankruptcy, the owner Chua met the largest media conglomerate AOL-Time Warner—a company that fervently desired to enter the China market at all costs. In February 2001, AOL-Time Warner acquired 85 percent of the shares of CETV and the latter then became the conglomerate's first world Chinese channel. Only nine months after the acquisition, CETV, along with other global players such as News Corp's channels and Viacom's MTV, was granted permission to relay to all three-star or above hotels in China. At this juncture, contrary to the common belief, China seems to be very receptive to global media.

CETV goes off at a tangent soon after the acquisition of Tom Group in July 2003 while AOL-Time Warner still possessed 36 percent of the shares. The entire programming was rescheduled and the management was newly recruited from other television stations and other business sectors. The new management admitted that in the early days of ownership shift, the entire

station was still in search of a new direction (interview with Starr Zhou, the Channel Controller, and Feng, Qi, the Assistant to Channel Controller on September 24, 2004). It seems that after years of reorganization, CETV has returned to the old model of entertainment. The owner of Tom Group, the multimedia platform that widens interests in China business, would not risk jeopardizing its Chinese *Guanxi* or its relationships with tricky political agendas. These days they have produced their own reality shows (*Big Star Raids Small Kitchen* (a Chinese version of *Hell's Kitchen* on Fox's TV, Damingxing Tuji Xiaochufang), entertainment news (e.g., *World's Entertainment Guide* [Tianxia Yule Tong] and music and fans shows (e.g., *All Stars Singing Show* [Quanmingxing Kehui]. However, for television dramas and soap operas, they would rather offer a potpourri of dramas from different places around the world, from Asia (*A Kiss* from Taiwan in 2005 and *Princess Hours* from Korea in 2006) to the Untied States (*CSI Miami* from the United States in 2007) in lieu of high-budget self-production. It is true that the potential of entertainment is tremendous. But so far CETV has not explored any new television formats or gone beyond the existing boundaries.

CETV under Tom Group still feels straitjacketed by the government's lack of a clear attitude toward foreign television. In the last instance, whether entertainment entertains depends more on the accessibility of the content. Thus, when there is no transparency about whether the Chinese authorities would allow border-crossing signals to be broadcast entirely across the territory, owners have to be very cautious in changing entertainment branding. The current branding that has a relatively easy predictable outcome and effect on the Chinese audience is logically a pragmatic strategy for a foreign medium in China. However, since keen competition among the mainland television stations has now pushed some of them to develop highly commercialized entertainment programs that enjoy extremely high popularity (as measured by means of audience interactions, online, and cellphone voting) the state started to take heed. These programs not only undermine the ratings for state organs, but also incite public sentiment and provoke democratic desire. For both the state and CETV, a television station with a drama, variety show, and music can very quickly become ideological. Accordingly, CETV and other global television stations have to reckon with the sensitivities related to the entertainment medium, no matter whether it is of their own production or those of an imported product.

Tom Group and the Great Firewall of China

The variants discussed earlier represent mass media with a single fo-cus—either television or the printed media that are marginally able to operate on the mainland. There are other variants whose businesses belong to a new media type that is not subsumed under the control of the SARFT or the General Administration of Press and Publication (GAPP) of the PRC. Tom Group is a Chinese media, jointly established by a few major international corporations including Hutchison Whampoa and Cheung Kong Holdings in Hong Kong in October 1999. The owner of these companies is Ka-shing Li, the ninth richest man in the world according to Forbes and the richest person of Chinese decent in the world. Besides his global business in telecommuni-cations and 3G mobile, he has shown great interest in the media business in Hong Kong and China.[13] Tom Group is one of his major media arms on the mainland. Headquartered in Hong Kong, the Group's main business covers markets in the PRC, Taiwan, and Hong Kong, branching from the Internet services, outdoor advertising publishing to sports, television and entertain-ment (CETV mentioned earlier). Despite Li's personal charisma and the Group's prospects, this new media business is still far less lucrative than his core property—telecommunication and shipping businesses. In the first half of the financial year 2007, Tom Group registered a net loss of 72.35 million Hong Kong dollars, reporting a fall of total revenue down to HK$1.3 billion, 8.6 percent lower from a year earlier. The interim report pointed to one of its subsidiary companies Tom Online as the primary culprit (Zhou, 2007, August 12).[14]

Tom Online is the most substantial medium of the Group rooted in China, and like other global media it carries huge profit potential but at the same time the operation is very unpredictable and therefore risky. Operating a Chinese language portal, tom.com provides mainly online and mobile services, wireless Internet connections and services for the younger, trendy, and technology-savvy generation in China. Its portal features over 50 content channels on topics such as entertainment, news, music, and sports and has a top three ranking in every wireless Internet segment attracting on average over 225 million page views per day. In 2004, Tom Online became a separate company from its holding company the Tom Group, and listed on the Hong Kong and U.S. NASDAQ markets with the Group holding a 65.73 percent controlling stake. In 2005, more than 70 million users had signed up for its wireless Internet services including SMS, MMS, WAP, IVR, ringtones, and

ringback tones (Wolff, 2005, September 5).

Tom Online losses reported in 2007 could be attributed to new policy directives from the MII, which had a vested interest in China Mobile, the largest mobile operator and also a direct competitor of Tom Online. If defined under the Western legal framework, this state-owned telecommunication corporation could face the serious charge of conflict of interest, but in a state-capitalist complex there is nothing strange let alone illegal about this activity. In 2006, the new policy officially released by China Mobile gave all customers of mobile and value-added service a free month-long trial for both new and existing subscribers. The new rule compelled all parties concerned to receive SMS confirmation from the users before charges were levied. It meant that Tom Online and other players would lose quite a number of existing inactive users while China Mobile could take this opportunity to entice customers to switch to their market plans. In general, the new policy was regarded by the entire new media industry, including Sina.com, as an incursion into the mobile value-added service market, creating an overall negative impact on existing players. To offset the negative effects and avoid future fluctuations due to the political manipulation of the market, Tom Online resorted to branching out into a number of new fields like e-commerce and new media. The new decree and the shifting legal framework that check foreign business operations are, however, not uncommon in many sectors in the PRC.

Given that Tom was a clear target identified by many Chinese counterparts, Tom's advantage may not purely be because of its China experience, but may instead hinge upon an international status that enables it to connect various global ventures and with China. Because Tom Online is a window to China's Internet world, multinational partners are keen to hook up to Tom Online in order to dispatch their Internet-related services in China. Tom Eachnet is one of these important joint corporations with Tom Online with 51 percent held by Tom Online and 49 percent by eBay International AG. Combining eBay's experience in e-commerce and Tom Online's resources in wireless services, Tom Eachnet is an enhanced auction customer-to-customer (C2C) platform migrated from the former eBay Eachnet platform that covers both mobile and the Internet marketplace. Before the collaboration, Eachnet had been the leading e-commence company allowing its community of users to buy and sell a wide range of items, from personal collections to commercial products, in both auction and fixed price formats. In 2003, Eachnet was reported to have 4 million registered users. Another of Tom's international

partners is the U.S.-based Skype, a company specializing in Internet telephony and messaging services. It is attempting to expand their market in the mainland China, after its partnership with PChome Online and Hutchison Global Communications in Taiwan and Hong Kong, respectively. The joint venture with Skype offers Skype Voice over IP Communication Services. In essence, it is a peer-to-peer software that enables users to communicate by message, voice and video over the Internet. At the end of 2005, Tom-Skype had 7.43 million registered users.

The problem with the global players that marched into China hand in hand with Tom is that they have to avoid party taboos if they would like to do business. Falling more or less in the same situation as global media and satellite television, these incoming technology partners are told to avoid irritating the authorities with words such as "Falungong" and "Dalai Lama" as transmitted through and by their Internet interfaces (Einhorn and Elgin, 2006, January 23). Registering their business in China, they have to echo the Chinese authorities that append filtering features to their vast infrastructure of online technology to monitor and screen out messages from without that are deemed offensive by Beijing (Feng, 2006). Although neither Tom nor Skype confirms the censorship and responds to the public complaints, the "security" network and the filtering procedures do exist. In the wake of the huge power of online and mobile discourses, the PRC steps up direct measures—such as jailing potential activists and cutting off access to servers with messages unfavorable to the national policy (e.g., Fung, 2005)—and indirect means such as screening out offensive messages and expurgating dissent by using an array of proxy servers to maintain a sphere of consensus within the state, these transnational players also fear that these political problems will hamper their commercial interests.[15] From a political economy perspective, it is not a matter of having the intention of or of not toeing the party line. In practice, the PRC ensures that for foreign investors, there is no business package without political obligation. For these new media business, as Guangchao Feng (2006) describes, with the advent of Internet technology, the Great Firewall of China is not just a core defending line located in the backbone or the nexus of the Internet, but is built virtually in everyone's home. Clearly, the authorities make the latter a duty of the global investor.

Another major branch of Tom Group, Tom Outdoor Media Group (Tom OMG)—one of the top 10 advertising media on the mainland since 2006—is also one of the favorites of international partners. Tom OMG's business

centers on advertising billboards and unipole networks, complemented by street furniture and transport advertising, claiming a total media space of over 300,000 square meters spanning over 60 mainland cities. As an advertising company, its profits oupaced many other new media and foreign television in China. In 2004, it was reported to have a revenue growth of 24 percent and HK$369 million and a profit leap of 118 percent to HK$5.8 million.

The booming of the outdoor advertising industry is promising for global investor. Global investors such as MediaNation, which is owned by Europe's top advertiser JCDecaux, had long marched into China, becoming the sole agent for advertising in the Beijing Metro and owned 1,000 newspaper kiosks in Shanghai. In 2004, it was reported to have a revenue of HK$439.6 million, representing a 17 percent increase. According to the State Administration of Industry and Commerce (SAIC), China's total advertising expenditure reached RMB126 billion in 2004, about six times as much as in 1994. But in comparison, outdoor advertising expenditure had an exorbitant rate of increase of 20 times from RMB611 million in 1990 to RMB13 billion in 2003, having an annual increase rate much higher than traditional advertising (Xinhua, 2005, December 3). Outdoor advertising has already become the third largest medium, after TV and newspaper, taking about 12 percent of the entire advertising market, and this makes Tom OMG an attractive partner for the global capitalists.

In addition, outdoor advertising is one of the few promotional tools that is relatively free of ideological control from the state-owned media channel in the Chinese context. It is also the terrain that global players can operate safely without restraints imposed by the authorities. Sporadically, there has been an outcry from the public about the fact that the outdoor advertisers changed the contour and look of skyscrapers particularly in those developed cities along the coast. But in general, the city and municipal governments are very receptive to large billboards with neon lights featuring international brand names because it represents the international status of the city and attracts incoming investors. There were even media reports expounding open complaints from the domestic operators about the privilege given to foreigner counterparts. Though officials from SAIC disclosed that long-term regulations were in the making, up to this moment, there was still no law keeping in check the content of outdoor advertising.[16] The lenient official attitude over this unattended area seems tailor-made for global corporations to expand their business.

As well, foreign players still need established and experienced companies like Tom Outdoor to build up their businesses. In line with China's WTO agreement, in theory, wholly foreign-owned advertising enterprises should be able to operate independently in the country after December 2005. However, those 4As (The Association of Accredited Advertising Agencies) or global advertising firms, including the world's top 10 firms such as Dentsu, Y&R, McCann-Erickson, J. Walter Thompson, and O&M, which had previously entered the China market based on the Provisions on the Administration of Foreign-Invested Advertising Enterprises,[17] had chosen to remain intact after the relaxation of the policy, preferring to continuously conform to the 7:3 rule of ownership, that is, global investors could own up to 70 percent of the shares of a Sino-foreign joint venture in advertising while 30 percent of it should be a local Chinese company stake. The logic here is simple. No foreign players could go it alone in surmounting the complicated politics and commercial regulations in China. For Tom OMG, it has the advantage of bringing in global outdoor advertising players into China. In March 2006, Singapore Press Holdings entered into a strategic partnership with Tom OMG through its wholly owned subsidiary, SPH MediaBoxOffice Ltd., Singapore's largest outdoor motion display advertising network. Investing in Tom OMG US$26 million, Singapore Press Holdings now owns a 35 percent stake in TOM OMG and has "landed" in this new expanding market. There are also over 60 magazines and publishing businesses with 14,000 titles under the Tom Group.

Yahoo and Google: The Virtual Chinese Police?

It's true that Tom Group as a foreign media has successfully taken shape in China, but it is an exceptional case: its owner Li is not only an influential businessman in Asia; he has had a long relationship with and is basically a strong supporter of the Chinese government. Li was one of the Hong Kong tycoons invited by former Chinese leader Deng, Xiaoping in the 1980s to become a member of the board of directors of the China International Trust and Investment Corporation (CITIC), the chief investment arm of the Chinese government, to support Deng's economic reform initiatives. In 2002, when Li's Hutchison Whampoa attempted to buy out Global Crossing, the largest telecom company in the United States, many U.S. media armed with evidence based on the Rand Corporation report noted that CITIC had acted as a front for Poly Technologies Incorporation, the arms manufacturer owned

directly by the Chinese People's Liberation Army (Smith, 2002, March 7). Li's personal as well as business relationship with China definitely has granted Tom Group a different status from other foreign media investments. As we will see, the two biggest international Internet businesses in China—Yahoo and Google—although they operate on a much narrower scope than Tom Group, they encountered an entirely different experience. It is not, however, suggested that these global media could not, as other businesses do, invest in the China market under normal trade relations. As a matter of fact, rounds of negotiation between the United States and China prior to the PRC's entry into WTO resulted in attractive terms for new media industry: foreign investment in telecommunication services could reach 49 percent, in added-value services and other message/paging services 51 percent, and more important, free entry and nonrestricted investment in Internet market. However, all these do not imply that these global investors can skip the content regulations that were applicable to all local and national media in China.

Yahoo (Yahoo.com or Yahoo!) is one of these trapped in the controversy over China's control of the Internet. Yahoo is an American corporation that specializes in global Internet services via its Internet interfaces, ranging from Web portal, search engines, games, news, and postings. Being one of the most visited Web sites on the Internet, it therefore wants to enter into China's fast-expanding market. Along with other big American corporations—Google, Microsoft, AOL, Skype, and Nortel, to name a few—Yahoo has been assisting the Chinese government in implementing the system of Internet filtering and censorship in mainland China by signing the "Public Pledge on Self-Discipline for the China Internet Industry," an agreement that guarantees their observance of the mainland Internet regulations. In terms of content on Yahoo China (yahoo.cn), after all, it is not too different from other Chinese sites that are subsumed under Chinese laws. Particularly on news, Yahoo's Chinese news is not very different from Sina.com; it chooses more or less the same news as their news headlines in that they are compelled to use the same official news source.[18] Practically then, Yahoo China is just another platform for conveying the government message and is not really an active supplier of information.

The problem of Yahoo is not its very meticulously monitored content in China, but its net users who could via the forum or e-mail account disseminate dissent information that Yahoo itself does not wish to see. These "subversive" behaviors lead to requests from the Chinese authorities that

Yahoo is obliged to follow. The most notorious case was Yahoo's release of the IP address of a journalist who used Yahoo mail service, which then in turn led in April 2005 to a 10-year sentence—a verdict of the Chinese Provincial Court convicting the journalist for "divulging state secrets abroad." In this case, what the journalist, Shi Tao, sent out from the Yahoo mail account was a brief list of censorship orders during a sensitive period just before the anniversary of the Tiananmen Square Incident. The recipient was the Asia Democracy Forum. In the eyes of the authorities, the latter definitely is an "antirevolutionary" organization that attempts to undermine the PRC. Accordingly they compelled Yahoo to disclose the information that they needed to jail the "dissident." This case finally forced Yahoo to give a sworn testimony before the U.S. Congress in February 2006. In 2007, Yahoo was also sued for the same reason when they released information that aided the Chinese government in arresting Chinese dissident Wang, Xiaoning who posted electronic journals in a Yahoo group calling for democratic reform and an end to single-party rule. In different parts of the world, there were movements initiated by human right groups to boycott all Yahoo products and services in protest against Yahoo's "iniquity" (e.g., Reporter without Borders). Temporarily putting aside a moral judgment of Yahoo's actions, this highlights the dilemma that most media organizations are faced with. Either being blocked for access or making concessions to the authorities, new media have to consider the issues of privacy and confidentiality of information in the light of the political correctness of the content that previous chapters have focused on.

Another U.S.-based Internet corporation Google faced an even more severe problem in China. Being mainly an Internet search engine without its own content, its popularity on the Internet depends totally on the usability of the Web search, meaning the capability of it to locate a comprehensive list of links ranked in order of importance and relevance to the keyword input in the search. China's tight rein on the Internet and its restraints on the access of certain virtual links tend to contradict Google's mission: "to organize the world's information, and make it universally accessible and useful." The filtering mechanism that caters to the requests of any authority leads to truncated information and de facto censorship.

To adhere closely to its philosophy, Google for a long time had eyed the China market but could only peripherally offer a Chinese language version of its search engine for mainland users. Overtly, aware of the foreign penetra-

tion, the Chinese authorities used its proxy servers to block the access to the link as much as they could. This resulted in the Chinese version of Google, Baidu, outperforming all worldwide leading Internet companies in mainland China including Google and Yahoo.[19] As of 2006, Google and Yahoo only secured 23 and 3 percent, respectively, of the China market, while 70 percent of the pie was in the hands of Baidu.[20] In order to take a share of the Chinese market and acquire a legal right to share China's fast-growing user market, and more important the annual RMB8 billion online advertising revenue (according to Nelson/Netrating in 2007) (*Daily Economic News*, 2007, August 28), Google chose to enter China with a safe solution: amputating its popular profit arms, including e-mail, chat room, and blogging services, it set up Google.cn that focused merely on the function of Web search in China in 2006. Google deemed that partial cessation of such services as necessary because it might repeat the lesson of Yahoo should the government demand it provide users' personal information, a political demand that might ruin the reputation of Google. The initial result seems successful. Since this global media in China is now reduced only to a search engine, there is no criticism about its content. However, to ground its service on the mainland, Google has to set net blocks to censor itself lest they damage the working relationship with the Chinese authorities. Sensitive terms (e.g., "Independence of Taiwan" and "Tiananmen Square Massacre") and Web sites (e.g., BBC News) are then made inaccessible, or the search of some banned articles such as those related to Falungong would be directed to a string of articles reproving the "religion" (BBC News, 2006, January 25). The payoff of this China venture is that Google has infuriated many worldwide Google users who attempted to call for a boycott of its service. Many human rights organizations also criticize Google as being hypocritical by upholding a corporate motto "Don't be evil" while working closely with the Communist censors.

The transnational new media such as Google, Yahoo, and other Internet global players are expected not to be too different from the mainland operators in that these giants readily push aside principles of privacy, democracy, human rights, religious freedom, and so forth upon their entry into China. They eventually join the crew of the virtual police. Nowadays, in these China ventures, we can see that the economic motives are not only prioritized over ideals but also coerce these global partners to side with the Chinese authorities in terms of political positions. These actual scenarios disprove the common thesis that new information and communication technologies foster cyberspaces in China that could empower individuals who eventually will be

able to campaign against governmental decisions (cf. Tai, 2006). When the Great Firewall cut off China from the outside world, civil societies inside and outside the national borders were then not able to be reconnected to transform local structure or reformat politics (cf. Anderson, Dean, and Lovink, 2006). Instead, the global has itself been co-opted by an extensive government network bent upon maintaining a state discourse that thwarts alternative voices. Global media of this kind can only produce hegemony.

Conclusion: Are They Really Variants?

In this chapter, we have examined a number of transnational media, comprising television stations, Phoenix, CETV, and Sun TV, and other media forms such as Tom Group, Yahoo, and Google, each of which attempted to enter the China market in their own pragmatic way. Under the control of the Chinese authorities, they could function—if not as puppets—only within a very strict political boundary. There seems no single path to reach Beijing, and their entries into China resemble guerilla warfare requiring a range of different tactics. The Beijing authorities also give different gestures of welcoming toward these newcomers. To some, the PRC appeared as a Forbidden Palace, but to others it opens the dragon gate for them. Thus, the legend, failure, and success of these various foreign media or transnational media cannot be taken for granted as models for other global media that aspire to enter China. At this point, it is not totally clear that the variants mentioned in this chapter are really all "deviant" cases. It may well be that the more predictable forms of collaboration in terms of hybridization or localization mentioned in Chapter 6 are just special cases that Beijing wants to establish so as to tell the world that the Chinese state is determined to open. Should we care to count the number of these variants discussed in this chapter, they might well end up being in the majority. Perhaps they are variants simply because until now, there is still no concrete route to follow and leave a reliable footprint for others to follow.

Despite these concerns, the cases do illustrate the fundamental position of the Chinese authorities and the reflective landscape of control and ideology in China. Whether the PRC is willing to give such attractive offers to incoming players depends very much on China's political situation at any particular historical moment. In the coming years, the key issue that continues to preoccupy these variants might still be legitimate and proper channels for media access. Many of these media are geographically still on the edge of

China, and have not yet penetrated into the core of the Chinese market. As the media race intensifies, these variants are busy grappling with the problem of reception, believing that the faster the entry, the bigger the market they can secure. For the Chinese authorities employ the same strategy as they did when they teamed up with Viacom's MTV and Murdoch's Channel V: those making greater contributions to the country in terms of money, national power, and social stability are likely to be given better terms and a higher priority. A good example is Phoenix that has demonstrated a phenomenal success in waging a slightly critical edge amidst the closed political environment. Its presence not only speeds up the reforms of their own media organ, but also keeps the political leaders vigilant of any potential issues flaming up both outside and inside the country. There is no reason why China would reject it, except the fact that China still has a lurking suspicion toward any global player who owns a very influential cultural weapon in China. China's worry is quite legitimate as international political powers seem particularly interested in mingling with the internal Chinese politics—in issues of Taiwan and Tibet, for example—prompting the leaders of the PRC to reflect on the idea of organized powers that would like to sabotage the regime. Under this special situation, the Chinese tactic is always to deal under the table. In the end, economic strategies are better and more legitimate measures of intervention since money is still deemed a neutral entity in the global world. The outcome is often shifting the controlling power of the influential variants into the hands of red capitals. The red capitals are after all more "self-disciplined" or easily tamed than the global capitals. In these cases, it is not that global capitals are more moral and hardnosed; rather, global players are content to compromise. It is just that the political discourse and environment that these players reside within gives them too much pressure to hide their real business motives.

Considering the long-term trend, it seems that the future is quite positive for these variants. At this point it is almost impossible for the Chinese authorities to bring back greater control over these media, in particular when China wants to appear good in front of the international stage. At least for those border-crossing television stations, China has maintained a robust policy to let them in with a relatively transparent policy of applications. For the new Internet media, rather than outlawing Tom, Yahoo, and Google, China now gives them an option—which is to voluntarily agree on Chinese terms—to operate their business in China, and above all with promising profit margins. On the whole, the exceptional and flexible policy of the

authorities to allow the entry of the magazine business, Internet business, and news and entertainment media also show that China is not unwilling to let transnational media share part of the Chinese market. Discretion, caution, and prudence are required. With the state becoming more advanced and active in creating its own culture and media, there will be new forms and strategies emerging to accommodate these global players. Symbiotically, political effects will remain superimposed on the global media's potential to make profits in China.

Notes

1. According to the Ministry of Labor and Social Security, there were only 150,000 and 40,000 of them resided in Shanghai in 2006 (Szdaily Web, 2006, April 5).

2. STAR TV and Today's Asia owned this listed company 75 percent and the public investors held 16.4 percent of its shares in 1996.

3. As I would discuss in Chapter 7, the dominant means to crystallize the Chinese community in the mainland is through the uses of popular culture. As for the formation of global Chinese community, CCTV and other state organs are still not able to accomplish this goal and that is why these Chinese media have to acquire a globalizing capability through global collaboration.

4. It is true that the news of the demonstration was suppressed, but in fact, journalists of Phoenix were dispatched to film the incident on the spot. Although the event was not reported as news, the footage was still used as background in various commentary programs.

5. There is internal rule in Phoenix forbidding all the staff to accept public interviews. The data obtained for this chapter thus goes through only informal anonymous talks.

6. This is the general impression of the personnel in a large national marketing research firm in China. Because of the sensitivity of the issue, the name of the firm is not revealed in this book.

7. Phoneixtv.com is the new media unit under Phoenix TV established in June 1998. Now registered under the Ministry of Information Industry of the PRC, Phoneixtv.com is a news portal based in Beijing. Like Phoenix TV, it posts many controversial Chinese news online and it enjoys a high reputation among Chinese authorities. The Chinese authorities also exercise the same measures of control on this portal. For example, the portal was warned of the oversensitive issues in the advent of the Olympics 2008. Now the bulletin board of the portal or the Phoenix Forum has become a semidemocracy wall of China in which complaints and criticisms of various Chinese affairs are seen. Yet, for many bold sayings sent to the forum are expunged, while the forum also restrained the replies to some of the visible messages posted out to avoid possibly crystallizing a large of potential dissident online community.

8. It was only until 2006 that the *Financial Times* disclosed a possible withdrawal of Murdoch's involvement in Phoenix.

9. Bertelsmann then extended its influence by setting up a book club in China with a membership of 1.5 million. With a green light from the authorities that do not censor the media, the Book Club gestured friendly attitude to the Chinese authorities. Bertelsmann

also partnered with a local Internet provider to launch www.bolchina.com, an international online media store (Bettina, 2002, August 1).

10. In particular after its acquisition of shares of Jingwen, the former music distributor (mentioned in Chapter 2) that holds the distribution right of Discovery Channel program, Sun TV branched out to educational multimedia products and distributors of audiovisual product.

11. In my opinion, this figure might be a little exaggerated.

12. StarEast had a valuable asset of exclusive online interview rights of many Hong Kong superstars.

13. Li of Hutchison and Cheung Kong owned the Hong Kong's Metro Radio. His son Richard Li owned STAR TV and had it sold to Murdoch's News Corporation in 1995. Richard Li also owned 50 percent of the *Hong Kong Economic Journal*, a daily famous for financial news and political commentaries in Hong Kong.

14. In 2006, the net profit of Tom Online was US$28.66 million, according to its annual report.

15. According to Einhorn and Elgin (2006, January 23), the authorities also employed more than 30,000 people to prowl the Internet world on the lookout for offensive content. Whether this is exactly true is not verified yet.

16. In September 2004, 130 local operators organized to press the government for a change of the unfair situation. The officials promised to consider legislating administrative measures for outdoor advertising, including those concerning the property rights of outdoor media, which were being studied too, according to the report of Xinhua (2005, December 3).

17. It was a joint promulgation by the State Administration for Industry and Commerce and the Ministry of Commerce that came into effect in March 2004.

18. Sina is the leading Internet portal in the PRC. Many of China's netizens develop the habit to go to sina.com for up-to-date and breaking news every day, giving Sina a similar status in the news market like CNN and MSNBC in the United States. Sina is also one of the biggest blogging service providers in China.

19. As of 2007, Google is the most popular search engine in the world taking 54 percent of the market while Yahoo's search engine takes almost 20 percent.

20. Baidu is the leading Chinese search engine in the China market. Besides the search engine, Baidu also competes with the international players with newly developing

features such as its popular search query-activated message boards (Baidu Post Bar), a social question and answers service (Baidu Knows) and an online collaboratively built encyclopedia similar to the Western dominant player Wikipedia.

References

Anderson, Jon, Jodi Dean, and Geert Lovink (2006) *Reformatting Politics: Information Technology and Global Civic Society.* New York: Routledge.

BBC news (2006, January 25) Google Censors Itself for China. http://news.bbc.co.uk/1/hi/technology/4645596.stm. Accessed on October 10, 2007.

Bettina, Ruigies (2002, August 1) Beyond Selling Books. Shanghai Star. http://app1.chinadaily.com.cn/star/2002/0801/pr21-1.html. Accessed on October 7, 2007.

Daily Economic News (2007, August 28) The Half Year Online Advertising Value Approached 4 Billion. ce.com. http://big5.ce.cn/cysc/tech/07hlw/guonei/200708/28/t20070828_12701813.sh tml. Accessed on September 22, 2007.

Dayan, Daniel and Elihu Katz (2006) *Media Event: The Live Broadcasting of History.* Boston, MA: Harvard University Press.

Einhorn, Bruce and Ben Elgin (2006, January 23) The Great Firewall of China. http://www.mywire.com/pubs/BusinessWeek/2006/01/23/1153297. Accessed on November 21, 2007.

Feng, Guangchao (2006) The Wall Is in Front of My Home: The Ban of Hong Kong Web Sites on the Mainland. *Twenty-First Century* 95 (June): 17–27.

Financial Times (2006, August 21) Yan Bihua: Wars on Television Program Branding. ce.com. http://big5.ce.cn/gate/big5/cme.ce.cn/left/yl/200608/21/t20060821_8218660. shtml. Accessed on September 23, 2007.

Fung, Anthony (2005) China Reporting on the US: Ambivalence and Contradictions. In Vladimr Schlapentokh and Joshua Woods (eds.), *America: Sovereign Defender or Cowboy Nation?* Hants, UK: Ashgate Publishing, pp.

91–101.

———— (Forthcoming) Media Consumption and Incomplete Globalization: How Chinese Interpret Border-Crossing Hong Kong TV Dramas. In Youna Kim (ed.), *Media Consumption and Everyday Life in Asia.* London: Routledge.

National Bureau of Broadcasting and Television Development and Research Center (2007, August 2) The Increase in the Average Competitive Power of Guangzhou and Nanfang Television. http://www.cjas.com.cn/n2596c28.aspx. Accessed on September 29, 2007.

Panwilder (2006, November 16) China's TV with the Most Communicative Power: Phoenix Ranked Third. http://big5.phoenixtv.com:82/gate/big5/bbs.phoenixtv.com/fhbbs/viewthread. php?tid=2073913. Accessed on September 21, 2007.

People.com.cn (2007, January 17) SARFT Announced the Scope of the Foreign Satellite TV Reception in Three-Star Hotel or Above. http://gov.people.com.cn/BIG5/46737/5291942.html. Accessed on October 10, 2007.

Shen, Yu (2005, November 21) I am not a Good Businessman. *China Women's News.* http://www.china.com.cn/chinese/funv/1036327.htm. Accessed on May 16, 2008.

Sina.com (2001, October 2) Sina Finished the 29 Percent Buyout of Sun Television. http://tech.sina.com.cn/i/c/2001-10-02/86723.shtml. Accessed on June 21, 2007.

Smith, Charles (2002, March 7) Global Crossing Buyout by Li Ka-shing Under Fire. NewsMax.com. http://archive.newsmax.com/archives/articles/2002/3/7/200817.shtml. Accesssed on October 21, 2007.

Szdaily Web (2006, April 5) More Expats Working in China. Guangdong News.

http://www.newsgd.com/culture/peopleandlife/200604050003.htm. Accessed on October 22, 2007.

Tai, Zixue (2006) *The Internet in China: Cyberspace and Civil Society.* New York: Routledge.

Wang, Xuemei, Jianhong Wang, and Min Ni (2005, October 10) The Influence of Television News Live Broadcasting. http://www.cnhubei.com/200510/ca889400.htm. Accessed on November 17, 2007.

Wolff, Phil (2005, September 5) Joint Venture: Skype and Portal Partner Tom Online. http://skypejournal.com/blog/2005/09/joint_venture_skype_and_portal.html. Accessed on November 23, 2007.

Xin, Hu (2002) The Surfer-in-Chief and the Would-Be Kings of Content—A Short Study of Sina.com and Netease.com. In S.H. Donald, M. Keane, and Y. Hong (eds.), *Media in China: Consumption, Content and Crisis.* London: Routledge, pp. 192–199.

Xinhua (2005, December 3) Feature: Outdoor Advertising Expanding, Still Vulnerable. *People's Daily Online.* http://english.peopledaily.com.cn/200512/03/eng20051203_225407.html. Accessed on November 21, 2007.

Zhong, Dalian and Wenhua Yu (2004) *Phoenix: Constructing a New Medium.* Beijing: Beijing Normal University Press.

Zhou, Qiong (2007) Tom Group Registers Heavy Loss in First Half. *Caijing Magazine.* http://www.caijing.com.cn/English/Others/2007-08-22/27735.shtml. Accessed on November 23, 2007.

Active Nation, Active Audience

This chapter examines the major consumer of localized global culture, namely, Chinese youth in China. Like Western audiences they are active, make choices, and are able to reconstruct their own lifestyles and identities despite hegemonic influences and propaganda that continually pour out from the paternal state and its media (Grossberg, 1984). In the first part of this chapter the external incorporation of globalized programs and youth values are examined in the context of satiation and the commercialization of culture in China. In the second part, a recast of the discussion about the relationship of audience needs and the state is examined. Whereas the state customizes popular culture using commercial logic, this customization is based on a very profound calculation of state interests. This begs the question of whether the so-called market-choices desired by the public in fact represent good choice for society, particularly in a society deeply entrenched in authoritarian values. The argument goes beyond a simple political economy critique that tends to argue that although the audience has the power to resist the hegemonic message, in the final analysis, consumption perpetuates the capitalistic ideology and serves to maximize the interests and profits of the capitalist class (Dorfman and Mattelart, 1975). To refute the somewhat exaggerated claim of the political economists (e.g., Schiller, 1996) regarding the internationalizing forces of capitalism, it is the authorities that closely monitor and steer the brewing of the commercial popular culture. The new culture is not created primarily to feed hungry capitalists although the very nature of cultural consumption and appropriation can be polysemic. Popular culture is still overdetermined by different structures, agencies, and institutions (Williams, 1980). The people's desires and the state agenda converge: the apolitical, highly commercialized popular culture caters to the audience while at the same time remaining unchallenging to the legitimacy of the state.

Rising Youth: From Contributing Society to Self-Contributing

History suggests that faced with huge social inequality, bureaucratic impotence, and individual helplessness, it was often Chinese students who boldly challenged the state. In June 1989, students blocked tanks with their own bodies and courageously faced a brutal military crackdown in Tiananmen Square. These were not the actions of a passive, cynical, and apathetic youth. The question that we really should ask should not be whether they are

active, but whether they have to be aggressive to get what they want. What are Chinese youth interested in today? Various anecdotal events have suggested that today, Chinese youth are not occupied with any collective social concerns or needs that push them into revolution. Notwithstanding Tiananmen Square, student activism remains subdued. According to a survey released in 2000 of 801 students in South China, among the 120 heroes recalled by the youngsters, only one of them was a political figure, with the remainder being singers, artists, and pop culture icons (He and Fung, 2000, April). The youth are capable of frenzied acts of idolatry connected to artists such as Andy Lau and the Backstreet Boys and international sports stars such as Michael Jordon and Ronaldo. Currently, and in contrast to politics, when it comes to issues of personal interest, consumption, or material needs there is a clear and contrasting assertiveness.

Youth in China (ages 14–46) represent 70 percent of the Chinese population. By their sheer size and ravenous consumer values they wield tremendous market power. With a sustained Chinese economy, consumer aspirations have been bolstered further by the emergence of a wealthy middle class. The rise of middle class in China—estimated to be 40 percent of the population by 2020 according to official statistics—nourished a large pool of "only" child families and children who are highly demanding and egocentric about their personal needs (China.com, 2005, November 10). This new generation pursues a "lifestyle of enjoyment," and makes material demands that are consistent with the pace of economic growth. In 2005, while the average annual disposal income of Chinese residents in urban city amounted to RMB9,000, youth consumption per person reached a staggering RMB15,288 (Xi, 2005, May 8). The overspending or "excessive consumption" occurs by means of mortgages and credit cards used to purchase high-class food, extravagant cars, luxurious apartments, and fancy commodities and, quite strikingly, this excessive consumption occurs five years earlier in China than it happens for youths in European and American society (Zhang, 2005, May 24).

The changing values of youth associated with materialistic pursuits are pivotal here in that they are one of the two forces shaping the popular culture. They also represent the role of the global within the culture as apart and distinct from official forces. There has been significant public discourse reflecting the dialectic between youth and the authorities. Toward the end of the Cultural Revolution, on December 6, 1979, a troop of Tsinghua University students[1] belonging to a branch of Youth Communist Group wrote a

testimony about "Constructing Socialism" in the *Chinese Youth Press* with the slogan "Let's start by myself; let's do it now." This statement was soon picked up by the editorial of the state propaganda apparatus *China's Daily* to further explore the quintessence and meaning of the slogan—a slogan that later became a well-known public discourse for all Chinese youth in the 1980s. Even more provoking was a letter-to-the-editor posted on the *Chinese Youth Press*, a retort entitled "Oh our way of life, the longer we walk, the narrower the path" about the discourse of a fictional 23-year-old female writer Pan Xiao, a pseudonym created to commemorate two youngsters, Pan, a sensitive and introverted female Beijing economic student who, after a number of family tragedies, committed suicide, and Huang, Xiaoju, a high school graduate assigned to work in a factory but felt despair after discovering no connection between her laborious work and the altruistic ideals of Communism. While Pan, Xiao is an "everyman" of Chinese youth trapped in the system, the title of the essay[2] reflected the gap between the practical vicissitudes created by the infant regime and vibrancy of the youth yearning to contribute to society (Fei, 2006, December 12). The essence of the debate was that youth were a significant social force and could be used to reduce social evils and to illuminate the veneer of the Communist ideology. Since the 1980s, both inside and outside the party, this has become a youth mission echoing with the original Tsinghua University motto "self-discipline and social commitment."

Unfortunately, this patriotism, outspokenness, and activeness eventually caused the military crackdown on the student movement in China in 1989 (Fei, 2006, December 12). The latter was also meant to thwart the voices active in the civic space and in politics. As a reaction to the impasse, in 1991, in the Shanghai *Youth Press*, an article written by another fictional character Mei Xiao—ironically in Chinese meaning "without effect"—pointed out that today's youth problematic had shifted from a noneffective voice in a corrupted system to a culture of compromise. Under the title of "Why do we live," the article described the pragmatism of youth who only focus on self-interest, pleasure, and wealth accumulation rather than on social ideals, collective goals, and patriotism. Their unwillingness to intersect with the social and the political might partially come from the refusal of the authorities to acknowledge their presence and opinions but it is globalism in the form of global culture, commodities, and modern values that has largely replaced social activism. This has been more apparent since the late 1990s. As China has become more open to the global world, consumption has

replaced abstract nationalistic and ethnic ideals and recreated lifetime goals, work momentum, and even identity formation. Youth at this juncture in time will have to wait for a more salient presence of the national before they can turn to the nation for goals and identity—a condition that in some measure may be realized in the not too distant future.

State, Ambivalence, and Youth Potentials

Chinese youth nowadays are active, pragmatic, and assertive. They are also individualistic and self-interested, and they readily divert their energy and emotion to surmount any obstacle that impedes their satisfaction of desires and vested interests. In terms of cultural and media consumption, the state could not continue to feed them the kind of cliché, propaganda, or hard moral values artificially inserted into the so-called entertainment programs with content produced by national, provincial, or local stations. Not only do youth find no interest in politics but also this content could not satisfy their individual craving for materialistic and nonmaterialistic culture. Content forced upon them only invited negative feedback. Joint media productions produced by global capital and CCTV are careful state manipulations that have found a more receptive audience.

Thus, there is a reason why the PRC has to please the new generation. Besides the fear of social instability as a result of youth as a counterforce, youth preoccupation with personal pursuits not only dissipates their energy for social struggle but also reduces time and energy available for challenging the state. Although the state publicly narrates politically correct statements about youth's passionate care for "building the party and country, whole-hearted involvement in serving others in the name of the party and reflection upon politics and party philosophy" (see regulations in Chinese Youth Party Web site),[3] in fact, the state has fears of the ability of the youth to crystallize into a community, mobilize each other, and partake in collective actions.

This explains why the state still legally forbids any association that could potentially mobilize and assemble youth for any purposes. Practically and to justify the exclusion, the authorities set bureaucratic requirements as obstacles for any registrations.[4] In the realm of popular culture, nonetheless, the state's position is ambivalent. On the one hand, continuing to ply rebellious youngsters with idolatry and the apolitical popular culture could maintain their unchallenged status. Thus, even though it is illegal to have youth associations crystallizing around fan clubs or fan society, it is an open secret

that the state allows the implicit existence of these clubs without formal registration, and refrains from making any public denunciation toward their activities. In the eyes of the youth and fans, fan clubs represent a dual avenue for fulfilling their desires of consumption and enhancing psychological ties with the artists. The former involves access to the songs, photos, movies, and all sorts of cultural consumption—even related to pirated goods and illegal goods—and purchase of peripheral products such as artists' secondhand clothing, franchised brands, and accessories. The latter refers to activities, fan club gatherings, and concerts where fans can meet their idols face to face. These organized activities in fact operate under the auspices of many local records, global music companies, and commercial organizations with vested interests in product sales (interview with Wang, Zhiguo, Manager of the Events Division, Jingwen Music on January 21, 2005, Wang, Lei, Vice General Manager, Beijing Starwin Music, and Han, Xiaofeng, Manager of the Promotion Division of Starwin Music on July 6, 2005).[5] These fan clubs are regarded as alternative spaces vis-à-vis the controlled local and national media and as such the state would not dare to close down these release valves of expression. With voices of these fans occasionally singled out by the mass media as a popular phenomenon, it also assists state efforts in bringing the existing local, provincial, and national media together in terms of what is popular culture.

On the other hand, the Communists still have a dreaded feeling toward the mobilizing potentials of the fan club. In public spaces such as Tiananmen Square in which youngsters gather for fete, flag-waving rituals to support their idols, security guards and nonuniformed police always intervene to stop these activities. In media discourse and in public interviews with officials, the fervent activities of the fans are therefore still demonized and stigmatized. But the stories in my observations do tell me that the fans are not antagonistic at all toward the official reaction. They candidly know that the vicious criticism is simply an obligation of the people in position. Without feeling too much that they should conform to the "orders" under duress, they are willing to "cooperate," so that their temporal acts of concession could pragmatically fulfill the goal (e.g., staying close to their idols). On a number of occasions I witnessed, given their absence of legal status, fan clubs willingly disperse, preferring to maintain a low profile that also enables them to continue to share pirated products and acquire free concert tickets and handouts from the record companies.

In other words, both the state and the audience want to avoid a head-on confrontation. It is a matter of image for the state to pledge openness and ostensible acceptance of youth, and for the fans, it is both pragmatic and strategic behavior necessary to preserve these outlets. Under normal circumstances, inasmuch as these fan clubs do not pose an immediate threat to the state, the state resorts to micromanage any potential upheaval from fan activity (interview with Jin, Zhaojun, music critic and judges for all levels of popular music awards in China on September 20, 2003). The target of controls is the stardom in conjunction with the fandom. The state is particularly dexterous and wise in harnessing public artists through music awards to selectively single out those stars who are less harmful to the state. The control is clear when you examine the case of Cui, Jian, the father of Chinese rock and roll, who shot to stardom in 1985 with his masterpiece "Nothing to My Name" (*Yiwosuoyou*), a sarcastic song declaring that Chinese own nothing under Communist rule. Given that this song later became a national anthem to student protestors in Tiananmen Square, the national hegemonic media were completely blind to Cui, Jian and other rock and roll stars at the apogee of their popularity in the 1990s. By the same logic, even today, no matter whether they are organized by the state or in conjunction with global partners (e.g., CCTV-MTV Music Awards), awards for various forms of popular culture, from films and television dramas to songs, are still closely monitored (interview with Yang, Yue, Vice Manager, Artist Management Division of MTV China on July 29, 2005). Despite the fact that democratic ways such as voting online or voting via SMS are now introduced to broaden the representativeness of the results, the state still has its power to influence who the popular singers are and what the popular films are. This kind of manipulation of awards as legitimizing devices is to assure that the "chosen" ones are friends of China.

The Borrowed Western Modernity

The authorities understand it is important to maintain a delicate balance between letting youth have a taste of popular culture that sustains their individualistic pursuits and consumption, and staying vigilant about the domino effect of the liberalizing potential of it that might trigger a wider youth political movement. To reduce potential danger in this regard, it is safer for the state to actively offer a "suitable" popular culture. Undeniably, at this moment the Chinese state is still not a good producer of popular

culture, but based on China's record of marketing itself as the organizer of the 2008 Olympics, it is getting much better.

In its attempt to create a popular cultural form that will be attractive to the audience, the authorities have initiated new subterfuges such as regulations and interim policies (as mentioned in Chapter 4) in an effort to automate a mechanism to accommodate popular culture from the West. Though these popular cultures might localize in different ways—from hybridization to deglobalization—and penetrate into China to different extent—from dispatching of culture from without to a full-blown settlement on the mainland—the outcome is that these globally involved productions have become a part of the popular culture in China. The state's collaboration with Channel V or MTV Channel is an example. The importation of Chinese songs from Sony, EMI, Warner, and Universal is another. Warner Bros. Pictures' involvement in film and cinema might be the most noticeable one. These various cultural forms not only match the public conception of "popular," but also act to incubate capitalist consumption, commercial values, and individualistic worldview of the Chinese. The latter is often packaged in a way congruous to the political ideology and continues to function to narcotize the public with pleasure, desires, imaginations, fantasy, and enjoyment. More important, thanks to the transnational media partners, the Chinese authorities are able to monitor and fix the floating and unstable popular culture, and anchor it onto some popular commercial grounds.

Thus, after 2000, China has been teeming with strategies and tactics for accommodating transnational media and plans to further accelerate the pace of internationalization. The extent of penetration of this global culture would reach levels never before seen in China. For the major international record labels, taking advantage of their network and regional headquarters located in Hong Kong and Taiwan, they actively marketed their globally produced Chinese albums to the entire mainland. On the local level, with the support of municipal governments, concerts of international artists from the three tenors Pavarotti, Domingo, and Carreras to the hip-hop band Linkin Park and punk diva Avril Lavigne created mania in main Chinese cities. For Hollywood movies, American hits such as *Spider Man 3* (2007) (with over 100 million ticket sales) can now sway the entire China market. Despite the popularity of unauthorized and pirated versions, translated Western fictions such as the Harry Potter series still sold millions of copies on the mainland. Foreign media such as News Corporation and Viacom that used to provide MTV and foreign movies for Chinese teenagers are branching out to provide sports and

cartoons. With the road wide open, today global players could march into any major university campus to promote their image with waves of advertisements representing different international brands (interview with Silvia Goh, Creative and Content Director of Viacom China on April 23, 2004). In every single function organized by these global players, for instance, the Channel V Music Awards, youth are repeatedly bombarded by sponsors in the media, ranging from local and national commercial corporations, including M-Zone—the youth brand of national China Mobile—the national Web site Netease, hairstyle products, and a local Beijing fruit juice brand as well as Japanese Panasonic mobile phones and international brand names such as M&M and a product line from Laurier. The entry of transnational corporations reinforces the youth's desires and materialistic aspirations.

We should guard against overstating the PRC migration toward a more liberal governance, and we should also be cautious about the intentions behind the opening up of the market. These internationalizing productions and cultures in China may borrow some Western musical forms, styles, and operations, but in terms of content and ideology, it is not so much different from the nationalistic culture. This means that, even when globalization prevails in China, the Chinese youth are not really inculcated with the deep-seated ideology of global culture. Instead, they are temporally fed with the superficial and decontextualized fantasy of the global culture. Thirsty for information and liberal values, they now have plenty to buy. It is in fact an anesthetic consumption and one that negates or perhaps even deprives them of potential sensations toward the state. Audiences are in constant negotiation with the authorities, but the degree to which the audiences can challenge the hegemonic control is relatively low because the starting point of the negotiation is in the commercial rather than the political realm.

The indirect outcome in China, at least, for the next decades to come, is that popular culture and entertainment forms will be dominated by the resourceful, trendy, global media, eroding the survivability of the local "made-in-China" Chinese cultural forms. In fact, in various interviews with local productions, producers and managers complained that many small to medium-scale local cultural productions have become casualties of globalization in that the state prefers the global to the local cultural productions. While global entities can survive using high-level communication with the government to untie various bureaucratic intricacies and huge capital to offset the loss in piracy along with high-quality content imported from without, local companies have disproportionately small resources to compete

in the same market (interview with Jiang, Hong, General Manager, Star-Making Music Company on March 21, 2005, and Hu, Zhanying, General Manager, Xinghan Music on December 2, 2003).

The major reason why the local was sacrificed at the expense of the globalization was cultural. It was not due to the incapability of the local companies to produce commercialized content. Nor was the local short of financial capital. Their lack of so-called modernity paired with cultural forms is more vital. This global modernity can be described as a fantasy of the audience toward the global: a sense that audiences can actually palpate the superiority of the modernity culture associated with the import over the "made-in-China" culture. Therefore, when a local Chinese producer is engaged in replicating the production of this supposed-to-be-Western cultural forms, consumers immediately label these products as "pretended," or as "fake" modernity and repackaged old-fashioned stuff. Naturally, when the local producers are not able to catch up with the global or replicate the Western modernity, the unassailable role of the global is of high value in the eyes of the Chinese authorities.

However, I would like to espouse that despite their unique position, there are limits to this irreversible trend of globalization and irrevocable fact of public aspiration for this Western modernity. Even on the realm of the insignificant and casual popular culture, the global by no means could usurp the role of the state. As illustrated in Chapter 5, the state uses its vantage to inculcate necessary Chinese elements and characteristics while preserving the appeal of popular Western modernity. In extreme cases, only Western forms are preserved but the values and ideologies are still a kind of local assertion of its position. At this juncture of globalization, the state has not given up its control over the media and culture; its position is still concordant with the existing cultural policy that culture of all kinds should not fall into the hands of "outsiders." The latter refer to both the foreign capital and the local independent producers. The state prefers to uphold its role as the ultimate gatekeeper of culture by serving more as a coproducer, not just an adjudicator interfering its production whenever deemed necessary. Assuming this active role, the state has to ensure that Western modernity and the amalgamation of the Chinese elements allows for a smooth complicity that retains the exuberant imagination of the original work.

The Birth of Pop Citizenship[6]

Young audiences are content with the culture offered by the authorities. Rather than interpreting the audience's reaction as a compliance with state ideology, youth are in fact quite complacent about what they actually consume in their daily life. As a matter of fact, audiences, in particular the fans interviewed, are very stubborn in this regard, having strong opinions and indicating hostility toward official control and the party guidance under the Youth Communist Party. This does not mean that although they may not be easily susceptible to propaganda, they cannot be readily swayed by popular culture.

Embellished by Western modernity, Chinese popular culture and its associated values, aesthetics, and lifestyles have been very well received among the young population (Latham, 2007). Along with this popularity, audiences are also incubating a brand new "aesthetic value." This newly evolved aesthetic value nourishes popular culture and the global-grafted-local popular culture is no longer regarded as an evil of society. The young generation's consumption of these products is now more open and public. At this point, and for perhaps the first time in China, aesthetic value and market logic are both reconciled and harmonized. The massive promotion of popular music, stars, and movies has gradually created a new cultural taste. The audiences are also naturally conditioned to consume a culture that is deprived of politics, controversy, social wickedness, and iniquity. From the viewpoint of the authorities, the state does surrender popular culture as a form of propaganda and the primal national goal of maintaining social and political stability is accomplished by depoliticizing and popularizing popular culture. The latter preoccupies the youth's work, leisure, and daily life. It is the discursive and nondiscursive formation around popular culture that functions to crystallize youth around the community and society as publics. More importantly it also connects youth to the state, albeit indirectly through the implicit and unvoiced immunization against any narratives that challenge the legitimacy of the state. This phenomenon is called pop citizenship and creates super or hyperstability in the state. So long as the state continues to use its engines to produce pop that desensitizes political criticalness, the population remains docile and placid. By citizenship, I literally mean that the people do conceive themselves as citizens contracted to the supreme state, but that the values, feelings, and beliefs the people invoke in the name of the citizenship is simply popular culture, not any principles of higher goal such

as public participation, deliberation, liberty, freedom, democracy, and equality. Besides, the public's assumption of their identity as citizens by consumption of commercial and commodified culture also means that the people no longer distinguish their role as consumers from a civil public. So long as the people could somehow practically locate a hook to the society or the nation, in this case, through consumption, they feel satisfied and even self-actualized. Perhaps for the Western audience, it is out of their question that they could be content with this low-level, mundane, and superficial connection to the state, but for the Chinese audience who are destitute of their own options and choices of their daily lives—choices of food, commodities, friends, own lifestyle, living conditions, destiny, expression, and emotions—this more concrete, though more corporeal and material, bonding with the nation nowadays is, if not a blissful ignorance, then a blessing.

Commercialization of Chinese Media

The question is how the hardware ties up with the software or in other words how do the Chinese media and other channels stay resonant with the state policy to manufacture Chinese popular culture? How could the mouthpiece of the totalitarian state suddenly appear to be "cool" or popular? By what means could they accomplish a face-lift of their out-of-date and conservative image and change the perception of the audience? As might be expected, it is a somewhat thorny and erratic path to go for the state because for a long time the state-owned media was burdened by its hardcore role of producing propaganda. To revivify their competitiveness and to tune to a mentality of producing popular culture—which is commercialized in nature, vulgar in taste, creative in style, and possibly also in need of an unbuttoned style of management—required a fundamental change in the structure of the media, an activity that has been accelerating since the 1990s.

The changing structure of the broadcasting industry presents clearer markers for the reform for commercialization. In retrospect, during the Cultural Revolution in the 1970s, with economic and the other resource limitations imposed, the market needs simply could not be fulfilled. After the revolution in the early 1980s, there were only 32 provincial and national television stations that survived, all under the strict control of the government. It was not until 1983 that the authorities allowed monopolistic control to relax somewhat and allowed a "loose" competition by bringing in the philosophy of "dual functions." In terms of structures, the media were then

supervised both by the governmental and party units as well as the adminis-
trative structure of the television stations themselves. Practically, it meant
that the media continued to serve as the mouthpiece of the state but could
also transform themselves into a more efficient and "popular" media to serve
public needs. The significance of this change is in laying the fundamentals
and principles for quicker media reform in the 1990s.

In the past decade, the ever-increasing commercialized state-owned local,
provincial, and national media, including the press, radio, and the television,
began to be more responsive to audience desires. Ran Wei (2000) suggested
that both domestic and external pressures accounted for the commercializing
trend in the Chinese media. The domestic factor is a direct consequence of
the "second reform" mentioned earlier in Chapter 3, a need of restructuring
of China's archaic planned economy into a socialist market economy after
the former Chinese leader Deng, Xiaoping's symbolic tour to the more
capitalist-like southern China. In the wave of the reform that followed, media
have had to be in tune in with the mandate of the government that is to create
media business enterprises. This new policy does not imply that the previous
role of the media as the mouthpiece of the government had in fact become
obsolete, it only means that the media to a certain extent had to consider
market needs because they have to be more financially self-reliant. Basically,
media have to search for new measures to achieve maximization of profits
within the ideological confines in a contradictory dynamics meeting both
political and economic needs (Guo and Chen, 1997). But noticeably, the
market consideration had become more pressing since the subsidies for local
and provincial television and radio stations were virtually terminated in the
1980s.

In terms of external pressure, as Wei (2000: 332–333) suggests, it is a
result of technological advancement that made access available to satellite
services and cable television. To put it more accurately, the abundance of
media choices made available by the relaxed policy for the newcom-
ers—though most choices are still under the umbrella of the state—created a
more competitive platform for media industries. This was a warrior period in
which television broadcasts mushroomed. It was also an epoch in which the
state replaced the political or administrative monopolistic control with an
economic monopoly (Hu and Du, 2005, December 17). Now there are
altogether 60 domestic regional (Asian) satellite broadcasts and 31 legal
foreign satellite channels (comprising the nonencrypted ones such as Phoenix
TV and Sun TV, and encrypted ones such as Xing Kong of STAR) fero-

ciously competing with the Chinese national television stations (4a98.com, 2006, January 30; Huang, 2007, March 15), a scale of competition larger than any market in the world. This current configuration is a means to strengthen the ability of the Chinese media enterprise to compete with the incoming foreign media.

The state's creation of a high intensity of media competition is definitely not an unintended outcome. It is a conscious effort to compel a previously crippled media machine to transform itself to an active media, capable of articulating audience preferences. For the audience the demand is for a public sphere medium providing access to information along with a copious supply of light-hearted entertainment in the form of sex, crime, violence, star gossip and celebrity scandal. However, for the state, the national media will offer only nonpolitical functions. Though, now and then, the ever-increasing liberalization trend "spills over" into sensitive political terrain—resulting in some waves of reforms—it does so only as a by-product (Wu, 2002). Most media would choose to stay close to the public sentiment by branding themselves as entertainment based, and commercialized media rather than as being political precursors or even reformers. Similar "reforms" to commercialize content have also occurred in the printed media.[7]

The public has mercilessly lampooned the "degraded" program quality and perverted social value of various Web sites and public events. However, media commercialization seems to be an irreversible trend. The media benefits in terms of its huge advertising revenues which have become too big a temptation though the programs offer a steady stream of tawdry love, romance, sex, tragedies, scandals, and various social evils (Zeng, 2007, February 15).[8] What is more essential is that the entertaining but narcotizing contents that have satisfied the audience cannot be unsubscribed. In terms of media functions, this does not imply that the national media purely pander to the needs of the audiences' taste. Rather, it is a congruous fit between the top-down policy of the commercializing national media and the bottom-up wants and desires of the public. In this case, both the audience and nation are active participants in this process. Audiences are actively looking for fulfillment and the nation has wisely created a specific pop citizenship to meet these needs. In terms of the relationship between state and market, this fusion has led to the formation of state capitalism in which the state and market are mutually constitutive of each other. Although the relationship can be full of tensions and dialectics, there are also possibilities for enhanced and harmonic containment and accommodation (Zhao, 1998: 21).

Conclusion: Free Audience But Uncritical

The undeniable fact nowadays is that global culture has softly landed and merged openly and discreetly with the local culture to become the Chinese culture. With complex appropriation and articulation, the consumption of such global-grafted-local culture imbues youth with a strong sense of blatant individualism, seditious independence, and above all, crude commercial values associated with cultural consumption and the consumption of commodities. Chinese youth might feel that they are free, unbound, and liberated. But uncritically fed with such highly capitalistic culture, they are in fact being caught up in the fantasization of the West. Despite the active consumption and appropriation of the audience, such decontextual, hence apolitical, Western consumption has not extended their daily life politics into real politics. In this sense, audiences are still active, but their criticalness does not go beyond their individual pursuits and satisfaction of unconcealed desires and at most represents the relative liberty of emotive expression. This is precisely the culture the Chinese government is trying to formulate. Chinese authorities have not only assimilated the strong commercial forces accompanying the global media, but they also preach the ubiquitous commercial culture in their own territory as if it were a religion. The state stabilizes these forces, proselytizes to the younger generation, and reinforces the social narratives associated with it. The new generation of consumers is hysterically preoccupied with self and completely enveloped by a capitalism that leaves no room for engagement with either civic society or with politics (e.g., Weber, 2001). In this mutually conducive relationship, the differences—which might have been expressed in the form of demonstrations, social upheavals, and revolutions—between the nation and the audience remain unexplored. The audience does not need to revolt against the authorities because the latter have already led the "revolution," yet in a controlled manner. Ironically unlike the Cultural Revolution in the Maoist era, which was in part designed to prevent Western intrusion, the new revolution actively invites global players to join in.

The political economy of media and culture nowadays in this sense is more complex in that the state hegemony is achieved through the discursive construction of an array of global strategic alliances, configurations, and forces (Laclau and Mouffe, 2001). It involves the proactive strategy of the state to perpetuate capitalism and advocate nationalistic sentiment. Both the nation-state and global capitalism are now seamlessly united to become one

unity of hegemony. From a critical perspective, the audience might think they now live with and travel within a globality that is democratizing and liberalizing. Sadly it is also an evolving globality itself that deprives people of their critical capacities toward both capitalist and nationalistic ideologies. After all, in the process of guiding the audience to admire a growing secular and gross culture, there is an implicit sense that somehow inherent in the consumption of commodities, popular culture, and the values associated with them is the promise of emancipation from authoritative control. The inventories and battlefields of popular culture are supposed to be testaments of public resistance, negotiation, and recuperation in an era of expanded window of opportunities after China's opening up. However, this generation is just as likely to find a way to accommodate, rather than challenge, a Chinese popular culture that includes national forces that bond the national identity.

Notes

1. Ironically Tsinghua was established in 1911 with the finding by an indemnity that China paid the United States after the Boxer Rebellion and it had been a preparatory college for Chinese graduates for further studies at American universities. My interpretation is that the seed of local transformation was originally planted by a foreign power, but it later goes beyond the imagination of the foreign power. This is a theme I would discuss more in detail in Chapter 8.

2. The title is in fact a self-expression of the young female Wang, Xiaoju.

3. The Web site zgyndj.com lists out the basic requirement for a youth to join the party.

4. Some fan clubs, such as the Jay family fan club, tried to register as a nongovernment organization, but the government department demanded 100,000 yuan registration fee and a permanent fan club address and thus the plan was called off.

5. These companies sometimes have had a love-and-hate attitude toward these fan clubs in that they need them for promotion, profits, and popularity of the stars but some fans are also hostile to the commercial nature of the activities.

6. I first came across such concept of "pop citizenship" used by Hyunjoon Shin and Jung-Yup Lee (2007).

7. Yuezhi Zhao (2000) classified the commercialization of the Chinese press into three crucial stages. First, it was the initiation stage in which the *People's Daily* first mimicked private business by running a profit accounting system since 1978. And it was followed by a stage of industrial reform, allowing the press to load with advertisements since 1988. Finally, the General Administration of the Press and Publication of the PRC pushed all major newspapers, except a few important party vehicles, to commercial operations. These papers have started to survive as a "normal" business operating on a self-independent and self-sufficient basis since 1994. Zhao's conclusion about today's Chinese press ironically pointed out that many other academic analyses on press freedom in China no longer make much sense because the content of the news does not matter anymore. What the state or local governance attempts to sell to the public is no longer the hard political news but soft entertainment, which is the more prominent means to attract advertisers and readers.

8. CCTV, their accounts record shows, gets a revenue of 9.8 billion per year, from commercial advertising alone.

References

4a98.com (2006, January 30) The Hidden Current of Satellite TV. http://www.4a98.com/article/2006/0130/article_4600.html. Accessed on June 8, 2007.

China.com.cn (2005, November 10) Middle Class Takes Shape in 2020, Forming a Middle Class Society. http://www.china.com.cn/news/txt/2005-11/10/content_6026151.htm. Accessed on June 8, 2007.

Dorfman, Ariel and Armand Mattelart, (1975) *How to Read Donald Duck: Imperialist Ideology and the Disney Comic*. New York: International General.

Fei, Tian Sky (2006, December 12) Commemorate 2006 Chinese Youth Values. http://flysky2006.spaces.live.com/blog/cns!63902AC2EDEE66DC!644.entry. Accessed on August 9, 2007.

Fiske, John (1986) Television: Polysemy and Popularity. *Critical Studies in Mass Communication* 3 (4) (1986): 391–408.

Grossberg, Lawrence (1984) Another Boring Day in Paradise: Rock and Roll and the Empowerment of Everyday Life. *Popular Music* 4: 225–257.

Guo, Zhongshi and Huailin Chen (1997) China's Media Content under Commercialism. *Mass Communication Review* 24: 85–101.

He, Zhou and Anthony Fung (2000, April) Idols and Popular Culture in South China. *Media Digest*. pp. 10–11.

Hu, Zengrong and Xuan Du (2005, December 17) The Comparison between the Policy and Structure of China and Foreign TV. http://ytv.blog.hexun.com/1798409_d.html. Accessed on June 20, 2007.

Huang, Xiaowei (2007, March 15) Who Seized the England League. *Nanfang Daily*.

http://www1.nanfangdaily.com.cn/b5/www.nanfangdaily.com.cn/southnews/z
mzg/200703150722.asp. Accessed in May 21, 2007.

Laclau, Ernesto and Chantal Mouffe (2001) *Hegemony and Socialist Strategy:
Towards a Radical Democratic Politics*. New York: Verso.

Latham, Kevin (2007) *Pop Culture China: Media, Arts and Lifestyle*. Oxford:
ABC-CLIO.

Schiller, Herbert I. (1996) *Information Inequality: The Deepening Social
Crisis in America.* London: Routledge.

Shin, Hyunjoon and Jung-Yup Lee (2007) What Has Korean Government
Done to Promote "Korean Wave"?: Cultural Policy in Korea for the Last 10
Years. Paper presented at the International Conference on China and Korea:
A New Nexus in East Asia. Lingnan University, Hong Kong, May 30–31.

Weber, Max (2001) *The Protestant Ethics and the Spirit of Capitalism.*
London: Routeldge.

Wei, Ran (2000) China's Television in the Era of Marketisation. In David
French and Michael Richards (eds.), *Television in Contemporary Asia.*
London: Sage, pp. 325–346.

Williams, Raymond (1980) *Problems in Materialism and Culture.* London:
Verso.

Wu, Guoguang (2002) The End of Reform and the Continuity of History.
21st Century 71: 4–13.
.

Xi, Bin (2005, May 8) Prior Spending Affects Betterment of Life, Experts
Reminded Youth of Scientific and Rational Consumption. *People's Daily
Overseas Edition*.
http://society.people.com.cn/BIG5/41158/3369513.html. Accessed on August
6, 2007.

Zeng, Yuquan (2007, February 15) Chinese Television Entered into a
Juvenile Stage.

http://www.cpw.com.cn/Article/2007-2/2007215105257868199.Htm.
Accessed on June 20, 2007.

Zhang, Yong (2005, May 24). Chinese Youth Overspending on Luxurious Goods; the Overspending Takes Place Five Years Earlier Than European and American Market. *Beijing Morning Post.*
http://big5.southcn.com/gate/big5/www.southcn.com/news/china/zgkx/20050 5240018.htm. Accessed on August 8, 2007.

Zhao, Yuezhi (1998) *Media, Market and Democracy in China: Between the Party Line and the Bottom Line.* Urbana-Champaign, IL: University of Illinois Press.

———— (2000) From Commercialization to Conglomeration: The Transformation of the Chinese Press within the Orbit of the Party State. *Journal of Communication* 50: 3–26.

Zhou, He and Anthony Fung (2004) Chinese Youth Idolatry and Media. Media Digest, April.
http://www.rthk.org.hk/mediadigest/md0004/06.html.
Accessed on August 2, 2007.

Toward a (National) Global Culture

Popular culture, entertainment, and the cultural industry used to be the propaganda arm for nationalism. It represented the very last PRC citadel excluded from global capital. As discussed in the previous chapters, because of various internal forces and needs, the state has already invited global players to extend their influence into this once virgin territory. Since external culture is now bound to come in, the theoretical question here is no longer a simple issue of political economy and media access but a broader one of the political economy of hybridization and finally of globalization itself (cf. Wang, 2004).[1] What will the final cultural form of such collaboration or integration between the Western capital and China be? How does the state synchronize the global culture in the long run? In this chapter, rather than continuing to interrogate the controlling strategies of the state based on a neoliberal critique, a probe is made into the long-term national philosophy and mission that guides and drives this global entry.

The key lies in the state's ultimate intentions under the new global politico-economic order. In the wake of globalization and implementation of WTO in China, in what direction does the PRC want to steer the new national culture? Do they simply want to dilute the hardcore Communist tenets that used to drive youth away from the party? Will the public continue to be satisfied with the current control of the culture, or will they demand a more "promising" (national) youth culture? What has already been discussed is that the authorities chose to select some national media and bureaucracy as trial points that were then granted special permission to join hands with global capital to create a new youth culture. This new culture combines a sense of Chineseness with Western modernity and it is characteristically devoid of any strong political values. Overtly, the baseline of any such coproduction is the absence of challenge to the establishment. In this concluding chapter it is argued that the state has a more proactive and higher goal. The piecemeal open-door policy to cultural production no longer impresses the public; nor does the PRC passive diplomatic cultural policy meet the national imperatives of the country in the long term. This chapter will explicate how the state-owned media tend to construct a new nationalizing global culture with the assistance of transnational media corporations such as Warner, News Corporation, and Viacom.

Any Chinese National Strategies?

The active, emerging national cultural policy that is described above goes against the commonplace conception that Chinese authorities are always on the defensive, sternly driving away foreign intruders and surreptitiously decelerating the process of globalization. However, nowadays evidence presented has cogently suggested that Chinese authorities and their media are more flexible, sophisticated and dynamic than the West thought them to be (interview with Zheng, Wei, senior producer of CCTV, September 23, 2003). Rather than awaiting the complete colonization of the Chinese market by global capital, Chinese media, possessing the ability to dictate national cultural policy, capitalized on the semiopen market to go commercialized—in a way also favoring the existing political leadership—to occupy the market first and possibly create the Chinese versions of Newscorp, CNN, and other similar transnational media that possess the capability of producing national cultures for their own people and for the global audience. In a broad analysis of cultural policies in different parts of the world, Diana Crane (2002) pointed out that today's state seldom set short-term targets to just protect and preserve the local culture from the effects of globalization. In the face of global competition, national media proactively fine-tuned their local culture to prepare for global competition and cater to the global market. It is only using this explanation of such a paradigm that the letting-in of the global elements does not seem to contradict national policy in China since this is a regime that is expected to balance national security, social stability, and ethnic harmony with economic interests.[2]

The argument is also well informed by the theoretical model proposed in Chapter 2 that emphasizes the continuing process of globalization and localization. Under the view that globalization of culture and localization of culture are not isolated processes of international cultural flow, the successful localization of transnational media in China from hybridization (local production emphasizing the balance between Chineseness and the West) to deglobalization (the made-in-local strategies merely has taken the Western form without connection to Western ideology) is neither a natural cultural flow from the modern, advanced first world to developing countries nor is cultural globalization a stage of equilibrium that signifies the end or terminal stage of the cultural flow. If globalization were just a one-way unilateral flow, global culture would have been the magic hand that turned China into another democratic state operating under a laissez-faire capitalist market.

This was evidently not the case. From a historical perspective, as stated in Chapter 3, since the inception of the regime, cultural terrain was always reserved for national purposes. Without the state's explicit and implicit approval, global media would not be so smoothly founded in China. In Chapter 4, it was amply demonstrated with examples that the apparent ambivalent cultural policy of the PRC continues to provide an environment under which burgeoning global cultural industries in China could survive. In the wake of the pending entry of the global moguls who are armed with high communication technologies, advanced production, proven content, strong experience, and huge capital, the Chinese authorities are now seen—not to retreat with a protective strategy always—but to react to the incoming forces of globalization in a more "positive" way. The more expedient strategies as described, particularly in Chapter 5, are a form of collaboration and integration with the Chinese partners under strong direction from above. In the long term, besides simultaneously setting up formidable barriers to delay the entry of global capital and haggling with the global powers over the pace of their entry to local market, one expects that the authorities have accelerated the formation of their own media empire. The latter is not only to counter the localized or would-be localized foreign media but also to construct a national culture—a strong image of China and Chineseness—that could be marketed to the global world. The next step that follows in the cycle of globalization-glocalization thus should be for the state to empower itself with the global culture and push outward a reverse cultural flow, a cultural process ready for the day when the state is well equipped with the national power to globalize.

Diametrically opposed viewpoints from Western scholars (e.g., Miller, Govil, McMurria, Maxwell and Wang, 2005) and Chinese intellectuals alike (e.g., Zhang, Hu and Zhang, 2000), who continued to assert that the globalization of media—with subsequent ferocious strategies of acquisition, uneven division of labor and content monopolization—market would lead to an imbalance of money and cultural flow between the global and the local. In China, on the contrary, in terms of money, global participation has no sign of leading to the outpouring of money out of the state. The localized global media instead has become the major source with which the state can "modernize" their media and transform them into another outgoing locus of globalization. CCTV itself is a classic Chinese model that is moving full speed toward this national goal. Currently it collaborates with 134 countries and districts and 208 international television corporations for various

broadcast service or Chinese program exchanges. It is through teaming up with global media that they have strengthened their competitive capability and increased the efficiency of the operation and management structures.

From the viewpoint of the Chinese media, the partnership squarely matches their own organizational goals as well as the national global goals. The globalization of the Chinese media is also a way to tackle the internal problems inadvertently created out of the development and commercialization of the television industry. Practically, with an enormous demand of programming from the 2,194 national and over 100 paid cable networks in China (Zhang, 2003: 127), the Chinese media faces the immediate problem of simply filling all the time slots to compete with internal competitors. Besides the import of global content to supplement the shortage of the programming, the new way of programming and management learned by global contacts can modernize and widen the variety, quality, and quantity of their programming. This is particularly true of the entertainment content of the big media giants such as CCTV, Shanghai Media Group, and the Hunan media. For the latter, for example, it has already demonstrated their ability to generate Supergirl, a phenomenon covered in the Asian edition of *Time* magazine. This globalizing power is a sequel to its frequent visits, exchanges and absorption of experience from the Western media corporations (interview with Long, Mei, Producer of Hunan TV, November 21, 2004, and Long, Danni, Director of Programming, Hunan Economic TV, November 22, 2004).

However, behind the veil of all the collaboration, commercialization, and modernization of Chinese media, a civic society in which media as public sphere serving the role for public participation is not yet seen (Dahlgren, 1995). Nor do we see any sign that the party organs have abandoned their propaganda or ideological mission. As a matter of fact, during my observations, I could still see party circular still posted on the notice board of an entertainment news department, and in one of the office spaces where staff were producing one of the top entertainment programs of the country, party flag still waves on those desks belonging to those party media workers. In sum, the party or the politics still has enormous leverage in the media scene. All these seemingly open media policy, as I would suggest, are intended strategies of the state, which, via the Chinese media, avails itself of the opportunity to partner with foreign capital to promote the nation's image and culture. Inwardly, the state-global media complex, as mentioned in Chapter 7, indexes the apolitical popular culture without intervening in its dictatorial governance. Outwardly, the state sends the message to all culture industries

that are intent on capitalizing in the China market, that they are obligated to reinventing a state-global complex to help govern the society and move China into global markets.

Global Players' Contribution

With the participation of the global players in China's global venture, the immediate consequence is that Chinese media are able to accelerate their reforms. Thus, while foreign media might be suspicious about China's inclination to collaborate with global powers, for the Chinese authorities, it was exactly the right strategy. As a matter of fact, China is even doing more than the WTO commitments require of it. For example, China recently has opened up the television market—a blackout area in WTO agreements—to seek joint production and exchange programs with foreign media capital in their own territory. According to a report from China Daily, Rupert Murdoch's News Corporation reached an agreement on December 19, 2002, for joint television program production with its Chinese counterpart, Hunan's Golden Eagle Broadcasting System (the entertainment hub in South China that owned the only listed company specializing in Chinese television, the Hunan TV & Broadcast Intermediary Co. Ltd.). The latter was listed in 1999 with the ambitions of becoming "China's Hollywood." In this sense, China's Hollywood is being built on the very foundation of Western support.

The dollar sign implied by the huge China market, particularly the television industry, is obviously a bait to the global player in that this broadcasting medium has the highest commercial potential among all its media business. In 2005, the advertising revenue of the entire television industry was only around RMB20 billion, and this was comparatively a very small amount compared with Viacom's MTV that had a US$5 billion advertising revenue in the same year. Now the average annual advertising cost per person is only US$7 (world average is US$1.65) while the United States reaches US$500. Even in the film market, although the Chinese film industry demonstrated success in expanding the market in terms of ticket revenues, the total profit generated annually (RMB3.6 billion) is only 0.6 percent of that of Hollywood that accrued an annual profit of over USD60 billion (Yin and Wang, 2005). It is expected that the global players are continued to be bewildered by the unfathomed potential of the market. From the viewpoint of the PRC, it would be content to depend on experienced foreign partners who have proven records in the competitive capitalist states. More global col-

laborations in the infrastructure and hardware of the cultural industries that involve high initial capital are expected to come. These involve large-scale, high-tech production factories (e.g., Sony Pictures Television International and the Hua Long Film Digital Production of China Film Group in November 2004 declared their joint investment on digital production facilitates), and distribution networks (e.g., global investments on the 6,000 Chinese cinemas and the 36 theater chains) (Chinese Film Industry Report, 2006).

Today, the transnational media are not at all shy in expressing their interest in China. Unlike international politics in which ideological disparity is the key concern, global media partners are all business. When commercial goal is upheld, whatever means and measures, from political to economic ones, are applied to secure it. For example, Rupert Murdoch immediately sent a congratulatory letter to the Shanghai municipal government as soon as Shanghai won its bid to host the 2010 World Expo (Wang, 2002, December 24). Many other international media curry favor from China despite the fact that there is a growing global cry that players were helping China to build its empire—with unknown downstream effects on the Chinese people. In return, the Chinese authorities have also rewarded various transnational media with privileges in operating in China. Since 2002, STAR TV of Murdoch has been granted the permission for a cable network in some parts of Guangdong province, which is an exception to the broadcasting rule for foreign media. Now more than 10 programs produced by STAR TV and also the programs of Newscorp and Chinese co-owned Phoenix TV are received 24 hours a day in South China. In 2005 another China companion, Viacom was, unprecedentedly, allowed to broadcast a signal across South China.

Bringing China to the global stage amidst the various international players seems more pertinent to the long-term mission of the PRC. Carrying China's international image is not simply nationalist propaganda, but once again demonstrates the powerful formation of the global-state complex, not just in China but internationally. The basic skeleton of such an operation has already begun to take shape. Now Newscorp helps distribute the CCTV-9 signal via its American network Fox to 9 million homes in North America (Davis, 2003: 90; Tang, 2003: 63). Deals on relaying CCTV-9 via Newscorp's UK media BSKYB to Europe is also in the process of negotiation. Since 2003, MTV has also relayed the CCTV-9 broadcast to their North American territory, ironically spreading national reports of the National Congress of the Communist Party of China (CPC) through Viacom's extensive TV network. All these global "contributions" have debunked the

mistaken assumption that in authoritarian and closed nations, either the state counters global capital, or the liberating force democratizes the state. In the new world order, the global succors the state, and the state becomes global.

China Eyeing the Global Market

As a matter of fact, with an ever-increasing China mania—as a result of the bandwagon effect of China's rising geopolitical power and also the oncoming Olympics Games in Beijing in 2008—China has already exported many of its global-ready cultural products overseas. Many of these productions, mainly joint China-Western productions and a few national production, have achieved greater success overseas than on the mainland, in particular, in the film industry, which, as mentioned in Chapter 3, is always the national cultural priority. Table 7.1 shows that between 2002 and 2007, overseas ticket sales of China's film coproductions with either Hong Kong (e.g., *Hero* [2002] with Hong Kong's Ecko Film) or global capital (e.g., *Kung Fu Hustle* [2004] with Columbia Pictures) have far exceeded the local ticket sales.

Among all the major global markets, the North American market contains a distinctive and large audience who are very receptive to the Chinese film culture. What is appealing to them are the Chinese martial arts (e.g., *Kung Fu Hustle*), costumes (e.g., *Curse of the Golden Flower* [2007]), the traditional Chinese historically based but fictional stories (e.g., *Hero*) that have very unique Chinese elements, including a blend of kungfu, wuxia (sword fighting), ancient palaces, and glamorous kingdoms. The high concept of China or Chineseness embedded in these Chinese blockbusters targets both Westerners, who have an increasing desire to learn about ancient and not so ancient mysteries, as well as Chinese residing abroad. From the Chinese authorities' point of view, such Chineseness not only possesses strong market value for overseas audiences but also carries with it national influence.

Nevertheless, while extending its national influence is the dream of the entire nation, the embarrassing situation is that such Chinese blockbusters are not viable at home on the mainland. As a matter of fact, the infant Chinese market alone could not offset huge film productions that could cost up to RMB300 million. This amount might be comparatively small when compared to the Hollywood productions, but represent the upper limit of Chinese production. At most, the undersized local Chinese ticket sales could cover only the cost of the production. That explains why presently in China there

are only one or two such Chinese blockbusters in production, and thus going global is the practical and pressing need of all these big productions. The most famous Chinese director Zhang, Yimou and also the director of *Hero* once said that without relying on the overseas market, such big productions could hardly survive on the mainland (Ma, 2006, October 12).

Year	Title	Ticket sales in China	Tickets sales overseas
2002	*Hero*	RMB400 million	RMB450 million in North America RMB110 million in Japan, Europe, and Korea
2004	*Kung Fu Hustle*	Over RMB100 million	Over RMB1 billion
2005	*The Promise*	Almost RMB200 million	RMB366 million
2006	*The Banquet*	RMB130 million	Around RMB6.7 million in North America RMB1 million in Europe RMB4 million in Japan
2007	*Curse of the Golden Flower*	RMB300 million	RMB423 million

Table 7.1 Comparison between overseas and internal ticket sales of Chinese blockbusters

Complexity and Competition: The Regional Media Race

Yet, paradoxically, the potential and proven success of a few of these aforementioned blockbusters in the overseas market has complicated the global and regional competition and distribution of power. It entices foreign investment in the China market to quicken its pace and Warner Bros. Pictures is clearly one of those forerunners. Since these blockbusters have swayed the Asian market, many regional cultural industries, from Japan, Korea, and Thailand, to name a few, also came to China to gain a share of this market. Of all the regionally exploited Chinese indigenous culture—ranging from fiction, to music, films, and television series—the most well-known is probably the 12 Girls' Band, which is a female 13-member classical Chinese band that plays trendy popular music with a dance beat. Appearing in skin-baring outfits they play Chinese musical instruments, including the

Chinese violin (erhu), the pear shaped lute (pipa), and the Chinese zither (guzheng); they have an image reminiscent of the Australian-British string quartet Bond.[3] Dating back to 2003, under Japanese Platia Entertainment, the outmoded classic Chinese orchestra was morphed into a fashionable pop group with Japanese version albums, Miracle Live (2003), Shining Energy (2004), Journey to Silk Road (2005), and the Beautiful Energy (2007) becoming the top sales albums in Japan with each having sold over 1 million copies. Besides Japan, South Korea's core cultural business—including music, film, and game industries—was also quick to grasp Chinese culture and devised concrete plans to make a foray into the China market (interview with representatives of Korean Universal Music and SongBMG Music, August 25–26, 2006, and interview with Korea Film Archive, October 27, 2007). In June 2007, Korean online game company WeaverKorea that had previously drawn on the classic Chinese fiction Three Countries to create an online role play game that swept Asia. They also employed the 12 Girls' Band music as their thematic game songs, and albums of the 12 Girls' Band were also produced with Korean versions. Korean entertainment company JYP not only established alliances with China's music company Starwin to market its singer Rain but also arranged him to release Chinese commercial songs such as The Perfect Interaction (Wenmei Di Hudong) with Taiwan singer Li, Hom and the first mainland song Hand-print (Shouji) that was aimed to market mobile phone Pantech into the China market in 2006. Rain now maintains a record of selling his Korean 500,000 album Raining (2005) out of his 1 million Asian sale album in China, while at home, Raining had a sale figure of only 154,000 copies. As China market and culture have become vital commercial assets for Asian cultural industries, there is no ground why these regional players would graciously let the transnational media take the share of their adjacent China market (observations in Rain's promotional tour on June 30–July 4, 2005, and interview with Wang, Lei, Vice General Manager, Beijing Starwin Music Company, and Han, Xiaofeng, Manager, Promotion Division of Starwin, July 28, 2005).

Given the Asian centripetal cultural forces that act as a counterpoint and competitor to Western culture, and hence a barrier against globalization (Fung, 2007), global partners have moved quickly to break this regional resistance and advantage (of proximity). The quick-and-dirty way to ensure an effective soft and smooth landing in China is to pitch in with the Chinese mission to help their national media to modernize and globalize. It is not that the global capitals simply kowtow to Chinese authorities; or that the Chinese

state merely takes advantage of them. Both these arguments are too simple. To outwit the regional players, the global players have to recognize their own vantage point—their global positions or experience—and then offer some concrete benefits to the state. Partnering with the state seems an optimal strategy to maximize their economic interests in that the global capital not only reaps additional revenues in the China market but also develops an alliance with the would-be global Chinese media empire.

For PRC's part they also concede that it is unrealistic, as a nation-state, to maintain itself as a fortress against these new and accelerated global capital flows. In this increasingly global environment, it leaves no option for China to adopt an internationalist strategy that counterhegemonizes capital's penetration (Hardt and Negri, 2001: 43). In today's scenario, when media capital establishes no center of origin, no fixed territorial power, and does not limit itself with rigid boundaries or barriers, the Chinese authorities can take advantage of the decentered and deterritorializing nature of these global capitals, and progressively receive and embrace them, and help them and also China's own media to expand their new geopolitical frontiers (Hardt and Negri, 2001: xii). Rather than being reluctant to accept such globalization, in coalition with the transnational media corporations, the Chinese authorities push for the construction of a state-global media complex that is rarely seen in nondemocratic nations. China also coproduces with the global alliance a national (global) Chinese culture with Chinese characteristics and global modernity. This process in the theoretical model of glocalization is not just accelerating the localization of the transnational cultural forms that these global media are dedicated to bringing into China but is also strengthening the culture's competitiveness and stepping up the rate of Chinese globalization.

The PRC now promotes itself through a cultural empire that is global in nature and in reach and it is an empire that's growing. First, with its massive population both on the mainland and overseas it can aspire to be the regional cultural center and the cultural hub of Asia, and, second, with its growing world influence and power (not the least of which is a huge internal market shared by global capital) China has substantial potential to go global by cultivating and exporting its products with strong Chinese nationalistic values (Sinclair and Harrison, 2004). In other words, Chinese media have also started to get into step with global capitalism to secure global market positions. The would-be Chinese cultural products exported are not entirely Chinese, but represent a cultural form that could be understood as stereo-

typically Chinese and cater both to the global audience and Chinese overseas. If capitalism cannot be vehemently pushed away and will come anyway hand in hand with globalization, the globality of the PRC might be regarded as the only counterhegemonic means of assimilating capitalism.

Media Conglomeration and Emerging Chinese Media Empires

At this stage, we might not witness the formation of a bona fide Chinese media empire with globalizing capacities and international capabilities, but obviously, the process in which the prototypes of these empires take shape can be seen. In this regard, as mentioned in Chapter 7, the Chinese media had been experimenting with a relatively long stage of self-realignment, the reorganization of company structures, content-wise commercialization with regard to programming, and the development of content branding. But all that we have seen might just be as a consequence of the process of media conglomeration that occurred during a short period around 2000–2001. The previous processes of media commercialization streamlined the former media organs with clear identity, enhanced their profit potential, and flattened them into more specialized media outlets (social news, traffic information, entertainment, sports, finance, etc.) that laid the groundwork for mergers, acquisitions, and the formation of media empires to take place. As for the link to globalization, the Chinese media empire serves two major functions. First, the highly compartmentalized and specialized media empires could spare certain parts of their affiliates, which included the less sensitive branches of production and most profitable global-ready media (e.g., satellite televisions) to collaborate with global media, form global alliances, and transform themselves to market to the globe, while reserving some domains for strictly national and internal uses. Second, the conglomeration is an internal means to save the less profitable but essential state media and cultural outlets that are developing. The latter could be subsidized by the profit made by the empire, not directly by the state. Overall, the process of conglomeration has strengthened the competitive power of the national media, but also constructed a more vast and extensive media empire or media carrier to compete with the more internationalizing China market in the long term.

Under this agenda of "conglomeration" of the state, the authorities, however, had to temporarily bend the existing cultural policy to facilitate the formation of media empires. Previous to the conglomeration, there was no sign at all that the state was preparing for this large-scale "media revolution."

The process of the formation of regional media empires was very short but the implications were wide reaching. At certain points, the pace of reform leading to the incorporation of the broadcasting media happened faster than the legislation and regulation of the state. It turned out that many of the mergers took place without a full-fledged legal framework. It was the de facto formation of the broadcasting empires that spurred the SARFT to later recognize the status of these de jure empires in subsequent policy regulations in 2002.[4] Unlike the former phases of reform that were mainly preoccupied with improving the efficiency and effectiveness of the operation, the new strategy of the state is to gear the profit-making-ready media to a media conglomerate or a media empire. Currently there are two models of conglomeration: the Hunan model and Shanghai model (e.g., Huang and Zhou, 2003: 11–14).

The Hunan model, namely, the Golden Eagle Broadcasting System, formerly Hunan Broadcasting, became the first media "carrier" to amalgamate a provincial television, cable and satellite TV (Hunan Satellite), a radio station, a production company, a music company, a hardware company, artist management, a television Web site, an electronic newspaper, and a training school for the media in 2000. It is a model characterized by initially buttressing a single medium of its corporation—the Hunan Satellite TV—branding it and exporting its program out using the bandwagon effect of its popularity followed by merger and integration of other media under the same system. In contrast, in the Shanghai model, the formation and enlargement of the media corporation takes place prior to the branding of its empire. Basically the SMG at the outset built up its monopolizing power through multiple stage integration and the mergers of different media platforms (including television, radio, and film industries) and cultural agencies (e.g., Shanghai Opera House, Convention Center, Orchestra, event offices, and news center, etc.).[5] Once the status of the monopoly was fully attained, it wielded its RMB14.6 million accumulated in the merger to bolster some selected media vehicles such as the Oriental Satellite TV and some of its reformed subsidiaries that could be teamed up with global partners (Huang and Zhou, 2003: 13; interview with Yang, Xingnong, Vice President, SMG, May 16, 2004).

These two prototypes were later cloned by other media conglomerates such as Beijing Broadcasting and Film Corporations and Shandong Broadcasting and Film Network Company Limited, to name a few, who rushed to emerge their electronic media and cable televisions before the provisional

edict regarding conglomeration from the state came into law before June 30, 2001. The sate resisted the formation of other huge media corporations to build its own dominant national media empire. By horizontal (integration of different electronic media) and vertical integration (integration of station, production company, music companies, Web sites, etc.) of all broadcasting and related industries of the same region, China's media empires benefit from the economies of scale in terms of territory, media, and capital—almost a foolproof formula for the development of the Western media corporations. The process of territorialization essentially builds up a regional monopolistic power over all media outlets in the same territory, reducing overlapping resources and capitals needed to target the audience. The multimedia capability of the new conglomerate also guarantees content of the empire to reach audiences of all walks of life using different channels and means. Above all, the huge broadcasting conglomerate now controls and centralizes all the capital at its disposal whereas these resources were previously scattered amongst different competitive media. The unified resources are not only deployed more flexibly within the empire but also utilized by satellite television to compete with regional and global competitors.

In sum, the new media milicu in China represents a huge media empire, which, via its emerging satellite television capability, programming, and organizational affiliate collaboration, can compete with each other internally and global media players that come in. These satellite televisions, with their cross-provincial and regional capacities, started to grow rapidly since 2000 and each of these stations specializes in different areas of entertainment using content branding and repackaging that highlights its strength in a sea of competitors. The growth of these satellite televisions was also made possible owing to the technological advancement of China through abundant wavelengths available to it as a consequence of successive launches of Chinese space satellites (estimated to be about 50, or one-half of that of Russia).

Among the satellite televisions of these Chinese empires, Hunan Satellite Television is most prominent, producing the legendary Supergirl or diva in a singing contest cloned from UK's Pop Idol. There is also a prominent partnership between Zhejiang and Guangdong Satellite TV focusing on the dual positions of entertainment and wealth in the southeastern area, the renamed Shanghai Satellite TV, Oriental Satellite with the slogan "challenging media environment, transforming television framework," and the repacked tourism-focused Hainan Satellite TV in the south apex of China. Others include the Anhui Satellite TV's soap opera brand in the east coastal

zone and Kuizhou's Western area brand, to name a few. Some of these regional corporations also formed further alliances to become a metamedia empire in order to compete with CCTV and the Shanghai and Hunan counterparts on a national level. In 2004, five local television stations—Anhui, Hubei, Hunan, Zhejiang, and Shandong broadcasting—formed a media league called the Golden Calf Media Market Group, through which they try to attract common advertisers (Zhang, 2005, May 27).

The rise of many regional media powers in China might appear as a contradiction to the state top-down media policy that protects the monopolistic position of CCTV against any competitors. However, this "relaxation" and flexibility for the creation of regional aggregation and the formation of a strong cultural media empire has created opposite but positive effects. The new distribution and rise of regional media power along with the national media further boosts state power by increasing the competitiveness of the national and regional media, an important factor for survival when future WTO requirements open the market. As a matter of fact, improving its anachronistic mix of propaganda and entertaining production, CCTV has become more responsive to market needs to produce more entertainment programs in reaction to the threat posed by these regional empires.[6]

As for the film industry, besides the reform of the state-owned China Film Group that allowed collaboration with Warner Bros. Pictures, as mentioned in Chapter 4, the state also decentralized to allow the formation of semistate giant film corporations, including Huayi Bros. Media Group and Beijing New Picture Film Corporation. These two private-owned film companies with their owners intricately networked with the ruling authorities, are privileged to own authorized production rights and coproduction licenses with global partners. These corporations can be regarded as shadow national media empires that own the capacities to produce huge productions such as Huayi's *Banquet* (2006), a modified Chinese version of Shakespeare's Hamlet (with US$15 million investment) and New Picture's *Curse of the Gold Flower* (2006), an Academy Award–nominated film (with US$45 million investment). CEO of Huayi Bros., Wang, Zhongjun in an interview, explicitly said that despite public criticism about typical Chinese content he regarded his investment in *Banquet* (2006) as a triumphant victory because the film "let [the Chinese director] Xiaogang Feng walk out of the door of the nation," and because of the internationalizing nature of the production (Ju, 2007, March 24: 129). In the years to come, Huayi Bros. and Beijing New Pictures Film could grow into the scale of Warner Bros. and Paramount

Pictures, respectively, and more importantly, these shadow empires will become national icons par excellence, taking up the functioning role as the Hollywood for China. Similarly, in other arenas such as satellite television, Phoenix TV also serves as another shadow Chinese media empire or the Chinese-CNN to extend China's global influence.

From a political economy perspective, internally, eventually, the playing field of China will be occupied with a few Chinese media empires, some selected shadow national media empires and many major global-state joint corporations with competitive capability. Politically, the global-state complex could set the standards for the game for the interested players to come in, and the condition of their entry is to "contribute" to the development of the national Chinese media. At the same time, the Chinese and shadow media empires, apart from functioning as moneymaking engines and as production hub of good quality satisfying the new generation, could serve to balance the influence of the global players. From propaganda machine to commercialization of Chinese media and then the formation of giant media empires, there is a fundamental change in the PRC's media philosophy. The state has borrowed the powers of the global to build up its media empires and produce programs of Western cultural forms to colonize the public. Besides conciliating outraged forces of global and capitalistic giants from without, it alleviates the pressure of the population from the bottom. However, what I want to emphasize is that the prerequisite for this equilibrium is to construe a plutocratic control of the national media empires leaving a few dominant state or semistate agencies still dictating to the industries, not by political means but by economic monopoly. In this new era of globalization and free flow of information, only by economic means could the state manage the global and their own people.

Externally, we can understand the formation of Chinese media empires as an extension of the PRC's international power in global geopolitics. In the past, with politics reigning over economics, profit-making was secondary to political stability and ideological consistence. It was more consistent and efficient to garrison the state with one single centralized power in the form of national television or CCTV. But now with looming globalization what the state distills from the Western experience of global capital could be equally powerful. It recognizes that economic advantages and commercializing powers are also effective means, not only to reap more money returns, but also to further increase the national power and extend the global influence. The would-be globalizing Chinese media empires then become a key

politico-economic tool for the state to achieve superpower status. Thus, the very act of the state to reform its media—to accommodate the global—is then not a weak-willed concession to the global leviathans but a revised strategy to increase its own national strength.

Global Media and National Cultural Policy

In attempting to understand the philosophy behind the formation of Chinese media empires, we might not desegregate the media strategy from a discussion of the country's national cultural policy that aims to produce a Chinese leviathan on the global stage. According to the Blue Book on China's Culture: Report on Development of China's Cultural Industry in 2000–2001 (Jiang and Xie, 2001), one of the earliest Chinese blueprints fixing the boundary of operations for cultural industries, culture in China is dichotomized into culture for public interest on the one end and culture for market commercialization on the other, with occasional semimarket-oriented culture in the middle. Based on this logic, China uniquely fixed an unambiguous connotation for the term "culture enterprises" (Wenhua Shiye), which is to distinguish culture-producing business (Wenhua Zhenye). The presence of foreign film production, cinema operations, and global fashion, and entertainment magazines in today's China can be considered as the latter ones with less degree of governmental control. The former, the culture enterprises, ranging from party newspapers to all broadcasting news units, although it carried the term "enterprise," is basically a state-reserved operation demarcated for regional and national development, not for profit-sharing with global media. If any kind of "reform" is gong to happen within these culture enterprises, they are only deemed "classified reform" by policymakers with a view to mainly allowing only a few globally ready national media to commercialize and be globalized (Zhang, Hu, and Zhang, 2006:14)

This compartmentalization of culture—into the profit-oriented culture and the nationalist-oriented culture—based on the capability of receiving the global and the degree to which it could be meticulously monitored by the state represents the state of play in China at the present time. Based on this policy, after phrases of media reforms, we could not expect that there will be the presence and emergence of the provoking, objective, and critical CNN and BBC in China, nor any global Chinese news empire hall of fame. Reforms do happen in these arenas but are limited only to organizational and management restructures of the enterprises to enhance the efficiency of

propaganda. Perhaps except Murdoch who partially owned the unique Phoenix TV, global investors who are naïve to perceive these corporation-like enterprises as real businesses will ultimately feel frustrated. The Hong Kong–listed Beijing Youth Media is a vivid example. Even with foreign investors, the group still has not attempted to operate their newspaper Beijing Youth Press according to market logic. Many similar newspaper groups with funds coming from capitalists in Hong Kong are still under the panoptic watch of the Ministry of Culture. According to Hu, Weilin, an advisor as well as the editor for the PRC's annual report on cultural industries, in China, a position called the Secretary of Cultural Industries has recently been established at the Ministry of Culture, the nexus and headquarters of the PRC responsible for ideological control and also cultural development (interview with Hu, Weilin, on May 31, 2007). This also means that content and popular culture produced under cultural industries continue to be under the guidance and surveillance of China's national policy. The involvement, if any, with foreign capital for the development of the cultural industries in China, may be very much confined to enhancing market competitiveness, profit, and revenues, and also in a way pitching in with the national agenda. Under no circumstance could the development of media, popular culture, and content trespass the very baseline of politics.

China now faces a scenario in which internally transnational media players have "invaded" the China market by collaboration and partnership with the Chinese media on the city, provincial and national level, and externally the signal of 46 foreign satellites carrying television programs beaming into China providing around 300 television programs (Zhang, 2005, March 23). To cushion against the potential "baneful" cultural or political influence naturally becomes a priority of the state. When pondering the openness of their cultural policy, the aggressive and naked "intrusion" of the global in China has forced the Communist regime to consider the issue of sovereignty, threat to national ideology, the question of cultural paradigm for national integrity, social stability, and development. Thus, for the PRC, the core issue of cultural industry is not ruthless commercialization or just a matter of creativity, export, or GNP as these have been the central debate in Western society. Rather, China fundamentally connects the thesis of national security to cultural policy and industry. The cultural innovation, effective cultural supply and demand, and the ability of the cultural administration of the party after all are not governed by simple rule of capitalistic logic. These are preconditions set up to pave the way for stable national development (Hu,

2005: 3). Thus, when foreign cultural partners are allowed to participate, although capitalists are free to steer even the state-owned cultural industries to a highly capitalistic enterprise, they do have to prioritize the political consequences over economics. In any case, as repeatedly emphasized in the book, these privileged players are not the main drivers in the process of globalization in China because, from the very beginning, it is the state that handpicks the global players to work with them.

National Culture, Identities, and Cultural Policy in China

In sum, it is not just those global cultures that entered China that have to be evaluated according to political standards. The entire mission of the regime is to build up a globalized culture in China and this goal is very much connected to the effectiveness of political governance. Western scholars (e.g., McGuigan, 1992) worried that the rhetoric of public concern and also the government policy of culture and cultural industries would be eventually reduced to a cultural populism, and thus the final cultural policy employed would be one overwhelmed by economic concerns. In China, however, the opposite is of more concern. Dating back to the founding of the PRC, public culture in China has been framed under the umbrella of politics. Although there is an escalating pressure over commercialization of the media, the pendulum does not always swing back to the economic side. While the cultural industries are gauged and valued insofar as they are instruments for profit, contribute to the development of Chinese market economy, and serve as a bridge to the global world through the creation of local content, joint ventures, and even exports, their underlying direction does not deviate much from the political arm of the state.

The question centers on the role of popular culture in China and its long-term consequences. Despite the fact that the state has attempted to redefine popular or secular culture in different sectors in various ways—from embellishing such areas as cultural diversity, creativity, and even democracy to experimenting with new forms such as hip-hop, idol shows, Hollywood-sort-of-romance—in the eyes of practitioners and academics it is still not clear just what this culture is. But it is obvious that popular culture as the term is often coined in China is an instrumental term. No matter what becomes of the substance of culture, global, local, glocal, or other sorts, its formation continues to be dependent on the state policy, diplomatic relations, and China's position and power in the new international order.

Therefore, it seems that the rhetoric and classifications or narratives created for cultural policy in China have been designed to evade the explicit definition of popular culture. In fact, the state definition is neither direct nor systematic. Behind the veil of rhetoric, it connects popular culture to the national culture and to identities. While cultural productions are designed for the imposition of potent political power and culture serves only propaganda requirements at the state media level, now cultural productions are taking a detour into cultural economy (in the name of global-state collaboration, open policy, and media marketization) to produce a national culture. The culture produced thus has a social effect beyond the economic benefits. It is a national populism, the sentiments of which crystallize the nation, people, and their identity.

The globalization of Chinese culture will not only elevate the status of the PRC in the global hierarchy. It will also be felt as a national pride for people. The concept from Raymond Williams' "structures of feeling" (1961: 48) may be a useful one here to illustrate the Chinese state's strategy. From a culture studies perspective, the state is not able to change the perception or feeling of the people, audience and spectatorship from the top-down. However, the state could change the fundamental environment or structures in which they are living. The emerging national culture created boosts the nationwide cohesion or identities of the people who genuinely feel a strong affinity toward the country. What is paradoxical here is that the transnational media capitals are the active teammates in this restructuration of culture.

At this point, the neoliberal globalization becomes not just a guiding light of China's cultural policy. Outwardly, the PRC can compete with the globalizing powers such as the United States, Europe, and other Asian countries by having its own internationally competitive media and other cultural industries. The entire globalization and then the subsequent outward glocalization retour are assumed to maximize the national interest either in terms of power or national wealth. Inwardly it strengthens its governance. It satisfies people's popular aspiration for a culturally strong nation and a firm voluntarily attached identity that they have lost since the beginning of the PRC in 1949. The wide popularity of Chinese pop culture is deemed to strengthen people's identification with their own culture, state, and nationalism. What should be questioned is the relationship between the cultural policy of China and the public.

The cultural policy is equivalent to a new policy for public control. While those activities and operations that are conducive to the maintenance

of the status quo and political recognition are encouraged by the policy, alternative, oppositional, and dissident activities—despite creativity and diversity—are marginalized and compressed, or left alone to face the unruly competition with the strong global giants, thus rendering them untenable and fading in the market. This is the power of neoliberalism. It is a commercial strategy to fulfill the political purposes of the state and to deter the opposition. It may be true that there may still be sporadic political rows, minor social disturbances, and dissident voices within the nation, but in general the lumpen-bourgeoisies, the epicurean laymen, and most of the ethnic Chinese are content with their increasing wealth, resources-abundant social life, and rising national pride.

What is important is the fusion between the state capitalism and nationalism, which might result in a nonviolent, peaceful neonationalism in China that crystallizes the nation and people around the rising politico-economic power. In contrast to the outdated mentality of Chinese nationalism in which the state has to artificially keep the state intact with propaganda and promotion of all kinds, say, with a Maoist icon during the Cultural Revolution, neonationalism manifests the convergence between the intention of the regime and the wishes of the people. It is through the bottom-up global consumption that people crystallize their identity, gradually, not just for their own sake, but for the sake of the entire nation. The public are no longer satisfied with the fragmented national imaginations and uncoordinated communities (Anderson, 1983). They plead for a more organized and visible nation to make their imaginations more concrete, vivid, and real. The state also has no point of return. It has to continue to assure the people that one day their nation can also become a global superpower. Just that coincidentally in the case of localization of global media capital, the latter that pitches in with the Chinese nationalistic agenda and preaches neoliberal globalization has become a catalyst for the emergence of such neonationalism.

From a critical political economy point of view, we should be critically aware of the impotent nation—which is not a matter of globalizing power. The direct or indirect consequences of China's globalization and the formation of internal neonationalism neutralize the civic culture and deprive the public of a pluralistic version of popular culture and cultural identities. There should be a politics or a politics of culture that everyone should be questioning. This terrain should also be the forthcoming frontline of liberals' struggle against the hegemonic state as China develops. Despite the nationalizing ideology, at this point, it is too unfair to criticize the Chinese regime for

casting hegemony on its public by molding their popular culture in a specific direction—globalizing and nationalizing—because they are not alone among the world's superpowers. American intellectuals might debase and even deny McDonald or Disney as the genuine American culture, but the American economy does benefit from these temporally and spatially extending transnational corporations, and being in the politically unfree cities like Beijing, people of the nation can definitely claim to possess a high pride for their own system, independent of being culturally and emotionally attached to the Mc-icons and Mickey Mouse. The current national strategy of the Chinese authorities to jump on board with the other globalizing powers is simply an attempt to engage in the same mode of neoliberal globalization for their own people.

Epilogue: From National Culture to Neonationalism

In this epoch of globalization in which capitalistic culture, transnational media, and communication technologies prevail, it seems that few people have more to say about our already "flat world" (Friedman, 2005). This book has demonstrated that the localization of global media capital by various cultural forms does not eliminate the differences between the global world and China in terms of political ideologies. Nor do the people of China live on a safe and smoothly run motherland with complete freedom and rights; their path can still be a rocky one navigating through the political minefield that is modern China. This is because transnational media capital have chosen to localize their content and production in the PRC in the most effective and efficient ways—and at the expense of any philosophical ideals. Knowing that the WTO and the international pressure about piracy issues in China and the discussion of globalization from the ivory tower are just empty talk, they have been pragmatic in winning China's tacit approval. They partner with the regime to construct a national Chinese popular culture that is hegemonic in nature. As evidenced in this book the state is also very active and flexible in receiving transnational media capital. The regime no longer suppresses these operators using a heavy hand, but on the contrary makes use of the invisible hand to stabilize the status quo and perpetuate their legitimacy.

The next question then is what will happen to this flat world after the global has localized in China? What is suggested is that the PRC not only tames their own people with an uncritical neoliberalism brought along with capitalist market, but also aims to recreate itself from being a national

dictator to becoming a globalizing agent and all this with the competent assistance of its global media partners. As scholars, however, we should actually leave the worries and fears to the global powers that have yet to shake hands with the rising Chinese dragon. After all is said and done there will be positive outcomes for the people of China if and when the whole world is watching. In the globalizing PRC, we may see fewer grievances, no more student demonstrations, and no more military crackdowns but the regime has to be more open, democratic, and accountable.

Popular culture has been the thread of analysis maintained throughout the book. It's fitting then to end it with an analogy found in this popular culture. In mid-2007, the global record company EMI distributed the CD of a girl trio S.H.E entitled Play produced by the Taiwan-based HIM International Music to the Chinese markets. With the cyborg-dressed trinity as a cover, the album sells the concept of playing S.H.E's music by using an ipod. This parallels the globalization thesis, suggesting that the advance of communication technology, coupled with the presence of global capital, can surmount geopolitical obstacles and erase cultural boundaries. S.H.E's music culture crossed the entire spectrum of world Chinese communities. The cultural significance of the album lies in its bold signature of promoting a song called Chinese (Language), a double riddle for both the Chinese in China, Hong Kong, Taiwan and overseas and non-Chinese foreigners who follow China mania. First, for S.H.E to eradicate its former image of being a sympathizer for Taiwan independence by blatantly raving about the omnipotence of the Chinese language, this pop song sparked off a contentious debate among Chinese fan communities, the entertainment business, cultural critics, and intellectuals alike (see Nam, 2007, July 22). While Taiwan fans and others condemn it as a mere flag-waving exercise, saber-rattling or a political skullduggery designed to bully the Taiwan independentists, many mainland fans, on the same wavelength of the cultural producers, are reinforced with a stronger Chinese national identity that has an ever-increasing international acceptance. The half-a-million sales figure and the long list of awards given by Chinese stations have once again verified the role of popular culture in its ability to hegemonize and nationalize the public.

Second, within the purview of the localization-globalization debate, the song, which postulates the globalization of the Chinese language, echoes the central argument of this book which is that the global cultural importer today will become a global exporter tomorrow. Global capital may or may not be concerned about China as an ascendant global power insofar as they are all

part of a concerted alliance, but the implications of an emerging global superpower for geopolitics is certainly a new chapter of our history. This expected future of the nation may well be manifested in the sentiments of the following chorus:

The whole world is learning Chinese
The language of Confucius has become more internationalized
The whole world is speaking Chinese
The language we speak makes the whole world listen to us.
 (Excerpt from Chinese by Zhengnan/Shi, Rencheng, 2007; author's own translation)

Notes

1. Jing Wang (2004) termed the phenomenon of renovation of creative industries for a better feedback on market demand a kind of asset hybridization.

2. Zhao, Huayung, the head of CCTV, in his public speech emphasized that creating the atmosphere of ethnic plurality (the national policy), serving the audience (the commercial factor), and developing international markets are the three main objectives of CCTV (Zhao, 2003).

3. The name of the 12 Girls' Band plays on the Chinese numerology or mythology in which the 12 hairpins represent womanhood.

4. Dated back to 1993, the Hunan Broadcasting reformed its programming and structure in tandem with the national agenda of media commercialization. But quite unexpectedly, the reform went so promptly that it spearheaded the listing of the shares of the media company on the stock market in 1999, reaping a capital of RMB2 billion from the market, an unprecedented move to privatize a state-owned media in China. It was, however, not until 2000 that the SARFT gave consent to the large-scale merger, horizontal integration, and vertical integration of broadcasting industries.

5. In 1995, much earlier than the state's directive of formation of media empire, the Broadcasting and Electronic Media Bureau at Shanghai City was combined with the Film Bureau to form the Shanghai Broadcasting, Film and Television Bureau. In April 2000, it was merged with the Shanghai Cultural Bureau to form the current SMG.

6. For example, the CCTV produced *Dream China* (*Mengxiang Zhongguo*), a singing competition similar to American Pop Idol to compete with Hunan Satellite TV's Supergirl, another clone of the Pop Idol.

References

Anderson, Benedict (1983) *Imagined Communities: Reflections on the Origin and Spread of Nationalism.* London: Verso.

Chinese Film Industry Report (2006) http://www.esunc.com/Files/zxpd/XSYJ/book/ndbg2006/ndbg2006-dycy.doc. Accessed on June 28, 2007.

Crane, Diana (2002) Culture and Global: Theoretical Models and the Emerging Trends. In Diana Crane, Nobuko Kawashima, and Kenichi Kawasaki (eds.), *Global Culture: Media, Arts, Policy and Globalization.* New York: Routledge, pp. 1–25.

Jamie, Davis (2003) Media Innovation: Ideas, Philosophy, and Technologies. In Shiding Tang (ed.), *Innovation Co-operation: The Summit Forum on China TV Development.* Beijing, PRC: Huayi Press, pp. 86–95.

Friedman, Thomas (2005) *The Whole World Is Flat: A Brief History of the Twenty-First Century.* New York: Farrar, Straus and Giroux.

Fung, Anthony (2007) Intra-Asian Cultural Flow: Cultural Homologies in Hong Kong and Japanese Television Soap Operas. *Journal of Broadcasting and Electronic Media* 51 (2): 265–286.

———— (2006) "Think Globally, Act Locally": MTV's Rendezvous with China. *Global Media and Communication* 2: 22–88.

Hardt, Michael and Antonio Negri (2001) *Empire.* Boston, MA: Harvard University Press.

Hu, Weilin (2005) *The Security Thesis of the Chinese National Culture.* Shanghai: Shanghai People's Press.

Huang, Shenming and Yan Zhou (2003) *A New Century of China Media Markets.* Beijing, China: Citic Publishing House.

Jiang, Nanshen and Jinwu Xie (2001) *Blue Book of China's Culture: Report*

on Development of China's Cultural Industries in 2000–2001. Beijing, PRC: Social Sciences Academic Press.

Ju, Beiyu (2007, March 24) Huayi Bros CEO Wang Zhongjun. *Ming Pao Weekly Book B* 2002: 128–129.

Ma, Rongrong (2006, October 12) The Embarrassing Big Movie Dream. http://news.sohu.com/20061012/n245759558.shtml. Accessed on December 12, 2006.

McGuigan, Jim (1992) *Cultural Populism*. New York: Routledge.

Miller, Toby, Nitin Govil, John McMurria, Richard Maxwell, and Ting Wang (2005) *Global Hollywood 2*. London: BFI.

Nam, Wei (2007, July 22) The Rise of Chinese Elements in Chinese Pop Music. *Yazhou Zhoukan*: 27–32.

Sinclair, John and Mark Harrison (2004) Globalization, Nation and Television in Asia: the Cases of India and China. *Television and New Media* 5(1): 27-40.

Tang, Shiding (ed.) (2003) *Interviews with Senior Administrators from Global TV Operations*. Beijing, PRC: Huayi Press.

Wang, Jing (2004) The Global Reach of a New Discourse: How Far can "Creative Industries" Travel? *International Journal of Cultural Studies* 7(1): 9–19.

Wang, Qian (2002, December 24) Rupert Murdoch in China. China Daily BBS. http://bbs.chinadaily.com.cn/viewthread.php?tid=373066&page=4. Accessed on July 18, 2007.

Williams, Raymond (1961) *The Long Revolution*. London: Catto and Windus.

Xin, Zhigang (2004) "Dissecting China's 'Middle Class.'" *China Daily* 27 (October).

http://www.chinadaily.com.cn/english/doc/2004-10/27/content_386060.htm. Accessed April 20, 2007.

Yin, Hong and Xiaofeng Wang (2005) China's Film Industry Development Report 2004. In Cui Baoguo (ed.), *Blue Books of China's Media 2004–2005.* Beijing: Academy of Social Science Press, pp. 329–345.

Zhang, Chengmin (2003) Cooperation Makes a Win-win Situation. In Shiding Tang (ed.), *Innovation Co-operation: The Summit Forum on China TV Development.* Beijing: Huayi Publication, pp. 122–131.

Zhang, Mo (2005, May 27) Television Advertising Gradually Become More Specialized. China Advertising Net. http://www.a.com.cn/News/Infos/200505/27409806907.shtml. Accessed on June 11, 2006.

Zhang, Xiaoming, Weilin Hu, and Jianggang Zhang (2006) *Blue Book of China's Culture: Report on Development of China's Cultural Industries in 2006.* Beijing, PRC: Social Sciences Academic Press.

——— (2000) The Impact on China's Cultural Industries upon Its Entry of WTO, Proceedings on the Second 21st Century Forum on China's Cultural Industries, December 3, 2000.

Zhang, Yu (2005, March 23) The Impact of the Reform of CCTV on the China's TV Industry. http://media.people.com.cn/BIG5/40628/3263952.html. Accessed on June 13, 2007.

Zhao, Huayong (2003) CCTV: The Three Characteristics of Communication Innovation. In Shiding Tang (ed.), *Innovation Co-operation: The Summit Forum on China TV Development.* Beijing, PRC: Huayi Publication, pp. 22–30.

Index

Toby Miller
General Editor

Popular Culture and Everyday Life is the new place for critical books in cultural studies. The series stresses multiple theoretical, political, and methodological approaches to commodity culture and lived experience by borrowing from sociological, anthropological, and textual disciplines. Each volume develops a critical understanding of a key topic in the area through a combination of thorough literature review, original research, and a student-reader orientation. The series consists of three types of books: single-authored monographs, readers of existing classic essays, and new companion volumes of papers on central topics. Fields to be covered include: fashion, sport, shopping, therapy, religion, food and drink, youth, music, cultural policy, popular literature, performance, education, queer theory, race, gender, and class.

For additional information about this series or for the submission of manuscripts, please contact:

Toby Miller
Department of Media & Cultural Studies
Interdisciplinary Studies Building
University of California, Riverside
Riverside, CA 92521

To order other books in this series, please contact our Customer Service Department:

(800) 770-LANG (within the U.S.)
(212) 647-7706 (outside the U.S.)
(212) 647-7707 FAX

Or browse online by series: www.peterlang.com